DANDY
STYLE

EDITED BY SHAUN COLE AND MILES LAMBERT

DANDY STYLE

250 YEARS OF BRITISH MEN'S FASHION

Manchester
Art Gallery

YALE UNIVERSITY PRESS
NEW HAVEN AND LONDON

CHAPTER 5

PERFORMING THE DANDY

Kate Dorney

93

CHAPTER 6

EXTRAVAGANCE AND FLAMBOYANCE: DECORATED MEN'S FASHION

Miles Lambert

103

CHAPTER 7

CASUAL SUBVERSION

Shaun Cole

125

CHAPTER 8

CONTEMPORARY BRITISH MENSWEAR: HYBRIDITY, FLUX AND GLOBALISATION

Jay McCauley Bowstead

139

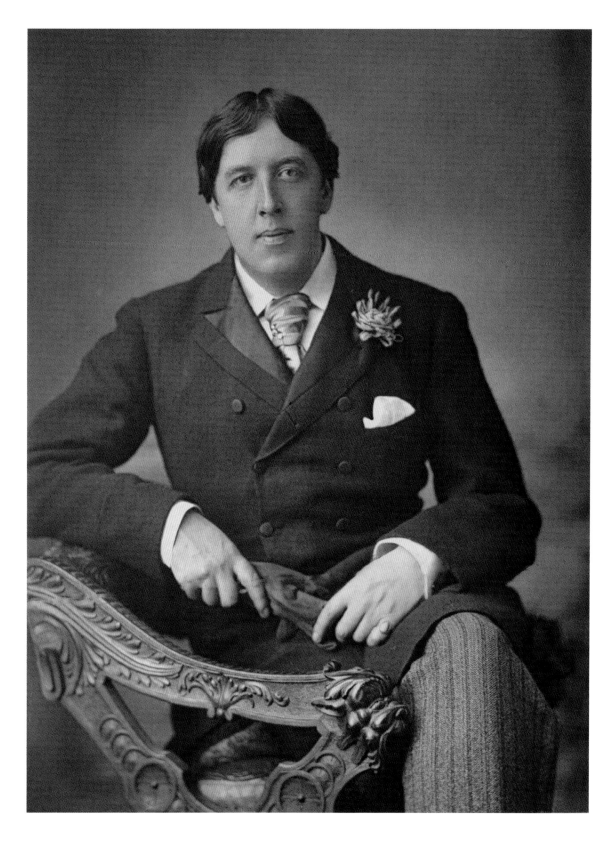

W. & D. Downey, 'Oscar Wilde', 1891. Silver print photograph. Manchester Art Gallery (2008.40.8.2417).

Foreword: Dandy Style

Christopher Breward

The early 2020s seem as good a time as any to revisit the idea and materials of dandyism. For we are in one of those pivotal moments in the history of culture when the dandy's detached gaze finds renewed focus, and dandies seem to thrive in the 'twenties', whenever they may fall. In the 1820s, arguably the first peaking of the style, dandyism captured the imagination of a generation traumatised by war in Europe and North America and energised by the transforming possibilities of technology in the fields of industrial production and trade. Revolutions and the dawn of empires called for a new attitude, new philosophies and – a new wardrobe. In the 1920s, the generation emerging from the trenches of the First World War, and working through an imminent global Depression, found that a reinvention of old-style elegance suited a new 'modern' era. While the politics of first-wave dandyism may have faded in the epoch of political extremes, the distanced pose of that 'roaring' decade seemed perfect as an emblem fit for celluloid reproduction and avant-garde experimentation. And now, in the early twenty-first century, it is time it seems for another radical realignment of 'Dandy Style'. A decade of austerity, populism and a recent plague, whose long-term social and economic effects are as yet unknown, has set a context of exhaustion and anticipation which offers fertile ground for new directions in dandyism's bicentennial story.

That is not to say that dandyism only recurs once every hundred years. It is a powerful concept and metaphor that has been reinvented by every generation. The anglophile French writers and artists of the 1830s, 40s and 50s captured its power to symbolise the experience of modern life. Balzac and Baudelaire translated it for Delacroix and Manet. The Wildean decadents of the 1890s focused on its amoral aspects, as a medium for exploring the transgressive aspects of psychology and desire. Aubrey Beardsley reduced it to a suggestive black line. On the rebound from the neophiliac radicals of the 1920s, mid-century celebrants of the dandy creed captured its nostalgic, Neo-Romantic elements for a mass audience eager for escapism. It became the stuff of Gainsborough movies, Georgette Heyer novels and chocolate box wrapping. And from the 1960s onwards, dandyism was regularly refashioned, literally, for the consumerist fantasies and identity politics of boomers, X-ers and millennials: as subcultural shorthand for 'cool'. It is, in essence, a palimpsest, over-written every thirty years or so, but always bearing a trace of its former incarnations. The ultimate in layering, as the fashionistas might say.

In preparing for these introductory words I scanned my own bookshelves for titles directly referencing the word 'dandy'. I wouldn't claim it's an exhaustive bibliography, but it's certainly suggestive of the ways in which scholars and curators have returned, again and again, to the terrain of dandyism for inspiration. Perhaps my favourite book is that bible of dandy texts, Ellen Moers's *The Dandy: Brummell to Beerbohm* of 1960. I am the proud owner of a first edition with its salmon-pink cover, retro-cartouche title plate and typeface, and clever use of a repeated reproduction of an 1816 caricature of a dandy in profile: high collar and cravat, cocked hat, riding crop and supercilious expression. It is the author's debut publication and the photograph on the back shows a young woman, barely thirty, with cropped hair and round-necked sweater: an Ivy League revolutionary looking for a subject.

By the 1970s, Moers's interpretation of dandyism for the new world of cultural history and second-wave feminism found many followers in the worlds of literary and cultural studies, and not just in the anglophone world. It is no surprise, perhaps, given the interest in radicalism, style and aesthetics that defined the new Italian culture of the 1960s, that a strong seam of dandy works are to be found published in Italian. Giovanna Franci's *Il sistema del dandy: Wilde – Beardsley – Beerbohm* of 1977 was given to me by the author at a symposium on men's fashion in Rome over twenty years later. It is, appropriately, an elegant production, bound in brown artisan card, imprinted with the indented characteristics of calfskin leather, sparsely illustrated with reproductions of plates from *The Yellow Book*.

For me, the 1980s and 90s were not decades for book buying. I spent most of the 1980s in my north London bedsit reading about contemporary dandyism in *The Face, Blitz* and *Arena* (and occasionally experiencing it first hand in the bars and clubs of Soho) and most of the 1990s in the British Library and the V&A's National Art Library, studying primary dandy texts for my doctoral research. Aside from the back issues of 80s style magazines, my study lacks secondary literature on dandyism from the period. The twenty-first century, however, was a different prospect. A job in academia, new social networks and an explosion of interest in style culture across the media and museum worlds made the turn of the twenty-first century a new gilded age for the dandy class. American writers, buoyed by the *enfant terrible* Camille Paglia's success, got there first: seeing the obvious links between the literary history of dandyism and contemporary celebrity culture, and capitalising on them. Rhonda K. Garelick's *Rising Star: Dandyism, Gender, and Performance in the Fin de Siècle* of 1998 is a well-thumbed volume on my 'men's fashion' shelves. It shares space with Monica L. Miller's *Slaves to Fashion: Black Dandyism and the Styling of Black Diasporic Identity* of 2009 with its striking homage to Boldini, self-posed by artist Ike Ude, gracing the cover; and was joined more recently by Elizabeth Amann's *Dandyism in the Age of Revolution: The Art of the Cut* of 2015, a forensic reading of the sartorial and semiotic codes of revolution, with typography in shocking pink.

And while American university presses continued to reserve 'dandy' and 'dandyism' as modish academic keywords, British publishers mined a more traditional seam. The independent imprint Gibson Square Books produced a slim volume authored by ex-Tory MP George Walden in 2002. Titled *Who's a Dandy*, it included Walden's

translation of Jules Barbey d'Aurevilly's essay 'On Dandyism and Beau Brummell' of 1844 and the author's own reflections on the political economy of dandyism 150 years later. Jarvis Cocker faces off the Beau on the cover. It is one of those delightfully contrarian contributions to literature that remind us why dandyism was invented in Britain in the first place. It was also in 2002 that Alice Cicolini and I prepared our touring exhibition *21st Century Dandy* for the British Council, showcasing the best of British menswear design in the glory days of 'Cool Britannia', while placing them in thematic categories that might have been familiar to any Regency dandy-about-town. Audiences in Moscow, Santiago and Zagreb adored it; it seemed to strike a chord. In Kiev it had to be closed prematurely for the safety of the objects and attendants as the Orange Revolution took hold around it.

It's a shame it has taken almost twenty years for the dandy to find a museum setting again. I know of only one major fashion exhibition devoted to these timeless themes in the interim. The Museum of Art at Rhode Island School of Design organised the beautiful *Artist, Rebel, Dandy: Men of Fashion* in 2013, but otherwise major shows on dandyism have been rare (notwithstanding some impressive survey exhibitions on menswear in which the dandy has played more of a walk-on part). *Dandy Style* will, then, fill a gap in the bookcase at a prescient moment. I write at a time when much of Europe, America and Asia is in 'lockdown', sheltering from a viral pandemic. I reach for Balzac's dandified *Treatise on Elegant Living* of 1830 for tips on surviving enforced confinement. His aphorisms offer hope: 'Absolute repose produces spleen'; 'Elegant Living is, in the broad acceptance of the term, the art of animating repose'; 'The man of taste must always know how to reduce need to a minimum'. Dandyism still lives!

<div align="right">

CHRISTOPHER BREWARD
Director of National Museums Scotland

</div>

Director's Preface

Alistair Hudson

The collection of clothing and fashion at Manchester Art Gallery is superb and often surprising. The first pieces were donated almost a century ago and, since the purchase of the acquisitions of Cecil Willett and Phillis Cunnington in 1947, the collection has been regarded as nationally significant. Displays of fashion have always been extremely popular because they connect with everyone. We all wear clothes but we also understand the visual, social and cultural role they play. Everyone, consciously or not, uses clothing to say something about identity and culture, and how we want to appear to others. After many years of exhibiting costume at Platt Hall, our Georgian branch gallery 2 miles south of Manchester's city centre, we now want to feature it more prominently and regularly at Manchester Art Gallery in the context of our wider collections and to view it as an integral part of the story of art and culture. To this end, we are inaugurating our first dedicated permanent fashion gallery, a space which will host changing and challenging displays of costume, fashion and dress.

'Elegance is not standing out, but being remembered.' These words of Giorgio Armani could serve as a catchphrase for our show, *Dandy Style*, which investigates the meaning and legacy of the original 'dandy' concept, and highlights aspects of masculine style and identity over the succeeding 200 years. We explore themes of decoration, simplicity, subversion and, of course, elegance, and the selection of exhibits juxtaposes our exceptional collections of male portraiture and fashion. Underpinning the exhibition will be a public programme that will examine perceptions of masculinity, the construction of the male self-image and how visual culture shapes identity, behaviour and society.

Our exhibitions programme affords an opportunity to display our collections in new ways and in new contexts. *Dandy Style* will showcase eighty or so outfits and a similar number of portraits and photographs, with over 75% coming from Manchester Art Gallery's collections. We are nonetheless extremely fortunate to have been able to borrow significant examples of additional fine art and fashion to supplement our exhibits from a number of British institutions, including Tate, the Royal Society, the National Portrait Gallery, Wolverhampton Art Gallery and Museum, Leeds Art Gallery and Museum, the Fashion Museum at Bath, the Victoria and Albert Museum, Westminster University Menswear Archives, and various private lenders. We are truly grateful to all our generous lenders.

While this publication has been created as a stand-alone collection of academic essays, drawing on a range of contemporary scholarship, it also acts as a valuable catalogue to the exhibition, illustrating many of the exhibits, and providing a significant legacy that will enhance public access to our collections and research.

I would like to thank all the members of staff at Manchester Art Gallery who have worked on the show, especially Sarah Walton, Dress and Textile Technician and Rebecca Milner, Fine Art Curator. Particular thanks go to Shaun Cole from Winchester School of Art, University of Southampton, who has collaborated as co-curator, author and co-editor and my colleague Miles Lambert, Costume Curator, who originated the concept of this show some years ago and led the team as co-curator, author and co-editor.

ALISTAIR HUDSON
Director, The Whitworth and Manchester Art Gallery

Introduction

Shaun Cole and Miles Lambert

The majority of texts on the dandy, and indeed more broadly on men's fashion and style, credit George Bryan 'Beau' Brummell (1778–1840) as the 'original' dandy, in the sense that this sartorial style was first understood as restrained, almost austere, elegance with keen attention to detail (fig. 1). Brummell is seen as the first exemplar of 'a man who has decided to radicalize the distinction in men's clothing by subjecting it to an absolute logic'.[1] This is in sharp contrast to more flamboyant, ostentatious predecessors such as the fop or *macaroni*, who revelled in ornamentation and decoration. Brummell did not invent this restrained style, but drew on that of many English country gentlemen, who by the 1770s chose to wear plain woollen tailoring for their outdoor activities, both country and urban. Practical considerations for more active wear led to the need for improved construction and fit, and stimulated the development of the already dominant London tailoring profession.

Brummell was described as the 'Dictator of Taste', and his ideals, exemplified in his appearance and manners, stressed personal elegance and neatness; panache and languid hauteur; wit and intelligence; and meticulous care and cleanliness.[2] Scholarship has theorised that, although clearly some income was required, vast wealth was not. This 'egalitarianism' – radical, if incipient – is seen to have challenged ancestry and pedigree, and to have represented 'a conspiracy against aristocracy'.[3] Anne Hollander reinforced this view: 'Brummell proved that the essential superior being was no longer a hereditary nobleman. . . . His garments had to be perfect only in their own sartorial integrity.'[4]

Herein lies a deep, yet still promulgated, contradiction. Brummell may be identified as the source of nineteenth-century understated, plain, but elegant men's

1 Richard Dighton, *George Bryan 'Beau' Brummell*, 1805. Watercolour. Private collection.

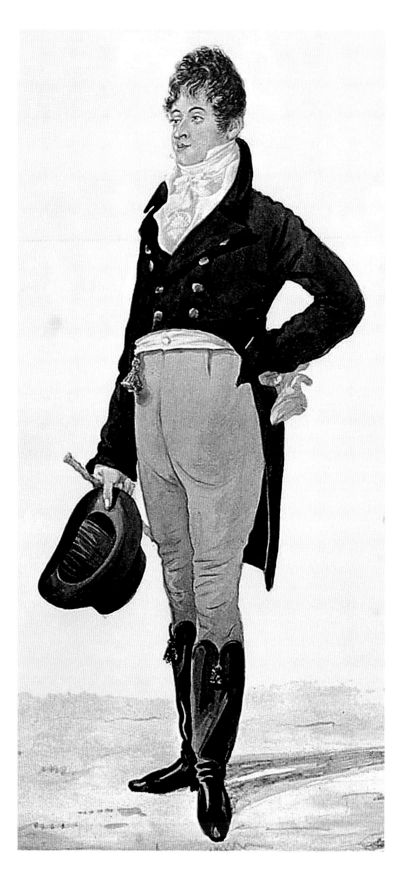

dress and style, but he was actually a paradigm of eighteenth-century conspicuous consumption, requiring admiration and emulation. He lived life as if he were a wealthy aristocrat and he used the fashionable arena of London's social high life as his canvas for self-promotion. In Christopher Breward's words, 'his houses in Chesterfield and Chapel Streets became the focal points of a new landscape of conspicuous display'.[5] Brummell's very emphasis on detail, fit and cleanliness was also prohibitively expensive. It was an exclusive lifestyle with clear elite connotations, which was not, in its essentials, egalitarian, but rather intellectual, inventive and the antithesis to unrefined, uncultivated, aristocratic privilege. Brummell's sartorial philosophy, his genius, was the clever acquisition and advocacy of an already established trend towards better fit and construction in tailoring, and towards plainer colours, lack of superfluous ornamentation and greater hygiene. This has perpetuated his now legendary significance as an innovator and a pioneer.

Taking Brummell as the epitome of a first wave of dandyism, Breward identifies two further phases.[6] Like the first, these were tied not only to a particular time period but also to key individuals who epitomised this archetype of dandy style and attitude: Charles Baudelaire (1821–1867) and Oscar Wilde (1854–1900). In the second wave, ideas and theories about dandyism emerged from the literature of Baudelaire and Jules Barbey d'Aurevilly (1808–1889); this phase differed from its predecessor in moving away from concerns around fashionable consumption and class towards a more individual bohemianism. Baudelaire equated the artist's creative talent with the dandy's quest for perfection in his 1863 essay 'The Painter of Modern Life', emphasising an intellectual stance that elevated both the artist and the dandy (and sometimes artist–dandy) beyond the ordinary existence and daily routine of a general populace. Described by Elizabeth Wilson as 'a defiant-nihilistic-political posture', this form of dandyism was exemplified in Britain by Count Alfred d'Orsay (1801–1852), and by the politicians and writers Benjamin Disraeli (1804–1881) (fig. 2) and Edward Bulwer-Lytton (1803–1873).[7] The celebrated novelist William Makepeace Thackeray (1811–1863) was also fascinated by the concept of the dandy, in particular in his two major novels of the later 1840s, *Vanity Fair* and *Pendennis*, which he set in the Regency period. In *Vanity Fair*'s Jos Sedley, Thackeray created a fastidious and ridiculous figure who only reached a certain maturity when purged of his obsessive and 'dandified' behaviour – behaviour lampooned in contemporaneous caricatures (fig. 3).[8]

The third wave, described by Ellen Moers as *fin de siècle* literary dandyism, was also concerned with literary expressions of style, but in addition, Breward notes, with new definitions of homosexuality as an emerging identity.[9] These coalesced in Wilde's infamous trials and the concerns with his self-presentation. The close association with the Aesthetic movement, of which Wilde was so much a part, is noted by Moers in her description of the single details – 'green boutonnière, a bright red waistcoat or a turquoise diamond stud' – that Wilde added to his formal evening wear in the 1890s, following earlier, more creative expressions of Aesthetic style (see p. 6 and fig. 15).[10] Breward critiques the over-reliance by some scholars on the decadence of this phase and notes how stylish young men were perhaps following the dictates of 'smart' society in the social and sartorial guides available, 'comfortably

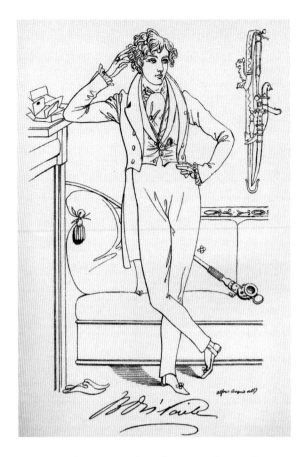

2 Daniel Maclise, *Benjamin Disraeli, Earl of Beaconsfield*, c.1833. Lithograph. From the Maclise Portrait Gallery, published 1898.

accommodating sexual conformity, advanced tastes and commodity fetishism'.[11] Wilde's notoriety both before and after his infamous trials elevated him to the status of a 'celebrity'. The way in which he disrupted hegemonic hierarchies of status and power has been noted as a common denominator of both dandy and celebrity.[12] In 'The Painter of Modern Life', Baudelaire also noted that 'Dandyism appears especially in those periods of transition when democracy has not yet become all-powerful' and that 'disenchanted and leisured "outsiders" ... may conceive the idea of establishing a new kind of aristocracy'.[13]

A new approach to dressing in the highest echelons of society was seen in the behaviour and dress style of Edward, Prince of Wales (1894–1972), who reigned briefly as King Edward VIII and then abdicated, taking the title of Duke of Windsor. In his 1960 memoir *A Family Album* (in which he frequently referenced Brummell), he reflected that 'all my life I had been fretting against those constrictions of dress which reflected my family's world of rigid social convention', contrasting his own adventurous styles with the adherence to sartorial conventions of his father, King George V.[14] While his contribution to changes in men's fashion lay in the context in which he wore certain items – suede shoes in town, single-breasted suits made in fabrics usually reserved for double-breasted – he followed somewhat in the tradition of his grandfather (also Prince of Wales and later King Edward VII) by paying what some considered *too much* attention to his dress. Indeed, the older Edward's mother, Queen Victoria, wrote to him: 'we do not wish to control your own tastes and

fancies … but we do expect that you will never wear anything *extravagant* or *slang*'. His father, Albert, the Prince Consort, advised him to avoid 'the frivolity and foolish vanity of dandyism'.[15] Edward (VII) dressed well and is credited with popularising a number of particular innovative garments and styles: the (tuxedo) dinner jacket; the homburg hat; a pressed trouser crease; the white dress waistcoat; but particularly a form of tweed, Glenurquhart plaid, that has come to be known as Prince of Wales check. The younger Edward acknowledged his grandfather's style in his memoirs and continued his stylish innovations, but pushed harder against conventions, reflecting and influencing a new generation of men who were attempting to move away from the formality and strict protocol of their parents.

Colin Campbell compared the older 'mannered … aristocratic ethic' of the early nineteenth-century dandy's consumption, which focused on mannered perform-ance of the self, with the supposed authenticity and naturalness of the Romantic bohemian.[16] 'Bohemianism' was seen by Campbell as 'the attempt to express romantic ideals in a complete way of life'.[17] Campbell's proposition does not claim that there was a direct identity link between 'Romantics' and 'modern consumers', but in her reading of Campbell's ideas, Joanne Entwistle links Romantics to hippies of the 1960s and 1970s and dandies to 1960s mods, by invoking Dick Hebdige's claim that mods were modern-day working-class dandies.[18] The keen attention to detail in the clothing of the first waves of mods in the late 1950s and early 1960s was as slavish as that of Brummell

3 *Dandies Preparing for Promenade*, 1819. Hand-coloured engraving. Manchester Art Gallery (1955.181).

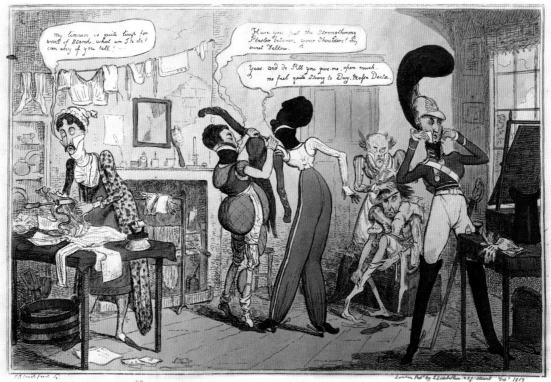

Introduction 17

(see further discussions in Chapters 6 and 7) and led to accusations of effeminacy.[19] At the same time, mods and their successors, skinheads, were inspired by the West Indian rude boy styles that arrived in Britain with post-war migration, and consisted of sharply tailored suits, polished brogue shoes and trilby hats. The pared-back attention to detail manifested by nineteenth-century dandies, and continued by rude boys and mods, has been linked by Olga Vainshtein to concepts of minimalism in late eighteenth-century Neoclassicism and mid-twentieth-century modernism.[20] This could be taken forward further to the skinny male aesthetic that became popular in the early twenty-first century, following catwalk presentations by Hedi Slimane (1968–) for Dior Homme.[21]

For hippies, the spirit of Romanticism was reflected in a return-to-the-earth ethos, alongside a search for spiritual enlightenment that took many on the hippie trail through India and North Africa. This infused the hippie wardrobe with casual 'ethnic' elements that seemed as exotic as the Turkish-inspired smoking jackets and hats of the mid-to-late nineteenth century (also discussed in Chapters 6 and 7). In contrast to the minimalism of dandies and mods, this maximalist approach continued through the psychedelic, patterned and extravagant styles of the 1960s, the postmodern parody and pastiche of the 1970s and 80s, returning in the 2010s as a counter to pared-back skinny-boy style. The monochrome minimalism of the Slimane skinny archetype references the sleek mod silhouette of the 1960s, but in terms of its (lack of) colour echoes dominant images and hegemonic styles of men's fashions in the nineteenth century. A move towards a black palette is not surprising when one sees the darkness of the uniform of both the fashionable world and that of industrial money in the spa resort, the metropolis and the northern town. John Harvey writes that one might speak of a society, or at least of a gender within society, selecting a colour to express its sense of common cause, shared by people in diverse roles.[22]

In *The Psychology of Clothes* (1930), John Carl Flügel proposed that the 'Great Masculine Renunciation' came at a time when 'men gave up their right to all the brighter, gayer, more elaborate, and more varied forms of ornamentation … thereby making their own tailoring the most austere and ascetic of the arts'.[23] Drawing on theories such as Flügel's, German-Jewish philosopher and critical theorist Walter Benjamin (1892–1940) highlighted men's 'preference for all shades of grey down to black', which, in his opinion, 'shows our way of socially and in other ways of appreciating the theory of educating the intellect above everything'.[24] The uniformity of black and subdued colours in men's fashions is clearly seen in the 1877 painting *Interior of the Manchester Royal Exchange* (fig. 4), by Frederick Sargent (1837–1899) and H. L. Saunders (d. 1899). Flügel's proposition has been utilised as a dominant paradigm in discussions of dress and fashion, particularly to explain men's seeming disinterest in the cycles of fashion and fashionability, but has also been contested as limited and simplistic. As Hollander states, 'the truth is men have never abandoned fashion at all, but have simply participated in a different scheme'.[25] David Kuchta particularly questions Flügel's chronology and pushes men's 'modern' relationship with clothing back to the seventeenth century, with the beginning of what we can identify as the three-piece suit.[26]

Breward counters Flügel's simplification, assumption and shorthand by arguing that the 'possibilities of the narrower range of masculine sartorial models on offer' positioned men at the centre of debate concerning fashion and modern life, 'while apparently denying their participation in its wider cultural ramifications'.[27] In the latter half of the nineteenth century, when the so-called man in black is perhaps understood to have been most prevalent, a variety of decorative additions remained customary, for example in waistcoats as seen in both fashion plates and photographic records (figs 5 and 6). In his 1859 novel *Twice Round the Clock, or the Hours of the Day and Night in London*, G. A. Sala describes 'spruce young clerks … who purchase the pea green, the orange and the rose pink gloves; the crimson braces, the kaleidoscopic shirt studs, the shirts embroidered with dahlias, deaths heads, race horses, sunflowers and ballet girls'.[28] This variety in a man's wardrobe could be seen in the extensive collection of clothes belonging to Edward, Duke of Windsor, which was sold following his death in 1972, and in the donated wardrobes of Sir Roy Strong and art collector Mark Reed (discussed in Chapter 2).

Baudelaire's ideas of how dandyism appears at particular social, economic and political moments is echoed in Roy Strong's statement that 'clothes are the mirror of society – of its idiosyncrasies and its characteristics. They reflect its aspirations and realities'.[29] This has become a common theme in discussions of men's fashion and is manifested in *Strictly*, a series of six images that originally appeared in *i-D* magazine

4 Frederick Sargent and H. L. Saunders, *Interior of the Manchester Royal Exchange*, 1877. Oil on canvas, framed 194 × 255 cm. Manchester Art Gallery (1968.245).

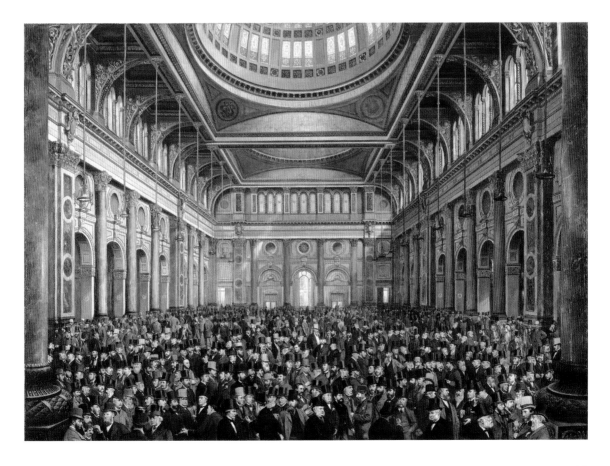

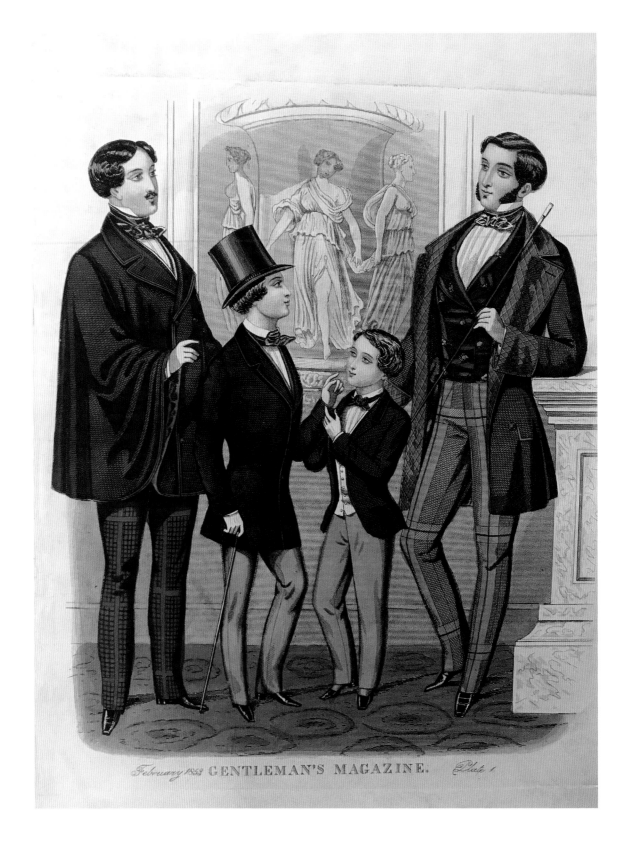

5 Hand-coloured plate from *Gentleman's Magazine*, August 1852. Manchester Art Gallery.

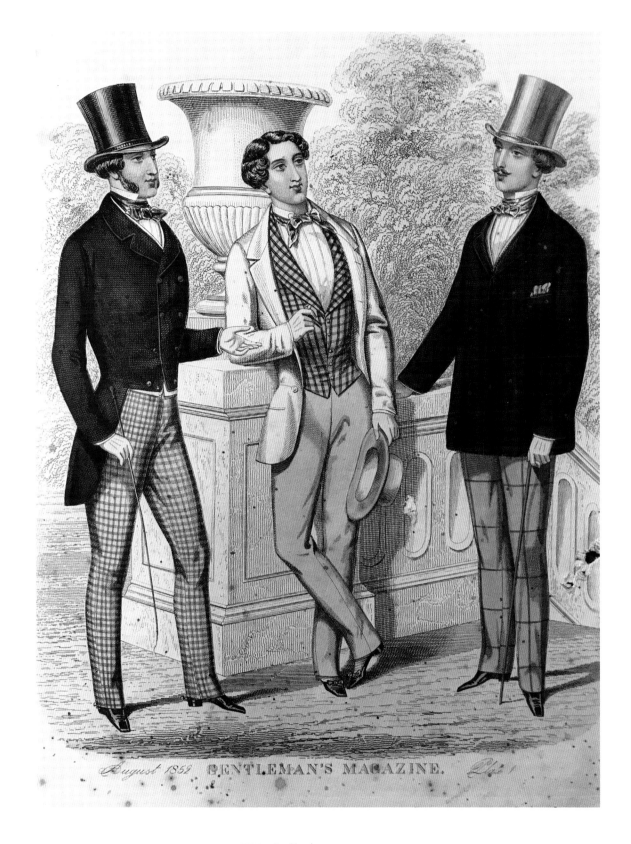

6 Hand-coloured plate from *Gentleman's Magazine*, February 1853. Manchester Art Gallery.

7 'Travis' (Jason Evans),
Strictly, 1991. Photograph, colour,
on paper. Tate (P11786).

in July 1991. Styled by Simon Foxton and photographed by 'Travis' (a pseudonym for Jason Evans) in suburban London (Northfields), the series made links between different sartorial traditions and juxtaposed classic English tailoring with louder, patterned designer garments and street styles (figs 7 and 8). The images celebrated the black British communities' contribution to British style and culture; the magazine spread opened by quoting James Laver's comment on Beau Brummell's attitude to style and dressing: 'No perfumes . . . but very fine linen, plenty of it and country washing. If John Bull turns round to look after you, you are either too stiff, too tight or too fashionable.'[30] Through the 1980s, stylists such as Foxton, along with Ray Petri and his Buffalo collective, had created images for lifestyle magazines, such as *i-D*, *The Face* and *Arena*, to articulate the multicultural nature of Britain and British men's style and to offer new perspectives on late twentieth-century masculinities.[31] Drawing on ideas from the 1960s rude boy style, Dean Chalkley and Harris Elliott investigated the continuing sartorial explorations set in motion by this stylish group in their book and exhibition *Return of the Rudeboy*.[32] Elliott differentiates the rude boy from dandies, as the former's style was 'rooted in survival and defiance . . . sartorially and stylistically "cut", but with an attitude which was needed to withstand all who challenged their existence'.[33] In 2005 the Victoria and Albert Museum's *Black British Style* exhibition (which toured to Manchester Art Gallery) offered a comprehensive exploration of the contribution of black Britons and the influence of diasporic dress styles on British

8 'Travis' (Jason Evans), *Strictly*, 1991. Photograph, colour, on paper. Tate (P11787).

culture from the Windrush generation onwards. The importance of the dandy in black diaspora style is highlighted by his 'ability to wear the clothes of the white man with a difference', combining 'colors, patterns, textures and histories literally, symbolically, and metaphorically'.[34] Carol Tulloch, Michael McMillan and Christine Checinska all note the dandified styles of those men that arrived as part of the Windrush generation and how they drew on Caribbean tailoring traditions to create distinct black British street styles and other forms of sartorial syncretism in what Checinska dubs 'the great masculine enunciation'.[35] The ongoing influence of what William Dalrymple describes as 'promiscuous mingling of races and ideas, modes of dress and ways of living'[36] is also considered in Chapter 8 of this book, where Jay McCauley Bowstead examines particular British designers' approaches to menswear in a globalised world.

Elliott contrasts rude boys with dandies, and raises a pertinent point: that the very term 'dandy' is filled with contention and has been open to multiple definitions. Its original meanings and associations, from Brummell's manifestations through to the later waves in the nineteenth and twentieth centuries, have been gradually corrupted, reappropriated and misused. Rather than relating to a restrained elegance and particular set of rigid sartorial codes, the word has been applied to men's efforts to create stylish and extravagant manifestations of dressed appearance. In *I Am Dandy*, Nathaniel Adams explores contemporary interpretations of British dandyism through photographic portraiture and accompanying interviews to discuss both

the relevance of this term and the ways in which it has been interpreted through his subjects' choice of dress style.[37] The context and location in which Adams's dandified men live, work and present themselves perhaps invoke ideas of the *flâneur*, described by Baudelaire as a 'passionate spectator' at home in the crowds of a city, observing and reflecting back the energy and styles of the world he traverses and observes.[38] These practices are identified as common to the dandy, particularly by Walter Benjamin, and as such the *flâneur* and the dandy, while not identical, are similarly concerned with the presentation of self within a metropolitan context.[39] In 'De Profundis', Wilde conflated archetypes, writing: 'I amused myself with being a flâneur, a dandy, a man of fashion.'[40]

Emphasising the urban and metropolitan in relation to men's style and fashionable consumption, Mark Simpson coined the term 'metrosexual' in 1994 to define 'a single young man with a high disposable income, living or working in the city (because that's where all the best shops are)'.[41] Although originally defined in terms of consumption as much as sexuality (the 'metro' more important than the 'sexual'), the term gave rise to a concept of a heterosexual man embracing consumption of sartorial and grooming products and processes previously seen as feminine and/or effeminate. As such, the term is often invoked as an identity position that denies that an interest in fashion and appearance is in any way an indication of homosexuality. Thus, the notion of the metrosexual expanded upon the identification of 'sensitive' male 'types' such as the 'New Man' during the 1980s.[42] Echoing earlier fashionable and subcultural men's styles, the hipster who emerged in the late 1990s in 'the neo-bohemian neighbour-hoods, near to the explosion of new wealth in city financial centres' became both a celebrated and demeaned male fashion figure in the twenty-first century.[43]

While this book and the exhibition it accompanies are concerned with 250 years of British men's style and fashion, it is key, as noted earlier, to acknowledge the cross-fertilisation of cultures in the development of British men's style, as well as the increasing research that is being undertaken into the global and gendered perspectives of style and manifestations of dandyism beyond those of the white western male, who has traditionally figured centrally in the study of the dandy.[44] The 2010 painting *Dandy* (fig. 9) by Lubaina Himid (1954–), which forms part of a set of four archetypal 'portraits' alongside *Tailor*, *Striker*, and *Singer*, draws its form from early nineteenth-century images of dandies and other fashionable male manifestations such as the *incroyables* (fig. 10). However, contesting the historic and hegemonic representations of the dandy as a white man, Himid reimagines her dandy as black. Himid's *Dandy* dresses not in the monochrome simplicity of the 1805 Richard Dighton watercolour of Brummell that it references (see fig. 1), but in a more colourful interpretation of the fashionable styles of the early nineteenth century. The decoration on the purple-grey jacket, which is close in colour to Thomas Carill-Worsley's lilac facecloth three-piece suit (see fig. 27), seems to reference both shell decorations of traditional African garb and the buttons of London's pearly kings. The striped socks, waistcoat and yellow cravat echo some artists' interpretations of nineteenth-century fashions, and the yellow of his patched pantaloon-style trousers reflects the colour of fashionable doeskin garments popular in the early nineteenth century. Posing the questions, 'Who do you want to be?' 'Who is it possible to be?' and 'Can what you wear help you

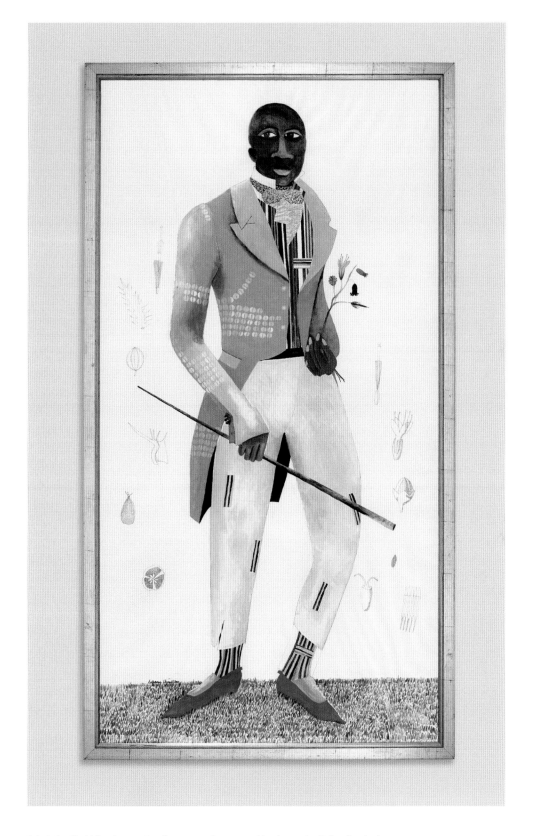

9 Lubaina Himid, *Dandy*, 2010. Acrylic on paper, 183 × 102 cm. Manchester Art Gallery (2016.39).

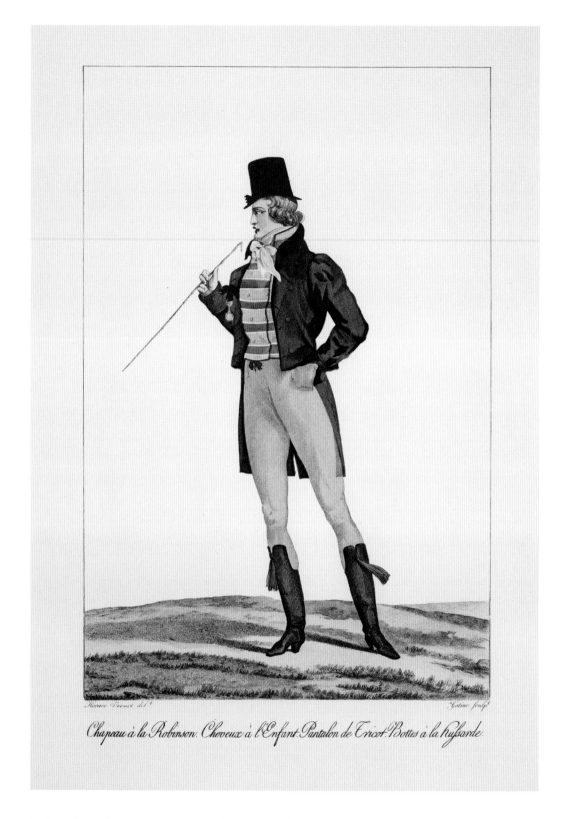

10 George-Jacques Gatine, after Horace Vernet and Louis-Marie Lanté, 'Chapeau à la Robinson. Cheveux à l'Enfant. Pantalon de Tricot. Bottes à la hussarde', from the series *Incroyables et Merveilleuses*, 1814. Reproduced engraving. Private collection.

be who you want to be?' alongside her life-sized images of black men, Himid describes the dandy as 'the person who is not afraid to be seen as elegant and bold, charming, eloquent and strategic. The Dandy understands how everything is structured and designed and is always aware of how everything looks'.[45]

The *Dandy Style* exhibition is divided into two distinct sections, 'Tailored Simplicity' and 'Embellishment and Extravagance', which draw primarily on the men's clothing and portraiture collections held at Manchester Art Gallery (MAG). Both sections of the exhibition take a thematic rather than strictly chronological approach, juxtaposing portraits and garments to highlight similarities of styles, forms and ways of dressing. This echoes Walter Benjamin's ideas of the 'tiger's leap' and labyrinth, discussed by Ulrich Lehmann and Caroline Evans, where fashion doubles back upon itself, creating alignments between the historic and contemporary.[46] Aileen Ribeiro has stated that 'from a study of surviving dress we can understand cut and construction, we can appreciate qualities of design; but we cannot gain perceptual knowledge', something that is challenged in Ben Whyman's material analysis of two men's wardrobes in Chapter 2 of this book.[47] Many of the garments in the exhibition can be tied to a named wearer and so have traces of their bodies and behaviours. By bringing together with equal importance garments and portraits, sometimes in a direct comparison, the exhibition emphasises not just *what* fashionable men wore but *how* they wore it.

Portraiture accounts for around a fifth of MAG's paintings collection and has been a significant area of collecting since the Royal Manchester Institution's 1827 purchase of *Othello, The Moor of Venice* by James Northcote (1746–1831). The gallery has continued to acquire a steady stream of portraits with many gifts and bequests, but also purchases, chosen as examples of a particular artist's portrait work and to demonstrate particular artistic developments, styles and ideas. The 450 portraits in the collection, of which 250 are of men, are mostly of British sitters and by British artists, and date predominantly from the eighteenth, nineteenth and twentieth centuries. They not only present us with a visual history of men's fashion and dressed appearance, but also show us artists' approaches to the aesthetic challenges and possibilities of male style. Rather less well known than its vast holding of women's fashion is MAG's more selective but similarly significant collection of men's clothing. The 2,150 'accessioned lots' range widely in size and type – from buckles to boots, drawers to dressing gowns, gaiters to gloves, shirts to suits – and in this sense are typical of other large menswear collections.[48] The development of MAG's menswear collection is discussed in more detail in Chapter 1. As with comparative costume collections, women's clothing predominates, mostly because the continuous and subtle changes in fashion are more clearly seen in female dress.

The *Dandy Style* exhibition and this accompanying book set out to try to address the long-established imbalance between the collection and exhibition of men's and women's clothing, and takes into account Breward's point that the study of men's fashion is still in its adolescence and there is much work to be done to redress the imbalance between studies of male and female dress and fashion.[49] Now seems an appropriate time to add to the growing interest in the study of British men's fashion and style. The apparent increase in the number of men concerned with fashion is

reflected in the growth of printed and online men's style and fashion magazines in the last 15 years, as well as influential blogs and advice websites. With the inauguration of London Fashion Week Men's in 2015, the number of online fashion and lifestyle retailers aimed at men, such as Mr Porter, continues to grow. The value of the men's clothing market (not including underwear and accessories) rose from £9.1 billion to £11 billion between 2013 and 2017.[50] Mintel reported in June 2019 that while British men shop less frequently than women, they spend more money on each shopping trip, and as a result the UK's spend on menswear rose 3.5% to £15.5 billion in 2018.[51]

The first chapter of this book considers how museum collections of men's clothing have grown. Miles Lambert uses MAG's collection as a case study to explore the motivations behind the acquisition of historic and contemporaneous men's clothing and examines some of the donors who have contributed to the building of this significant collection. Building on the theme of donors and their contributions to museum collections, in Chapter 2 Ben Whyman investigates two particular men who have donated considerable parts of their own wardrobes to museums. Using a selection of clothing donated by Sir Roy Strong and Mark Reed to the Fashion Museum Bath, Whyman employs a material culture approach to examine what garments can tell us about these men's sartorial and broader biographies, and offers a useful model for further consideration of other men's wardrobes and life stories. In Chapter 3, Joshua M. Bluteau explores the importance of the suit as a key part of men's fashion, particularly from ethnographic and anthropological perspectives. He draws parallels with other forms of dress and body decoration, such as tattooing, to demonstrate how the suit is utilised by men both historically and today, in order to comprehend embodied practices of dress and representations of the 'social self'.

Moving away from the garment and towards forms of representation, Chapters 4 and 5 both address the ways in which imagery can help us to understand men's dressing habits and practices. In Chapter 4, Shaun Cole, Miles Lambert and Rebecca Milner consider the role of artists in constructing our understanding of a garment and the importance of pose, stance and attitude in appreciating the relationship between contemporaneous masculinities and dress. The authors address the style of clothing worn by men considered worthy of painted portraits from the late eighteenth to the mid-twentieth century, exploring the skills of the painters and their relationships with the sitters. Kate Dorney picks up on this notion in Chapter 5, where she uses photographic images to discover the ways in which a selection of artists and performers in the late twentieth and early twenty-first centuries have performed their dandified styles, particularly through wearing suits and military dress uniform.

In Chapter 6, Miles Lambert considers how traditions of extravagance and flamboyance have emerged, ebbed and reappeared in British men's fashions since the late eighteenth century. He considers the place of colour, textiles, and surface decoration and pattern in offering distinctive visible styles. Building on Lambert's explanation of the role of British sporting and country styles in the Brummellian wardrobe, Shaun Cole further explores the casual styles that developed from the early nineteenth century as an alternative wardrobe to the smart, seemingly ubiquitous

suit, as addressed by Bluteau. Thus, Chapter 7 examines relaxed forms of dressing at home, the rise of sports clothing and its adoption broadly as leisure wear, as well as the place of certain subcultural garments deriving from a sporting tradition and the influence of key individuals on today's casual male wardrobe. Focusing particularly on recent British menswear designers, the final chapter investigates ideas of change and hybridity in an increasingly globalised marketplace. Here Jay McCauley Bowstead considers the formality of the suit, addressed in Chapter 3, elements of extravagance as explored in Chapter 6 and how these sit alongside a casual, athleisure approach, witnessed in the recent renaissance in British designer menswear.

1

Creative Collecting: How Museums Acquire Men's Fashion

Miles Lambert

As has often been observed, women's clothing vastly outnumbers men's in most museum and private collections. This overwhelming focus on collecting womenswear has also resulted in an historical paucity of studies of men's clothing more broadly, and the imbalance raises the 'question of what narratives and insights have been missed'.[1] One reason for the traditional focus on women's garments is the still prevalent view that fashion exhibits its novelty and nuances more clearly in female dress.[2] In addition, men can be seen more often to wear out their clothes, habitually to prefer plainer, functional, long-lasting garments and only rarely to offer pieces as donations. Julia Petrov has noted how museums were initially predominantly masculine spaces that 'mirrored the social processes of the elite', functioning 'as public monuments to the established order' and 'appear[ing] to function as a "boy's pocket", offering up collections of treasures . . . selected for masculine tastes'.[3] Collecting is a 'highly gendered activity' reflected in the development of museum and private collections, and the hierarchies of the fine and decorative arts allocated fashion and textiles only a relatively lowly position. Petrov has also observed that donors of clothing to museums tend to be women, perhaps 'because women are seen as keepers of family histories', reflecting this stereotyping and gendering of fashion.[4] Focusing on temporary exhibitions, rather than permanent collections and displays, fashion historian and exhibition maker Jeffrey Horsley undertook a survey of fashion exhibitions containing menswear since 1971, and this confirmed the lack of representation of both historic and contemporary men's clothing in such shows. Of over 940 exhibitions identified, only 18 had titles that indicated they were dedicated to menswear. Significantly, Horsley also identified instances where menswear could have been included but was

conspicuously absent, for example in monograph exhibitions of designers who create menswear, such as Alexander McQueen.[5] Sharon Sadako Takeda, senior curator at Los Angeles County Museum of Art, perhaps spoke for all collections in the introduction to her catalogue for the 2016 show *Reigning Men*, when she regretted that the museum had 'frequently lavished attention on collecting, researching, publishing and exhibiting women's dress while largely neglecting menswear'.[6] Andrew Groves, curator at the Westminster Menswear Archive, interviewed for the *Independent* at the launch of the 2019 exhibition *Invisible Men*, said that he hoped the show would help to tell 'the untold story of menswear', which he felt had been marginalised and excluded from the history of dress. He continued: 'Both in museums of the decorative arts or dedicated fashion museums, menswear is significantly underrepresented.'[7]

Given the right conditions, and a degree of luck, garments can last for hundreds of years. The earliest surviving British men's clothing generally comes from archaeological contexts, such as late fifteenth- and early sixteenth-century leather shoes or woollen caps excavated from the Thames. Seventeenth-century pieces are treasured, scarce and unusual rarities. The wealth of eighteenth-century suits and coats allows a much fuller survey of fashionable dress. Many garments survive only by happy chance; the motives which direct donations to any collection are similarly random. Donors might be searching for a safe home for preserved garments or personal collections, and they might also seek for a permanent memorial of their benefaction. Custodians of collections, such as individual directors and particularly curators, also hold views, preferences and obsessions on what should be accepted or declined. After an item has been acquired by a museum, its status and meaning changes, and its future is usually assured. As Linda Baumgarten has summarised:

> A garment that enters a museum collection acquires new functions. No longer wearing apparel, the item of clothing now becomes a 'costume', a museum artefact touched only with white gloves. The garment has become a work of decorative art to inspire today's public, a document of past technology, and a text for teaching history.[8]

As a case study, and to delve more deeply into the motives behind all acquisitions, the significant men's clothing collection of Manchester Art Gallery (MAG) is surveyed here. The collection originated a hundred years ago, in 1922, and has grown to be large and wide ranging. This chapter explores some of the impulses and intentions behind the entry of pieces into the collections, and it paints a picture of professionalism and pragmatism, commercialism and change. Above all it indicates expansion, largely opportunistic, carefully regulated, and full of human interest. As with all public collections, the source or origin for each item, or collection of items, varies. Donations are the most common, often of an odd piece, and MAG's Accessions Register also has examples of purchases from auctions, dealers, private individuals and institutions, and from contemporary high street stores or designers. There are donations via other museums, or transfers from them; bequests; anonymous gifts and gifts from designers, patrons, councillors, museum staff and friends; offers in lieu of inheritance

11 Black woollen tailcoat, 1825–30. Manchester Art Gallery (1922.1910).

tax; and, most commonly, gifts from members of the public. There are also 'long-term' loans from individuals and families of material that the owners would not donate outright but left on trust to the museum, although these have now largely ceased and few remain in place.

As Russell Belk has observed, 'collections seldom begin purposefully' and MAG's is no exception.[9] The few men's garments that arrived as pioneers to Manchester in 1922 accompanied women's garments, and were part of the huge and somewhat un-focused 'Mary Greg Collection of Handicrafts of Bygone Times' amassed by Mrs Greg (1850–1949) to illustrate the domestic environment and to preserve fast-disappearing craft techniques. Included within the 20 men's pieces was an early nineteenth-century black tailcoat, without a recorded provenance, but which can be fairly precisely dated by its construction (fig. 11).[10] As the London tailoring trade developed

Drawn Etch.ᵈ & Pub.ᵈ as the Act directs by Richard Dighton April 1824

A View in the Royal Exchange

from 1800 onwards, significant improvements in cut were regularly adopted to improve the fit. A narrow horizontal panel just above the waist seam became a usual feature of coats sometime around 1820.[11] Some five years later a separate narrow vertical strip was attached for buttons and holes either side of the front openings; and 'side bodies', or insertions, and smoother sleeve tops were developed during the 1830s. This tailcoat has all these features except side bodies, and also has the overly long sleeves intended to be gathered and bunched up the arm. It can thus most likely be dated to the later 1820s, which makes it roughly contemporary with a striking Sir Thomas Lawrence portrait of c.1821 of Sir Humphry Davy (see Chapter 4; fig. 54), which is imbued with drama and Romantic panache.[12] It is also comparable to tailoring depicted by Richard Dighton (1795–1880) in his series of London worthies, such as that of a contemporary figure, dated April 1824 and annotated in pencil,

13 Navy wool facecloth tailcoat, 1830–35. Manchester Art Gallery (1938.88).

'A View in the Royal Exchange'. This gentleman wears a blue coat with typical over-long sleeves and gathering at the elbows and side-waist (fig. 12).[13]

Mrs Greg's gift was followed by a series of smaller donations in the 1930s, sometimes from the local area, as knowledge of the new costume collection and its displays spread. These were often specific, such as uniforms (e.g. a Lord Mayor's uniform) or livery (e.g. a hunting outfit), but there were also some examples of fashionable dress, such as a 1936 donation of another early tailcoat.[14] The curator sent thanks for the gift, 'which will make an interesting addition to our collection of old costumes'.[15] This navy wool facecloth coat slightly post-dates Mrs Greg's coat; it can be dated to the early 1830s, as it has sleeves which have been smoothly applied to the body without gathering, but still has no side bodies (fig. 13). Thus, little by little, the crucial story of the development of early nineteenth-century tailoring could be appreciated and represented.

In 1947, Manchester Corporation purchased the Cunnington collection of clothing and archival material after a public appeal to raise £7,000. This vast and significant private collection then formed the foundation of a new costume museum, the first such specific museum in the UK. The Cunningtons – Cecil Willett (1878–1961) and Phillis (1887–1974) – were primarily interested in nineteenth-century women's and children's clothing, and this comprised the glory of the new gallery (largely 'middling' or 'typical' pieces, rather than aristocratic or couture items). Men's clothes seem to have been of far less interest, particularly pieces from the nineteenth century, which became ever more dark, sober and formal. Cecil Willett Cunnington, the driving force behind the collections, evinced distinctly Victorian masculine views on the motives and roles of female dress, and this is where his research focused. James Laver (1899–1975), a fellow costume writer and friend, wrote of Cunnington in his obituary in the *Manchester Guardian* in January 1961: 'He was particularly interested in women's dress – in underclothes, costume jewellery, fans. His many books on costume were always written in a certain light vein, such as *The Perfect Lady* and *Why Women Wear Clothes*, but they also provided some valuable social and philosophical theories.'[16] Reflecting this, Cunnington had collected little to represent the flamboyance of the eighteenth-century male peacocks, and even less to reflect the sobriety of the nineteenth-century 'men in black', who have been described as looking 'to dress as if going to a funeral'.[17] Fashion may have been as decorated for the Georgian man as for his female counterpart, and clothing for the Victorian man may have diverged to become darkly synonymous with a powerful masculine business image, but it has been left to subsequent donors and vendors to represent both these concepts in Manchester's collections.

The national attention surrounding the marketing of the Cunnington collection during 1945 and 1946, and the subsequent well-publicised Manchester purchase, meant that gaps were quickly filled. A flurry of approaches to the new museum ensued. In August 1946 Mr F. G. Pakenham approached the gallery, writing:

> In an article in the Daily Graphic, it is stated that your Art Gallery is purchasing the costume collection of Dr Cunnington and as Executor and Trustee of an Estate I have two beautifully embroidered gentlemen's or noblemen's suits … and as the Estate must be realised, they must be sold …[18]

The gallery duly obliged by purchasing one of the figured silk suits for £12.[19] Another approach in February 1949 from Edith, Lady Partridge, sent an equally pressing message about eighteenth-century men's clothes collected by her late husband, Sir Bernard Partridge: 'As I am going abroad I would be prepared to sell them at a great deal less than the price I know my husband paid for them.'[20] Anne Buck, the first curator of the Gallery of Costume, examined the large trunk of clothes sent on approval, eventually applying to the Corporation Committee to buy seven pieces for £20, including a suit and two coats.

To provide a clear brief for collecting priorities, and to act as a note to send out to dealers and donors, Miss Buck drew up a concise 'wish list' or collecting policy,

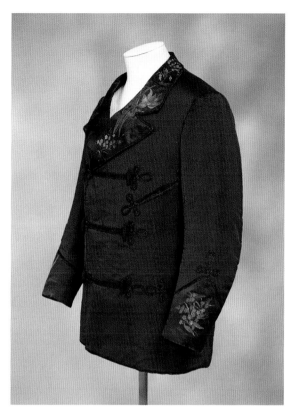

14 (*top*) Black silk smoking jacket with hand-painted decoration, 1875–95. Manchester Art Gallery (1949.55).

15 (*bottom*) Oscar Wilde in Aesthetic dress, 1882. Photograph by Napoleon Sarony.

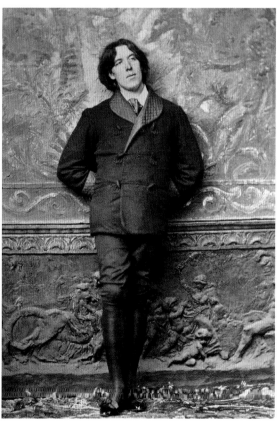

which specifically recognised the importance of actively soliciting donations of 'men's costume of the nineteenth century, with the exception of frock coats and embroidered and figured silk waistcoats'.[21] At the new gallery in the late 1940s and the 1950s, awareness of the glaring lack of men's clothing and fashion was acute, and, in 1949, Miss Buck thanked a local donor for the presentation of an unusual painted smoking jacket, saying that menswear was 'the side of the collection which most badly needs strengthening'.[22] The striking jacket offered, with leanings towards the Aesthetic movement, seems redolent of a style that might have been chosen by Oscar Wilde, and provided a remarkable addition that remains unique in the collections (figs 14 and 15). Miss Buck herself pursued a policy akin to the Cunnington campaign, tirelessly publicising her new museum and its collection needs. Chas H. Cook from the Borough Clothing Market in Macclesfield wrote to her after reading an article in the *News Chronicle* of 20 April 1951, in which he had noticed that the museum was looking for 'old fashioned clothing'. He assured her that he had 'a number of *really* old-fashioned garments, including a man's jacket'.[23] Although apparently not tempted by the jacket, Miss Buck did purchase some nineteenth-century breeches, collars, ties and two hats.[24] A couple of years later, Ervin Wiesner of Wallasey also read of the collection and wrote to the gallery about his own costumes, which he was extremely anxious to sell: 'Soon we will have no room for our collections as we are compelled to convert this house into flats . . . and we will accept almost any offer.'[25] Two coats and five waistcoats came to the collection for £30.[26]

Two of the most significant gallery acquisitions of men's clothing were secured in the early 1950s: the purchase of family clothes from Lord Stanley of Alderley, comprising 12 eighteenth-century suits and coats (1952); and the gift of a trunk of clothing belonging to Thomas Carill-Worsley (1739–1809) totalling 25 eighteenth-century pieces (1954). The Stanley acquisition includes six embroidered court suits and is reputed to have belonged to Sir John Stanley (1735–1807), who held a position at court as Gentleman of the Privy Chamber to George III; a post that required the commissioning of full court dress. One of his court suits is extremely fine, beautifully and lavishly embroidered, almost certainly by French professional needlewomen, with coloured silks in a naturalistic floral design featuring narcissi, lilies of the valley and forget-me-nots (fig. 16).

The acquisition of Thomas Carill-Worsley's clothes was particularly apposite as he lived at Platt Hall (the home of the Gallery of Costume) from its completion in 1764 until his death in 1809. Worsley was the son of a Manchester textile merchant who was adopted as heir to the Worsley estate at Platt Hall in Rusholme, and his clothing presents as that of a well-off Manchester businessman, landowner and Nonconformist. Donated by his great-granddaughter, the clothes all date from the 1760s to the 1780s, suggesting that his more recent (and thus 'fashionable' and 'wearable') clothing from the 1790s and 1800s had been passed on to his sons, relatives, friends or household servants to be reworn. The collection includes seven suits and coats, nine waistcoats, a gown or *banyan*, a pair of shoes and a wig, and they hold a peculiar resonance for the gallery as they were all worn at Platt Hall. One of the suits, dating to about 1770, is made of an all-over figured and patterned silk, providing quite a dramatic appearance

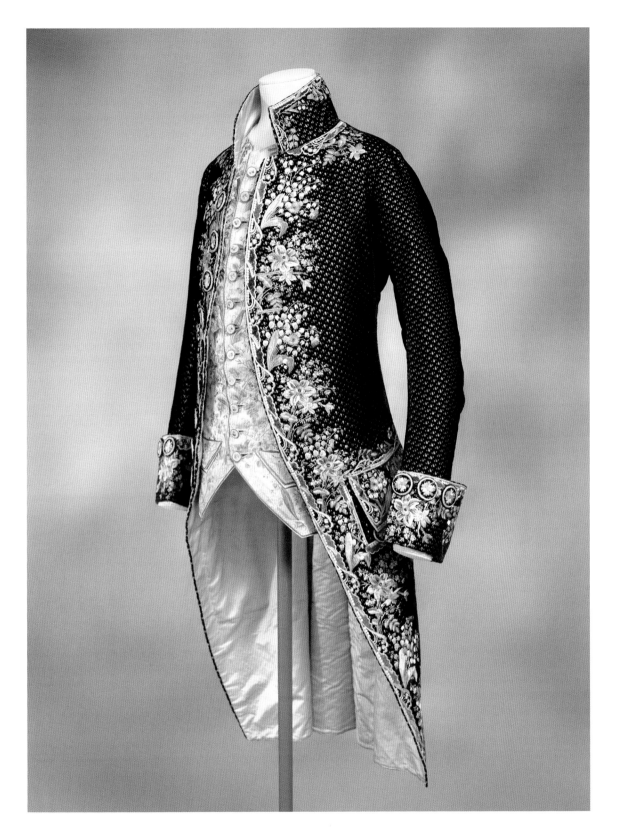

16 Embroidered court suit, 1770–85. Manchester Art Gallery (1952.359).

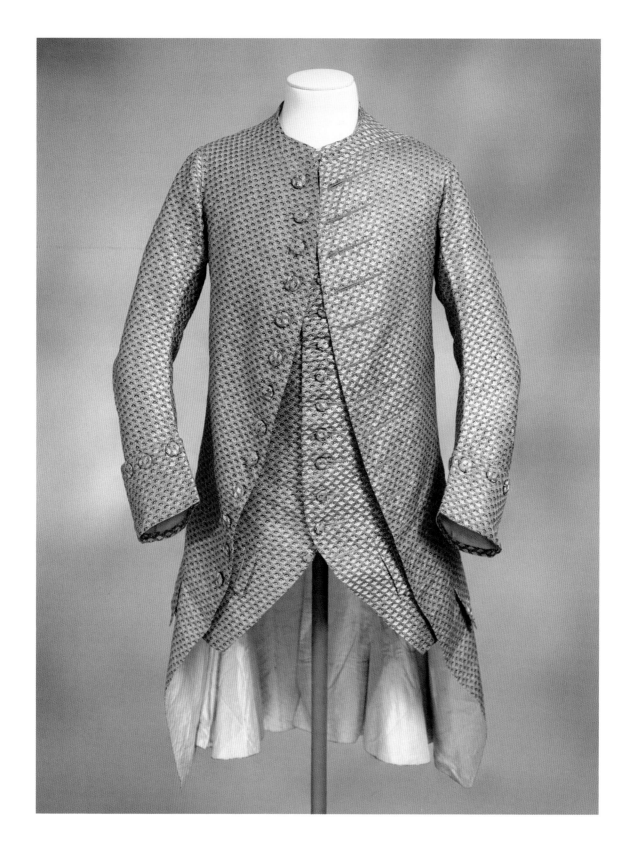

17 Figured silk suit, c.1700. Manchester Art Gallery (1954.962).

Dandy Style

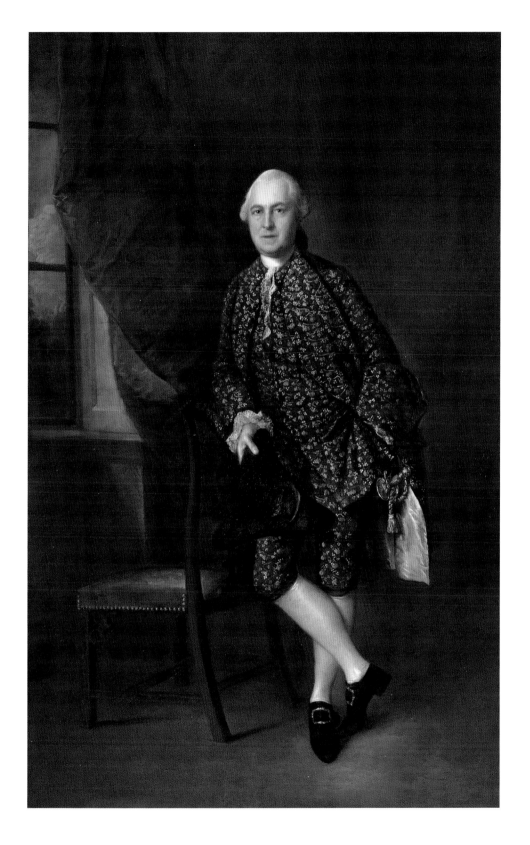

18 Thomas Gainsborough, *Sir Edward Turner*, 1762. Oil on canvas, framed 229 × 147 cm. Wolverhampton Art Gallery (OP491).

that mirrors the intensely striking 1762 portrait of Sir Edward Turner by Thomas Gainsborough (1727–1788), in which the costume struts boldly centre-stage (figs 17 and 18). Busily patterned fabric could be awkward and time-consuming for any painter to reproduce, and could be seen to compete with the 'essence' of the character of the sitter. Sir Edward, therefore, must have prevailed upon Gainsborough to paint him in his newly acquired suit in costly woven silk.

If the 25 years after 1947 saw a concentration on securing historic menswear, then from the 1970s, donations of twentieth-century and particularly contemporary costume escalated, reflecting gallery priorities and acknowledged gaps. Fashion as well as clothing became a preoccupation in order to embed and explain the mainly middling collections. Fashion students increasingly sought to study design and couture as well as technique and cut. Important subcultural pieces, such as a 'Teddy Boy' jacket (fig. 19), and stylish London high street and boutique clothing from the later 1960s and early 1970s brought the collections into the contemporary arena.[27] John Stephen, Tommy Nutter, Fox of London, Take 6 and Mr Fish pieces were acquired to represent a unique period when London led the fashion world, a brief era which has remained iconic for subsequent designers. Some items arrived as unsolicited donations, some as favourites from personal wardrobes, or as much-loved garments from relatives. Other pieces were sought from friends, or secured from charity shops, jumble sales or even skips. A Mr Fish brocade evening jacket from the early 1970s was donated in 2002 by a friend of the curator, who spotted it in a charity shop and made it his mission to find the garment a museum home (fig. 20). Budgets were always limited, so purchases remained sporadic. Personal stories and commitments emerge from

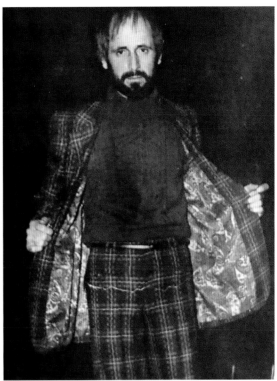

most gifts: one man brought in a fine selection of half a dozen early 1970s Yves Saint Laurent *Rive Gauche* suits, but requested to be an anonymous donor as he had spent far more at the Paris boutique than he had admitted to his partner![28]

Just as in the 1970s and 1980s, when the gallery acquired material from a previous generation, so the last 20 years have seen the acquisition of pieces by the acknowledged masters of contemporary menswear: Paul Smith, Vivienne Westwood, Alexander McQueen and Ozwald Boateng among them. At the same time, clothes from high street shops and boutiques, such as Biba, Marks & Spencer, H&M and Zara, have kept Cunnington's love of the middle rank alive. Tailoring as a skill, and perhaps still a peculiarly British trade, has also been represented. Three garments made by a Manchester tailor, Andrew Tryfon (1940–), for a competition run by the National Federation of Merchant Tailors in 1976, had been kept safely by the maker and were donated in 2010. The awards were reported in *Men's Wear* magazine, and Tryfon modelled his own pieces for the show.[29] His success was astonishing, as both his suits both won second prizes, while his overcoat won the overall best garment in all categories (figs 21 and 22). It was the first time a regional tailor had so triumphed over Savile Row.[30]

Occasionally, as a delightful and unexpected interruption to routine, an unusual and unforeseen donation can arrive unannounced at the museum, providing an entirely new dimension to an aspect of the collections. Such was the case with an anonymous gift in 1973 of an early nineteenth-century, three-piece suit made in a 'hard tartan' worsted wool (that is, cloth straight from the loom, not finished by being softened and pressed). The cloth was almost certainly a MacKenzie tartan, woven by

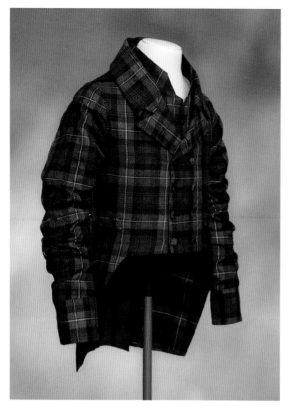

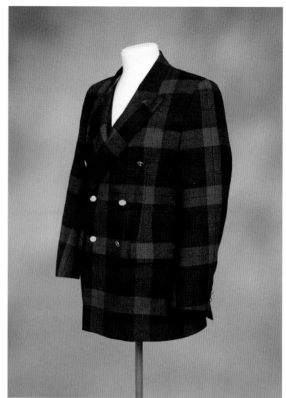

23 (*left*) Wool and worsted tartan suit, 1820–25. Manchester Art Gallery (1973.288).

25 (*right*) Vivienne Westwood wool tartan jacket, *Anglomania* collection, Autumn/Winter 1993–4. Manchester Art Gallery (2018.82).

William Wilson & Son of Bannockburn, who by 1800 dominated the British market for tartan wools.[31] As there is no horizontal waist seam and no separate buttonhole strip, the sleeves are in the over-long style, and the trousers have a very large, old-fashioned front-fall fastening, the date is likely to be the early 1820s (fig. 23). This coincides nicely with a renewed interest in and obsession with all things Scottish that was stimulated by the novels of Sir Walter Scott (published from 1814 onwards) and promoted by George IV's visit to Edinburgh in 1822, the first by a reigning monarch since Charles I in 1633. So far, it appears that this suit may be a unique early survival in fashionable garments, although tartan cloth was widely used in regional Scottish dress and in regimental uniform, and fashion plates of the 1840s occasionally show three-piece checked suits (fig. 24).[32]

In appearance, the MacKenzie tartan seems to stand as a historic precursor to and inspiration for the tailored tartan creations of Vivienne Westwood (1941–), in particular her *Anglomania* collection of Autumn/Winter 1993–4. In direct response to this piece, the gallery purchased a jacket and waistcoat from Westwood's collection to display the historic and contemporary pieces together as a creative concept.[33] The coat had been worn by Sam McKnight, the celebrity hair stylist who worked with high-profile figures such as Princess Diana, Lady Gaga and Kate Moss in the 1990s (fig. 25).

Another recent purchase at auction, and a piece long sought after, was an example of a Pierre Cardin suit with a Nehru-style collar. Although it was acquired without a provenance, contact was established with the vendor (and original wearer), who could recall with precision buying the suit at the Cardin boutique on the rue

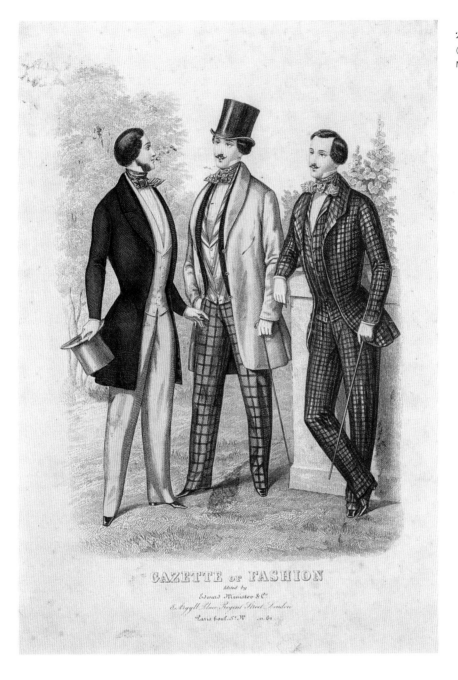

24 *Gazette of Fashion*, undated (c.1840). Hand-coloured plate. Manchester Art Gallery.

GAZETTE OF FASHION

Edited by
Edward Minister & Co
8, Argyll Place, Regent Street London
Paris Boul. S.t N. *.n. 61.*

Saint-Honoré in Paris in January 1972 and wearing it with either a purple cowl-neck jumper or a collarless lavender shirt. The piece is from Cardin's Autumn/Winter 1971–2 collection and is reminiscent of his original 'space-age' designs of 1968, with a full-length zipper with circular pull and very narrow trousers (fig. 26). On its arrival at the museum, this mottled lilac suit called to mind one of Thomas Carill-Worsley's outfits, a lilac facecloth three-piece suit whose arresting colour and sleek narrow silhouette also suggest both simplicity and modernity (fig. 27). We cannot know how invested Carill-Worsley was in his wardrobe and how meticulous he was with his dress and appearance, although we do have a youthful portrait from the time

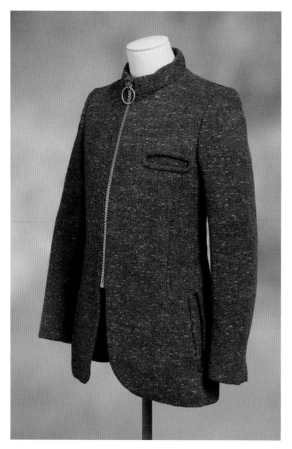

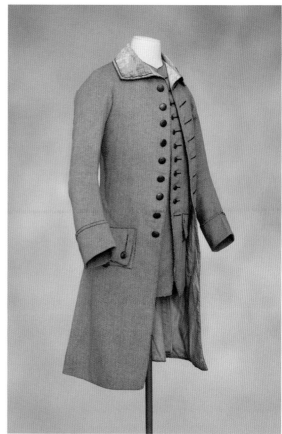

26 (*left*) Pierre Cardin wool suit, Autumn/Winter 1971–2. Manchester Art Gallery (2014.40).

27 (*right*) Three-piece facecloth suit, 1765–80. Manchester Art Gallery (1954.958).

of the building of Platt Hall, in which he is wearing a blue velvet suit with a studied nonchalance (fig. 28).[34] Certainly, his careful preservation of his own clothing seems to mirror the engaged and considered attitude of the owner of the Cardin suit, who also kept a collection of his clothes some two hundred years later.

Of course, even with publicity drives and an attentive pursuit of the market, when an institution has limited funding and relies largely on negotiating the vagaries of random donations, there will always be items on a wish list that prove elusive. Certain items are rare in nearly all collections: very early nineteenth-century coats contemporary with Beau Brummell; lounge suits from the later nineteenth century to the 1930s; mod suits; expensive contemporary couture. However, with imaginative use of limited budgets, outfits can be opportunely, and reasonably, commissioned from up-and-coming designers, or even altruistically donated.

The complex impulses behind the development of a costume collection are dependent on chance, on funding, on curatorial interests, on local engagement and on institutional agendas and priorities. This investigation of MAG's collections shows examples of all these vagaries and helps to explain the diversity and complexity of surviving material and the gallery's efforts to represent the variety of men's style. The British contemporary men's fashion scene flourishes; renowned for its vibrancy, it is as exciting as it has ever been. There is also an increasing freedom for the individual to follow his personal choice of style and image, as summarised by Peter McNeil:

28 Attributed to John Astley, *Thomas Carill-Worsley*, 1765–70. Oil on canvas, framed 145 × 118 cm. Manchester Art Gallery (1989.177).

'The rise of individualism in dressing is a marked attribute of the modern era'; a comment echoed in Chapter 8 of this volume.[35] As a museum can only ever collect a minute fraction of prevalent models and styles to interpret and preserve, much will remain accessible and recorded only through photography and the media at large. However, surviving material culture in the form of actual clothing – the cloth made human – will, surely, always be crucial for an understanding and exploration of appearance, image and identity. If each museum collection continues to select and preserve its own choice of clothes to reflect ever-escalating changes in fashion, we can go some way to ensuring that future generations will be able to explore the historic 'fabric of fashion', and to experience, at close hand, the pleasure and pitfalls of personal choice and taste.

2

The Life Stories
of Men's Clothes

Ben Whyman

This chapter scrutinises the object: in this case, clothes worn by Sir Roy Strong and Mark Reed. Both men donated large numbers of their garments to the Fashion Museum Bath (FMB), and small selections from the two collections at the FMB are interrogated here. The approach employed is known as material culture analysis, and involves a detailed and close study of the physical characteristics of an object or objects.[1] The intention of this chapter is to reinforce the notion that clothes can act as biographical evidence, and allow the wearer's life to be examined from perspectives different from those historically presented in life stories, biographical exhibitions or wider-ranging fashion and social histories. Clothes can be used, in effect, as a lens through which to view an individual's life. It will be argued that, because of these opportunities to uncover further aspects of a person's biography through a study of the clothes they wore and the worn materials of the garments themselves, researchers can use clothing as evidence when researching and presenting someone's life story.

Sir Roy Strong (1935–) is a celebrated former museum director, published art historian, journalist and gardener. Mark Reed (1971–) is an art collector and man of independent wealth. Both men, within different social contexts, are known for their personal style and love of fashion. The garments in the collections range from high-end designer menswear to affordable high street clothing; from professional suits to outfits worn for gardening.

Each of these two varied wardrobes becomes revealing when studied closely, and particularly when studied as a collection of garments. Exploring patterns and trends within a group of objects offers as many insights as does close examination of

an individual thing; this is true from the perspective of material culture analysis, just as it is in curatorial and fashion studies. The present research involved viewing and taking notes and photographs of every object in Strong's and Reed's wardrobes at the FMB. The museum houses over a thousand individual objects of Strong's, while Reed donated more than two hundred items. It is a valuable exercise to record every item in someone's wardrobe. Patterns emerge, as do trends of personal likes and dislikes. What is absent is often as revealing as what is present. For instance, Strong seldom had anything hand-made for himself. His preference was for off-the-rail clothing, from high street purchases through to high-end designer menswear from department stores, such as Harvey Nichols, and boutiques. Strong's wardrobe, as a collection of material objects, can reveal as much about his character and his life story as letters and diaries, but in very different ways.

For both theorists and practitioners, the 'biography of objects' has become an established field of material culture research.[2] Igor Kopytoff introduced the term in the 1980s and Janet Hoskins developed the theme, privileging the contextualisation of objects surrounding people's lives.[3] The biography of an object, in the context of this interdisciplinary research grounded in fashion studies, describes the life story that clothes can tell. This story can be traced from design and manufacture, through a person's selection of garments, their use and wear, to (potential) acquisition by a curator for a museum's collection. With that comes levels of public access, research and display. Increasing numbers of researchers over the past four decades have interrogated objects in this way. In 1983 curators Jane Tozer and Sarah Levitt, of the Gallery of Costume, Manchester Art Gallery (MAG), analysed the wardrobe of the eighteenth-century gentleman Thomas Carill-Worsley in MAG's collection, suggesting, 'can we guess anything of [his] character from his clothes? While it is misleading to weave fantasies and legends from museum specimens, the suits suggest a gentleman in good standing'.[4] Yet, clothing worn by subjects has not been a focus for sustained study from biographical or historical perspectives. Analysis of theoretical work reinforces our understanding of how clothing impacts on, and is impacted upon, by the body when worn, but also how clothing can reveal life stories from the past and the present. The biography of the person wearing the clothes and the biography of the object are, this chapter argues, inextricably entwined.

The interdisciplinary nature of fashion studies encompasses the theory and practice of analysing material objects (which may range from visual and literary analysis, to psychological insights, to studies of production and manufacture) and also the gendered aesthetics of dress, contextualised within sociocultural, political, economic and historical perspectives (among others).[5] Analysis of fashion studies literature on dress and material culture shows that, when researching the biography of an individual, working with the material evidence of clothes offers a fundamental point of difference from working with other objects surrounding that person's life. Material culture analysis prioritises the object and offers ways of describing and contextualising it, using an interdisciplinary approach that may draw on cultural and social histories, sociology, cultural geography and linguistics as well as visual analysis and other examples of material culture itself.[6]

Clothing has seldom surfaced in biographical research. This lack of investigation of the 'matter of [fashionable] matter' is because, as Peter Stallybrass puts it, 'we are surrounded by an extraordinary abundance of materials, but their value is to be endlessly devalued and replaced'.[7] He has argued for the value in analysis of clothing because of the capacity of textiles to be transformed by makers and wearers and, in the guise of dress, to exist and be worn across generations. Stallybrass makes the case for fashion as a conduit for histories and a bearer of biographies, both of the wearer and of the object.[8]

Items of clothing may reveal both tangible and intangible information about the owner's body; wear and change over time become evident in the materiality of the cloth. By 'materiality' we mean the nature of the constituent material and the physical changes that take place in the interaction between the garment and the body (cause and effect), during laundering and repair, and through the impact of the environment with which the body engages (surface wear and tear). It is part of the purpose of this chapter to stress the importance of studying not only the physical influence and effect that the wearer has on their clothing, but also the potential influence of the clothing on them; not only in restriction of movement, containment and resistance, but also in transformations and distortions of the body.

The materiality of Strong and Reed's clothing can evidence presence, and establish biography. Might these clues, the distinctive patination, suggest that something was worn often and, if so, perhaps indicate that it had been a favourite? How could such assumptions be corroborated? Similarly, what might each man's selection of a garment (of a certain colour, texture and volume) say about his lifestyle choices, and private and public constructed identities?

Born in 1935 in London, Strong was a curator at the National Portrait Gallery from 1959 until 1967, when he became director. He left the post in December 1973 and took up the directorship of the Victoria & Albert Museum (V&A) in January 1974, resigning in 1987. Throughout that period, Strong's dress suggests very personal and particular approaches to self-presentation. Visual evidence is provided by 122 scrapbooks of photographs and paper ephemera that he assembled from the 1960s until 2003; a review of the scrapbooks indicates that, in both his private and public life, he dressed in highly fashionable, stylish clothing.

During the 1950s and 60s, at the time that Strong was establishing his career in museums and as an author, London was home to a rapid escalation of fashionable menswear retailing, particularly in such places as Carnaby Street.[9] Fashion companies responded to the demands of young tastemakers and designers. Boutiques such as Vince, and fashion entrepreneurs like John Stephen (1934–2004), attracted a growing market of men willing to spend money on clothing in order to 'fashion' a masculine identity for themselves.[10] The multicultural influences of the city and the art schools that trained artists and designers – along with the associated media attention – created a 'vibrant consumer culture'.[11] Strong actively engaged with this rapid rise of easily accessible, relatively affordable, fashionable clothing.

It is clear from photographs that Strong was attracted to velvet from the 1960s onwards, commonly in the form of a jacket paired with trousers of a plainer fabric.

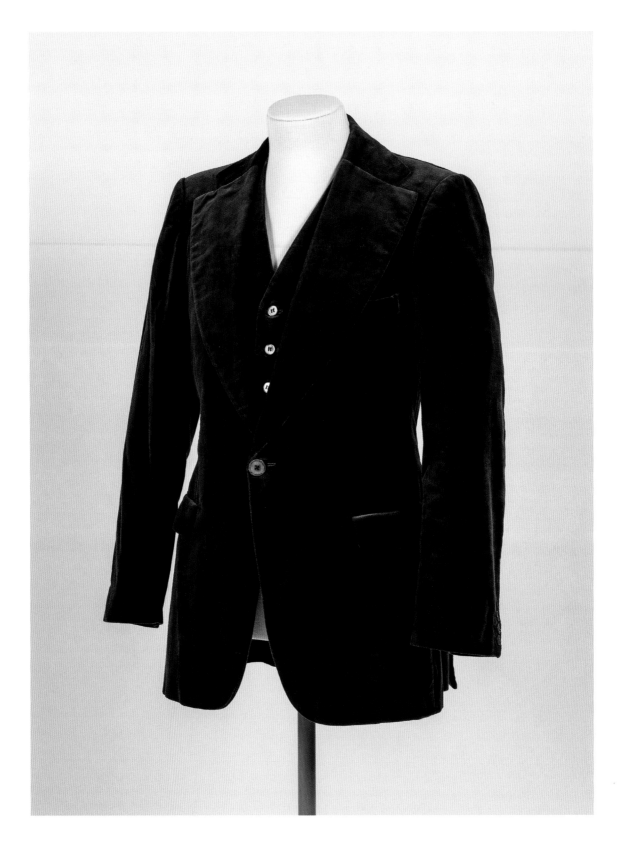

29 Just Men velvet three-piece suit, late 1960s. Fashion Museum Bath (BATMC 2006.251.256a; 256b).

Strong purchased a Just Men velvet three-piece suit in the late 1960s (fig. 29). The brand was manufactured in an east London factory called Rightmade, which specialised in velvet, and made garments for other companies including Take 6 and John Stephen. Velvet is a woven material with a short cut pile (nap), which reflects light as it moves. In the suit bought by Strong, the velvet has been cut so that the nap faces upwards, the opposite direction to normal, giving a darker colour and richer texture to the cloth. A single mother-of-pearl button binds the waist of the jacket, creating an angular silhouette that would have fitted close to Strong's body. The long vents on the back of the jacket reach to the waist, enhancing the narrowest part of the torso. There are 'shadows' of stitching (remnants of stitch holes in the material) either side of the back central seam (fig. 30), evidence that the waist circumference of the flared trousers has been altered. The French bearer (an additional button fastening behind the fly of the trousers, which helps the cloth lie flat) has a hand-stitched buttonhole that has been stretched through regular use (fig. 31). Visual documentation shows that Strong was heavier in the late 1960s than he was in the mid-to-late 1970s (fig. 32). The material culture analysis of the suit corroborates this visual evidence of a changing body size. Strong's Just Men velvet suit was transformed by his altered body shape; his weight change necessitated the suit's physical alteration. These details, revealed through the surfaces of the cloth, enhance our understanding of his life, as his body shape changed over time, and as someone who wished to be perceived as fashionable in the clothing in question.

By the 1980s and 90s, Strong was patronising high street stores such as Next, and he invested in suits by such fashionable and stylish designers as Tommy Nutter (1943–1992). He cultivated a cultured public persona, using fashionable menswear (particularly suits) to establish himself as a *bona fide* museum director and academic. This encouraged the media, eager for personality-driven news and imagery. The overall quality of the designer clothing Strong bought in the 1980s and 90s is relevant to his life story. Most of his clothes in both FMB's and the V&A's collections (he also

30 (*left*) 'Shadow' stitching, either side of back seam, on the trousers from the Just Men velvet suit (fig. 29).

31 (*right*) Close-up of French bearer, on the trousers from the Just Men velvet suit (fig. 29).

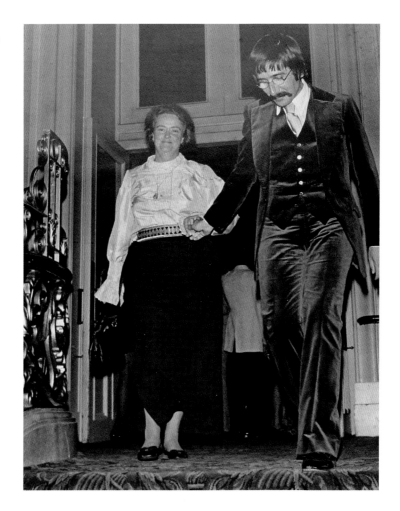

32 Roy Strong, wearing the Just Men velvet three-piece suit (fig. 29), with his wife Julia Trevelyan Oman. 'First public appearance', at the Crush Bar, Covent Garden (scrapbook 'September 1971–December 1972'). Photograph credited to Donald Southern.

donated to the V&A from the 1970s until 2006) were factory made; they include very little bespoke tailoring and very few individually made pieces. However, Strong's keen eye for design meant that he often chose designer menswear, including that of Giorgio Armani (1934–), Nicole Farhi (1946–), Issey Miyake (1938–), John Rocha (1953–), Gianni Versace (1946–1997) and Yohji Yamamoto (1943–). He was purposefully presenting a fashionable facade: smart, aware of trends and engaging with them to construct different ensembles that suited his public appearances, whether presenting television programmes or giving public talks.

Strong purchased a black-and-white, Prince of Wales check wool suit by Thom Browne (1965–) in the autumn of 2005 (fig. 33). The jacket has a label cross-stitched to the inside left breast pocket stating that it was 'hand made in New York' for the London-based Harvey Nichols department store. There is corded ribbon stitched beneath the jacket buttons.[12] In the process of machine-stitching the buttonholes, the cording has been 'chewed' by the machine, causing irregular stitches and frayed edges (fig. 34). The cuff buttonholes appear to be hand stitched. The jacket is lined in stretch technical fabric. There are rectangular patches on the elbows of the sleeves. The trousers have a button fly, with square patches on the knee, a V-notch at the back waistband, and double darts at the front, which again have been distorted through the

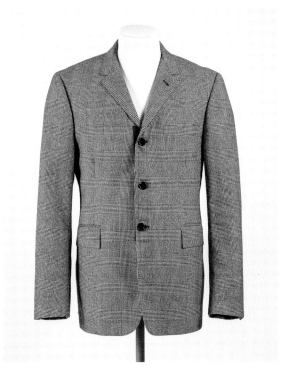

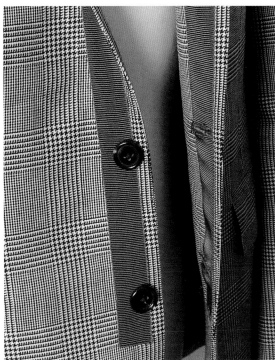

stitching process. This finishing suggests problems in manufacturing. Additionally, the suit is lumpen in places, and heavy in comparison to other suits of a similar style and material. It is designed as tailored work or performance wear, for use, for instance, when cycling to work in an urban environment.

Similarly to the Thom Browne suit, a John Rocha double-breasted jacket suggests Strong's love of stylish, fashionable menswear (fig. 35). The material is 73% cotton, 27% modal. Three welted pockets (two on the right panel) are stitched closed to preserve the line of the suit. The jacket waist tapers in, creating a shaped, elegant silhouette, much like that of the Just Men suit. The peaked rever collar draws the eye to wide, padded shoulders that would have imparted the illusion of a classic masculine 'V'-shape to Strong's torso.

Strong wore some of his clothing for only two or three years; other items he wore in many different places and contexts for more than two decades. His conscious vanity and love of fashion is well-documented. His regard for certain garments, such as the Just Men suit (worn time and again, as the wear and tear shows), suggests another side to his character, one that has not been documented previously. What emerges is a narrative of someone who appreciated well-designed clothing (not necessarily high-priced), who loved many of his garments and wore them for their comfort or design appeal, and who cared for the things he loved (evidenced in the alterations to the Just Men suit). Material culture analysis of his clothes offers insights that enhance what is known of Strong's life story, pointing towards a more nuanced biographical portrait. In *this* suit, in *that* environment, he consciously became *that* person.

Like Strong, Mark Reed carefully constructed a stylish and fashionable identity through his choice of clothing. Reed's parents ran a successful business, from which

33 (*left*) Thom Browne Prince of Wales check two-piece wool suit, 2005. Fashion Museum Bath (BATMC 2013.320.53 and A).

34 (*right*) Detail of buttons and buttonholes on the Thom Browne suit (fig. 33).

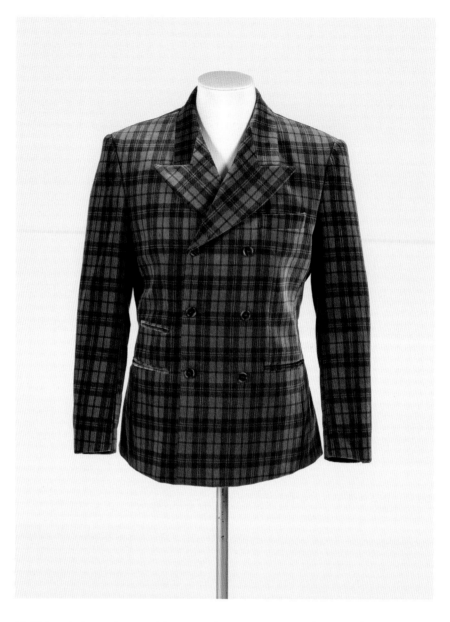

his lifelong independent wealth stems. His teenage years and young adulthood in the 1980s and 90s coincided with a period of increasing demand for more stylish, fashionable clothing for men, to which menswear designers and producers responded with enthusiasm. In that pre-social media age, the growing exposure of designer and non-designer clothing in such British style and fashion magazines as *i-D*, *The Face* and *Arena* (launched in the 1980s) offered consumers access to shopping information and profiles of fashion designers. Increased purchasing power encouraged magazines to style new fashions in visually exciting ways. Young, urban male audiences with an interest in style and fashion were deliberately targeted by editorials and graphic spreads, helping to construct the media-driven marketing concept of the 'New Man'. At the same time, growing attention to street style created a demand for information. During his teenage years, Reed remembers reading these style magazines and

watching late-night weekend television programmes including *The Old Grey Whistle Test*, *The Word* and *Club X*.[13] It is evident that the popular culture and media of the 1980s influenced his perception of self, reflected in his developing fashion tastes and use of clothes as an expression of identity.

From the mid-1980s to the early 2000s, Reed enthusiastically purchased designer menswear, buying complete, head-to-toe catwalk 'looks' in designer boutiques, and wearing them every day. In a 2014 interview he recollected asking himself, 'Can I, to make myself different, do anything in particular, project myself, create myself as a person?'[14] Clothing and hairstyles became for him a tool for self-expression, through which he could present a number of different identities. Three striking outfits serve as examples here. All are white, and two of the ensembles are embellished with large buttons or embroidered beading. Reed regularly wore these outfits to present a stylish persona to the world.

Reed purchased a Gianni Versace three-piece suit in 1992. The jacket is lined at the shoulders only, where padding lends a broad 'V'-shape to the silhouette (fig. 36). The material is 55% linen, 45% silk. Four metal buttons originally fastened the front panels; one of them is missing (its location indicated by loose threads), suggesting regular wear. Each button is moulded with the famous Versace 'Medusa' head emblem (fig. 37). The buttons are heavy, and their weight would have made the garment swing around the body. The tapered trousers, made of a 60% silk and 40% linen material, have a wide waistband with angled belt loops, two of which are attached to form a 'V'. There are four small pleats at the front, giving the trousers volume. The cinch-back waistcoat is made of linen. Four 'Medusa' embossed buttons fasten the front panels,

36 (left) Gianni Versace cream linen-silk three-piece ensemble, c.1992. Fashion Museum Bath (BATMC 2011.124.23 to B).

37 (right) Close-up of missing 'Medusa' button on the Versace ensemble from figure 36.

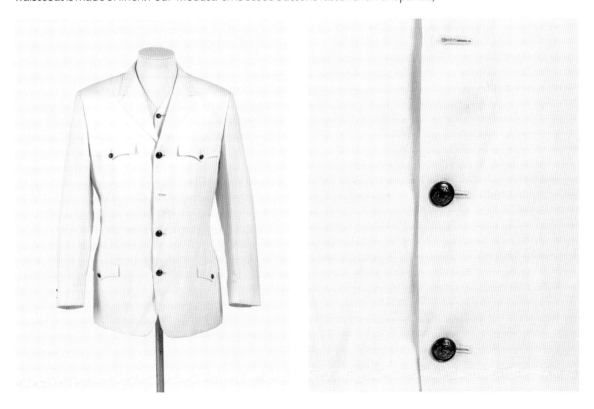

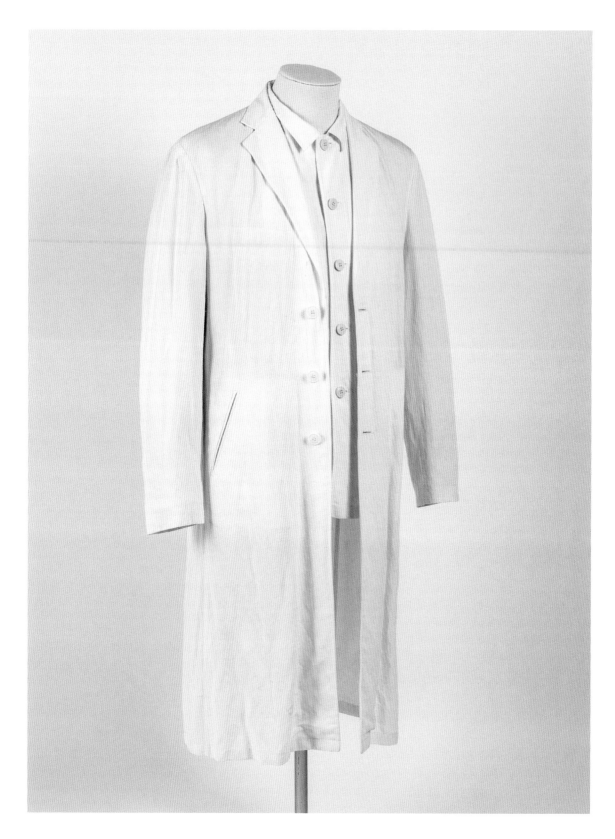

38 Giorgio Armani off-white linen overcoat and casual long-sleeved jacket, c.1998. Fashion Museum Bath (BATMC 2011.124.90 to B).

Dandy Style

which also feature four buttoned pockets. The loose silhouette of this suit was highly fashionable in the early 1990s.

A Giorgio Armani ensemble, purchased by Reed around 1998, consists of an overcoat, a long-sleeved jacket (both unlined through the body) and trousers made of waffle-weave material (fig. 38). The woven material of the off-white trousers adds to the interesting textures of this ensemble. The overcoat has two angled welted pockets, which are still stitched closed as Reed preferred to preserve the silhouette of the garment. The jacket is simply cut, with no cuff buttons. It has two patch pockets attached to the front panels. Hinting at use over time, there are small stains at the cuffs and on the front right panel of the overcoat. The soft drape of the material would have given the ensemble a fluidity (fashionable at the time) when Reed moved through the streets of London. He was purposefully presenting a particular identity to the world, one of a young man in the most stylish designer clothing of the period.

By the 2000s, Reed's wardrobe reflected an eclectic taste in clothing, spanning high fashion (Versace, Armani), the avant-garde (Japanese designers and brands such as Yohji Yamamoto, Mitsuhiro Matsuda [1934–] and Comme des Garçons) and the unconventional, such as Vivienne Westwood, Jean-Paul Gaultier (1952–) and Romeo Gigli (1949–). Reed has also displayed a love of Georgian dress, evident in coats made for him by Savile Row tailors Henry Poole & Company that replicate the eighteenth century's elegant silhouette and proportions. This conflation of historical and contemporary design was, for Reed, a viable way of expressing contrasts in his own personality. From the Spring/Summer 2000 collection by Versace, he purchased a coat made of 70% wool and 30% mohair that echoed historical styles with a distinctively contemporary flavour (fig. 39). Vents on each side of the coat are asymmetrically cut, in a style similar to eighteenth-century formal coats. The front panels are held together with a single mother-of-pearl button and cut away at the hem, again reminiscent of late eighteenth-century masculine fashions (see figs 16 and 71). Glass bugle beading (using small tubes of glass) and neon flowers, made up of diamond-shaped pieces, are stitched to create a meandering, asymmetrical pattern down the front left panel that curves towards the bottom of the side vent (fig. 40). From the nape of the neck to the back hem the coat measures 126 centimetres. Satin lining throughout the coat, woven with a Medusa-head pattern that also appeared on the buttons of Reed's 1992 Versace suit, offers structure and warmth. There are stains on the revers and upper front panels and at the sleeve cuffs, material evidence of life lived in this garment. Some moth damage is also evident, especially on the lower half (as noted by the FMB curators when the coat was accessioned into the collection).

Surface plays an important part in the analysis of both Strong and Reed's wardrobes. The biographies of these objects are further revealed through the materiality of textiles, and the inherent ability of cloth, and thereby dress, to change as it moves across and around the body. The field of surface studies offers useful ways to interrogate the complex interactions between, and upon, surfaces. Surfaces surround us: they are the boundaries between us and our environment, manufactured (physically manifested), invented (imaginary, ephemeral) or artificial (temporary, unnatural). Joseph Amato notes that 'once formed into images and representations, surfaces

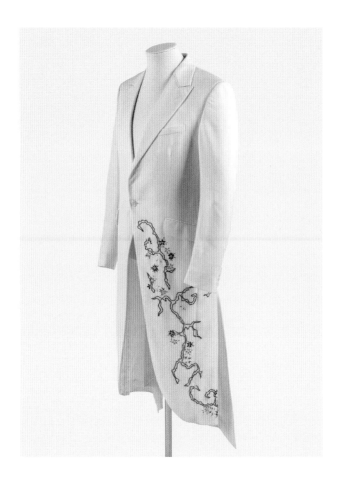

39 Versace embroidered wool and mohair coat, 2000. Fashion Museum Bath (BATMC2011.124.13).

become keys and corridors of perception, signalling immediate reactions, eliciting habitual responses, exciting associations, and awakening and establishing memory. All this explains, so to speak, why in *these* clothes in *that* room I become *that* person'.[15]

Analysis of the garments in Reed's wardrobe indicates that his clothing is generally less worn than Strong's. His wardrobe was large, and he wore many of his ensembles only a few times (some items still have price tags on them). But the detail of materiality in other items of Reed's clothing, such as the ensembles analysed in this chapter, is enough to indicate not only use (the stains, the missing buttons), but a purposeful, personal choice to wear very specific styles of fashionable garments, as a way of presenting an identity to the world.

This chapter proposes that the imprint of these two men's bodies and the hints of life lived in these garments contribute to the biographies of the clothes, as revealed through material culture analysis and object-based research. Such analysis of their clothing will not retrieve all information about these men's life stories, but amalgamating its findings with other research methods can offer new insights into their individual characters and biographies. Looking at the wardrobes of both men as a whole also reveals evidence of personal tastes, constructions of identities and the formation of fashionable public personas. This research approach exposes new questions to ask of Strong and Reed's lives, which would not have surfaced through a reliance solely on literary and photographic evidence and oral history methods.

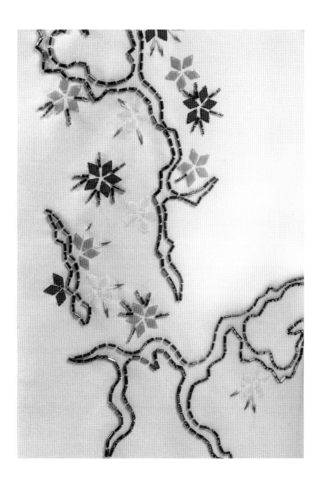

40 Detail of Versace coat
(fig. 39), showing the meandering
embroidered pattern across the
lower front left panel.

Daniel Miller has noted that a model of material culture biography allows us to
'understand people through the medium of their things'.[16] This chapter shows how
an enhanced sense of the life stories and masculine identities of Strong and Reed
is available through material analysis of their clothes. The use of such analysis, layered
with other research methods, offers an elastic, expansive response to biographical
narratives.

3

The Devil is in the Detail: Why Men Still Wear Suits

Joshua M. Bluteau

The suit is a powerful garment with a potent historical precedent, laden with symbols and bursting with hidden tricks to mould the wearer into a more ideal (and conventional) shape. In a modernity full of denim and athleisure, how is the suit still surviving? This chapter will explore this question, asking what makes the suit desirable, how does it mould the body and identity and, crucially, why do men still want to wear it?

For an anthropologist such as the present author, who has worked with both tailors and the wider fashion industry, the first and most obvious way of understanding the suit is as a form of body modification. Anthropologists often frame scarification, tattooing and other bodily adornments within indigenous cultures, such as neck rings or lip plates, as body modification; but why not clothing as well? Terence Turner conceptualises the surface of the body as the 'frontier of … the social self', but what does this mean?[1] That depends on the typical state of presentation of the body. In some indigenous communities, where traditionally held notions of body modification are practised, the body is often more visible, conceptualised by western standards as being in a state of undress – although this, of course, is culturally relative. In the western world, the suit is typically the required state of dress in certain circumstances and locations, where the skin of the body is intentionally covered, shrouded and hidden from view according to a variety of complex and historically motivated societal customs. This, as Turner suggests, is a 'social self', but it is possible to go further. Clothing acts, and can be thought of, as a second skin, crafted from cloth but nonetheless vital in the production of self. Various social theorists have discussed how we craft our identities and perform versions of ourselves in everyday life.[2] Clothes are the costumes that we wear; in the case of tailoring, the nuances of

this costume are complex but they can be read by those who know where to look. So, clothing is not merely a frontier of the self, but a canvas for the self: a place to create identity, cultivate desire or disappear into the background.

This notion of disappearance or invisibility is a curious one in this context. Ostensibly, clothes are clearly visible. They cover our bodies and can be lurid or brightly coloured to draw attention to areas we want to show off; but would we be more visible if we wore no clothes at all? For clothing scholars, so used to looking at the intricate details of garments, textiles and accessories, this may be a moot point, but for scholars thinking more generally about gendered material culture and the politics of the body, the issue is more nuanced. For many, the sight of men in suits at a wedding, funeral or office affords the wearers a degree of invisibility. The lounge suits and morning suits found at such events are the modern derivation of nineteenth-century frock coats, which would have provided an equivalence of invisibility in their time (fig. 41; see also fig. 12). This is comparable to Daniel Miller and Sophie Woodward's work on denim, in which they identify blue jeans as the first 'post-semiotic garment'.[3] Essentially, they argue that blue jeans are so ubiquitous in western culture (and beyond) that they make the wearer intellectually invisible; that particular choice of trousers being so universal, so typical (and – perhaps – so banal), it raises no reaction whatsoever. However, this argument can be disputed, since there will always be those who are so obsessed with the intricate details of garments that they will be able to spot Japanese selvedge denim, or a limited edition pair of Levi's, across the room. But the same could be said for all devotees of any particular style, garment or look.

With regard to tailoring, a similar occurrence is enacted in offices, formal spaces and on pavements wherever the suit is worn. For many, the sight of a man in a suit means that they then pay his choice of outfit no further attention: in some spaces and certain circumstances it can act as a uniform, an invisibility cloak of sorts, allowing the wearer's existence in the space to be instantly accepted and immune from comment. In circumstances such as this – perhaps exemplified by a black, two-piece, two-button, notch lapel (medium width), Marks & Spencer off-the-peg suit, with a white shirt and black tie, worn to a Christian church funeral somewhere in the UK – the suit could be termed post-semiotic.[4] So why do men still wear suits? Well, in circumstances such as these, there is a clear advantage to the form of dress: 'blending in' can be seen as culturally appropriate or respectful. A clear hierarchical statement is being made by intentionally not standing out (analogous to the social rule of not upstaging the bride); and there is an ease in putting on a prescribed uniform, knowing what to wear and how it will be received. This can be important at events where transition occurs (such as weddings, funerals, christenings or graduations) and a clear social hierarchy needs to be maintained; consequently the post-semiotic suit, whatever it may look like, is a clearly demarcated transitional garment. Nevertheless, this is not the whole story; what about those people who do stand out? Maybe they are wearing a suit in a surprisingly colourful fabric, or an unusual cut, or perhaps they enter the room and, for some reason that is hard to pin down, they just look fantastic (fig. 42). Suits are highly semiotic garments, and while of course they are relational to the wearer, this

41 Navy woollen frock coat, worn for a wedding in 1846. Manchester Art Gallery (1951.346).

symbiotic composite of wearer and cloth, person and crafted social self, allows for a whole tapestry of social relationships to be mitigated, and inferences of power to be woven.

The power of these 'stand out' garments is such that they can become intrinsically linked to certain individuals and certain times, becoming iconic and imbued with a hybrid identity, whereby wearer and garment become greater than the sum of their parts. Historical examples include the suits of rock stars and politicians, from the powder blue suit worn by David Bowie (1947–2016) in the music video to his 1973 single, 'Life On Mars?', to the chalk stripe suit, cut by Henry Poole of Savile Row, so prominent in that iconic photo of Sir Winston Churchill (1874–1965) cradling a tommy gun, taken in July 1940 (fig. 43). There is even a story of the Viceroy of India, Lord Curzon (1859–1925), as a younger man, attiring himself in vast 'gold epaulettes', various hired medals and an entirely concocted military uniform (from various sources including theatrical outfitters) for a visit to the Amir of Afghanistan – such

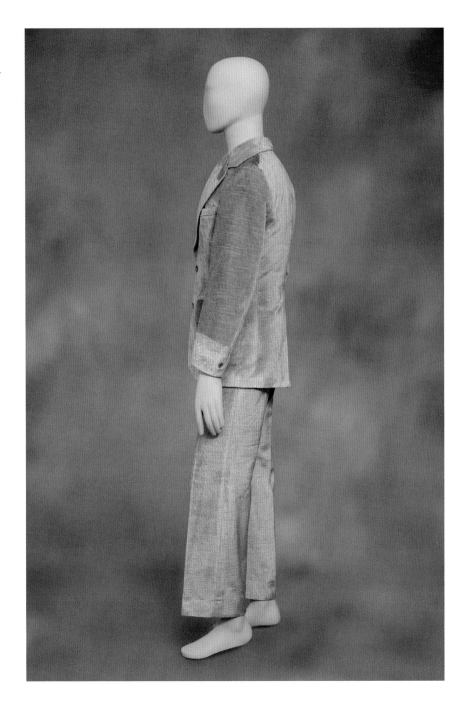

was his desire to display his position and power.[5] It is easy to dismiss such exaggerated wardrobe choices as costume, but they are simply at one end of the spectrum, with the social costume of everyday life at the other. Curzon, like Bowie and his blue suit, adopted a uniform and style to position himself in a certain way as a means of mediating relationships of power through the creation of a particular image. For Curzon this was through militaristic bombast, for Bowie an idiosyncratic choice of colour, cut and fabric; but both sought to embrace individualism through dress as a social, political and performative tool.

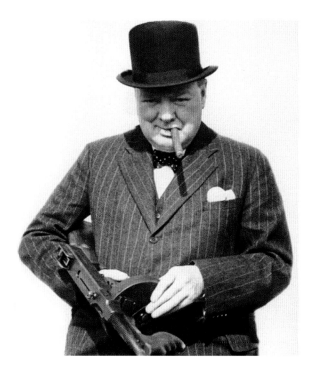

43 Wartime image of Sir Winston Churchill with a tommy gun, July 1940. From the archives of Press Portrait Service (formerly Press Portrait Bureau).

There is a sense of individuality, flair and perhaps even dandyism in images such as these. Flamboyant tastes and tendencies, demonstrated by a variety of historical characters from Oscar Wilde and King Edward VII to Marc Bolan (1947–1977), show how tailored clothes can be subverted and manipulated as highly powerful artefacts to create a certain type of visual self, to mould the world around the wearer and to weave a particular tactile narrative about class, identity and selfhood (see fig. 15). Naturally, such images filter down to the habits and wardrobes of those not in visible public life. Thus they not only highlight trends, but also illuminate the juxtaposed nature of the highly visible, public wearing of garments and the private acts associated with the same garments: getting dressed, purchasing the clothing in question, and the relationship between the owner and hidden details within the garment.

Once again, the link to notions of body modification – and in particular the academic literature on tattooing – is close here. Similar concepts viewed from slightly different perspectives shed a diffused light on issues of dress and self-making, as if looking through frosted glass: similar yet slightly obscured. Tattooing is both a 'public and private act', with issues surrounding what the tattoo means to the tattooee being thrown into sharp contrast with how others perceive the tattoo on their body.[6] There are echoes here of the wearing of tailored clothing, an intricate and multilayered act involving interwoven private and public performances. A suit may be purchased or commissioned in a private context. Equally, the act of getting dressed is typically a private one, too.[7] However, once the wearer steps out of the front door into a public sphere, the suit, like a visible tattoo, is available for those around to observe and use as the basis of assumptions as to the status, style, personality and masculinity of the occupant. This assumes, of course, that the gaze falling upon the suit comes from a cognoscente: someone who is aware of the intricacies of the tailored garment, who

can spot a bespoke suit at 50 paces and pales at the sight of polyester. This is atypical, however, so we must consider the wearing of a suit as both a public and a semi-private act, with the clearly visible symbols of tailored dress apparent to all, and the nuanced subtle details chosen by the wearer (including lining choice, who made it and how much it cost) visible to only a select few.

Irrespective of such inside knowledge, the suit is a cleverly crafted expression of an idealised form of masculinity, physically realised in the form of cloth, thread, padding and buttons. Current trends err on the more muted manifestation of these bodily modifications, certainly in comparison to the suit of the late 1960s and early 70s from tailors such as Tommy Nutter, but despite this modern subtlety, an effect is still felt.[8] Padding widens the shoulders, making the wearer's frame look bigger; a well-placed button and a nipped-in waist flatter the midriff; and elegantly proportioned trousers give the effect of a taller, slimmer physique (fig. 44). Furthermore, a beautiful cloth can heighten the whole effect. A tailor might advise that pinstripes are slimming, while a loud checked cloth can give the effect of enlarging and exaggerating the physical space taken up by the suit wearer: a sensation comparable to the notion of presence (see fig. 21).

The combination of public and semi-private performance is crucial to understanding why men continue to wear the suit, irrespective of the level of detail discerned by the world around them. Ostensibly it may seem odd that one can spend less than a hundred or up to many thousands of pounds for suits that, to many, will look very similar. The power of the suit lies in the multilayered nature of the symbolic enacted performance that occurs when it is put on and worn in public. The suit is a garment which, even at its most basic and inexpensive, modifies the wearer's form, not only physically but also symbolically, making him appear broader, taller and slimmer, changing the way he moves, and granting a certain powerfulness. This sense of power is enacted by creating a silhouette drawn, perhaps, from a militaristic legacy as well as implying a certain type of occupant, with a certain level of wealth, partly due to the large amount of matching fabric needed, in addition to the pre-existing historical narrative charting wearers of similar garments. Fundamentally, however, ideas about what the suit is and what it represents are culturally constructed. We believe it is smart, formal and masculine, implying a hierarchical sense of dominion over the lesser-dressed, thus it becomes so. There are exceptions to this, for instance, doormen and waiters, but these fit within particular cultural constructions, occupying a specific space, and would be hard to mistake.

This is the public aspect of the presentation of a be-suited self, but the notion of semi-private performance is more intriguing and perhaps more apt for the *Dandy Style* exhibition. Dress of all sorts is codified, with those in the know being able to read a set of hidden meanings or symbols. Shaun Cole has noted this repeatedly in his work on gay male dress and subculture, but with the suit, the devil is definitely in the detail.[9] This can be as specific as whether the buttons on the suit have two holes or four, with two being more desirable to certain clients as they indicate that the garment has been made by an old-school Savile Row tailor. In the same way, the material from which the buttons are made and the manner in which the lapel buttonhole has been

44 Tommy Nutter two-tone woollen suit, 1970–71. Manchester Art Gallery (1998.165).

The Devil is in the Detail

stitched – hand-stitched, excellent; Milanese style, even better – give an indication as to the provenance of the garment, the cost and the personal investment the wearer has made.[10] Elements such as these imply an assertion regarding authenticity and an active step in the crafting of the individual self through the choice of this garment. Such minutiae of detail are available not only from bespoke tailors but also from leading designers and from alteration work carried out by the owners themselves, playing with the shapes, texture and details of the garments that they wear.

Of course, in certain spaces wearing a suit at all is enough to stand out. In the same vein it can be palpably uncomfortable to misread the dress code (whether literally or figuratively) and enter a room full of lounge suits wearing a dinner jacket. There is an element of this fitting in, and the uniform-like nature of tailoring, which harks back to Beau Brummell's notion of being well dressed: the suggestion that one's outfit should be so perfectly executed as to draw no comment and barely a glance from passers-by. This is essentially conformity, while the artist Sebastian Horsley – the flamboyant and self-proclaimed dandy who died in 2010, notable for his drug addiction, use of prostitutes, the wearing of lurid outfits from London's best bespoke tailors and for being crucified in the Philippines as a piece of art – used tailoring intentionally to shock, provoke and arouse attention (fig. 45). Yet the tailored garments that both Brummell and Horsley wore are not so different from each other in terms of construction or fundamental concept.

45 Sebastian Horsley wearing a red velvet suit by Richard Anderson, with shirt by Turnbull & Asser and hat by Lock & Co., at the launch of his autobiography *Dandy in the Underworld*, London, 15 June 2010.

This sliding scale of flamboyance mirrors the complexity of the suit as a garment of desire and dependence. As the *Fashioning the Body* exhibition held in Paris (2013) and New York (2015) demonstrated, altering the shape of the body through padding and corsetry is a long-established trope in both men's and women's dress.[11] Despite the marked difference between the padded chests of the Regency dandies and the canvas-lined jackets of modern tailoring, these garments sit in a historical narrative of shape-shifting, moulding bodies through dress into idealised forms.[12] It would be nonsensical, however, to hang this whole chapter off this idea. While it is the case that tailoring does act as a form of bodily modification and many of its favourable attributes sit within this wider historical trope, the reality of purchasing and wearing tailored garments typically overlooks this feature. So while the padding, canvassing and cut of the garment do alter the wearer's perceived shape, imbuing the symbiotic fusion of wearer and garment with agency, not all wearers will be aware of this. Consequently, we must look beyond this to question what other factors impact on the reasons that men continue to wear suits.

In a world divided into strictly demarcated geographic and social spaces, each often requiring a specific dress code, crafting one's own notion of individuality through dress is increasingly complex. Yet it is here that tailoring and the suit allow for an enormously varied expression of identity through details which are primarily noticed by the wearer but also mark the wearer out as belonging to a certain kind of unspoken sartorial club. This could involve having a suit made by a particular tailor, perhaps Huntsman of Savile Row with their distinctive and heavily structured house cut; or it could be the fact that the cuff buttons undo (known as a surgeon cuff), or indeed simply how many buttons the suit has. In the case of bespoke tailoring, an intimate relationship develops between wearer and garment as the suit is repeatedly worn. This process, combined with perspiration and the 'floating' horsehair canvases contained within the layers of tailored perfection, actually allows the suit to mould to the wearer over time, becoming increasingly unique and a better fit the more the garment is worn. This intimacy between person and object is at one end of a spectrum of cost, but at many other points along the scale there are sartorial choices to be made. Does anyone *need* turnback cuffs, open lapped side-seams, covered buttons, box pleats, double pleats, ticket pockets, hand-stitched buttonholes or contrasting edging and facings? Perhaps not, but it is not all about need. Indeed, when it comes to luxury goods, Christopher Berry highlights the complexities inherent in differentiating clearly between 'need' and 'want', arguing that the positive or negative understanding of luxury is a cultural construction that fluctuates across time and place. So, far from being diametrically opposed, requirement and desire interact in decisions and purchases made in everyday life. Details elevate an outfit, demonstrating elements of design and craft that can make the wearer feel as if they have said something profound and authentic about who they are through their choice of garment. Furthermore, such choices might not only be aesthetically pleasing, but also raise questions. What do they mean? To what spaces do they afford access? From what historical characters do they draw inspiration? How do they change the perception of one's body? What do they say about the wearer?

46 Detail of demob suit in brown worsted, 1946. Manchester Art Gallery (1967.123).

While the suit is ingrained into western culture as a symbolically laden artefact, complex historical object, and potent garment for bodily modification, this does not answer the question of why men still continue to wear the suit. Surely these assertions are true for all dress, so why is the suit in particular so unique? The suit is not quite like any other article of clothing, and this in itself justifies its continued currency as a garment of choice in certain social settings, transitional moments and constructions of self. No other garment corrects sloped shoulders as bespoke can, or slim the physique quite so adeptly. No other garment, whether it is a multi-thousand-pound, hand-made piece of art or an off-the-peg suit from a high street shop, so acutely represents the realisation of the masculine ideal in cloth. For while the effect realised by the off-the-peg suit may not be as profound or as crisp as bespoke, the intention is very much still there. This is what makes the suit desirable. It shows us

how we are meant to be, promoting an idealised form and an idealised suggestion of elegance, refinement and social grace. Now this is of course gendered, heteronormative, western-centric and old fashioned, but nevertheless that does not diminish the desirability of the suit, or the possibilities for this form of garment to be adopted, subverted and reimagined for each new generation of wearers.

So whether it is the Sapeurs of the Congo employing the elegance of the suit as a political act, or Yojhi Yamamoto taking cues from the Yakuza gangster silhouette to flavour the suits shown on his catwalks, tailoring emboldens, empowers and subjugates in equal measure.[14] The suit can demonstrate excess, such as in Horsley's sequinned creations by Richard Anderson or the zoot suit of 1940s America; but equally poverty can be displayed in each thread. That is the case for the Sapeurs, and much of the tailoring seen during and after the Second World War in the UK, where the demob suits issued to men once they had left the armed forces set an aesthetic tone for oversized, poorly fitted clothing (plus a small number of generic cuts), highlighting the disparity between the affluent and the impoverished to an even greater degree (fig. 46). Furthermore, the banning of turn-ups, double cuffs and double-breasted cuts by the British government in the Second World War (to save fabric and labour costs), and the exaggerated double-breasted cuts pioneered by Armani in the power-dressing 1980s, are both indicative of a particular socio-economic epoch. The details of tailoring, then, are as much a social marker of the times as an aesthetic choice. Despite the continued reinvention of the suit – recut, rehashed and reshaped for each generation – it remains indelibly important, and an essential component of a man's wardrobe.[15]

4

Painting Men's Style: Portraying an Image

Shaun Cole, Miles Lambert
and Rebecca Milner

Portraits have long been recognised as important sources for the history of dress, fashion and style.[1] Alongside surviving garments, portraits enhance our understanding of how clothes looked when worn, how fabrics behaved on the body, and what elements made up a complete outfit or look together with accessories, make-up and hair styles. Aileen Ribeiro emphasises how a 'portrait represents the joint contributions of artist, sitter and costume; in this context clothes can reveal character, both heroic and mundane, and all the frailties of human nature including vanity and pretension'; the latter two have frequently been associated with an excessive interest in fashion.[2] Increasing attention has been given to analysing the presentation of a particular dressed appearance, pose, gesture and facial expression, although it must be remembered that any portrait captures 'a precise moment in time' that 'transfixes the sitter in a kind of time-warp'.[3] Alongside this has been an analysis of the particular style in which clothing might be represented by the artist, for example, in photographic detail, or through more loosely and imaginatively expressed areas of form and colour.[4] As Anne Hollander has noted, 'clothes must be seen and studied as paintings are seen and studied – not primarily as cultural by-products or personal expressions but as connected links in a creative tradition of image making'.[5] Our understanding of the style of individual men and the history of men's dress and appearance is enriched by paying close attention to garments and their representation in paintings.

In the eighteenth century, men, like women, were most commonly portrayed in their own clothes, including fashionable daywear, a uniform or other official clothing, and sometimes, working or sporting clothes. Some men, mostly of the upper

or middle class, who might wish to convey their fashionable tastes, knowledge and education, chose to be painted in imagined garments and draperies. These were often reminiscent of classical apparel or more recent historic dress that could be construed as fancy dress. In a 1770 portrait by Joseph Wright of Derby (1734–1797), the writer, philosopher and farmer Thomas Day wears a white shirt open at the collar under a long-sleeved vest with matching breeches.[6] A swag of rust-red satin drapery is artistically wrapped about his person (fig. 47). The asymmetry and colour of the drapery creates visual drama, its sinuous lines contrasting with the solidity of the classical column against which he leans. These visual devices, part of an artistic formula in eighteenth-century portraiture, functioned to elevate the status of the painting in its references to the art of the past, whether that was classical art or the work of artists such as Van Dyck in the seventeenth century. Portraitists believed that simpler garments and classical drapery gave a dignified and timeless appearance to the sitter.

Like Wright of Derby, Italian painter Pompeo Girolamo Batoni (1708–1787) had a keen understanding of the aesthetic possibilities of clothing in creating a great work of art. He also saw how dress, along with a careful choice of pose and background, could communicate aspects of the sitter's character. Drawing on the restrained classicism of artist predecessors such as Raphael and Poussin, his portraits frequently featured antiquities and Roman settings. A highly successful painter of Grand Tour portraits, Batoni had developed great skill in constructing images that conveyed the social status and fashionable tastes of his mostly aristocratic British and Irish clients. Much like the tailor or embroiderer, Batoni had complete mastery over his materials and an understanding of line, form, colour and how to flatter the male body. He developed a style and format that underpinned the image already created by the sitter's own clothes. Sir Gregory Page-Turner (1748–1805) had just succeeded to his father's title and great-uncle's fortune and was undertaking a lavish and comprehensive Grand Tour when he sat for Batoni in Rome in 1768 (fig. 48). Batoni 'delighted in the details of clothing for its own sake', and with its highly finished surface, bold composition and dramatic colour, the portrait confidently captures a young man known for his 'extravagant living and fine clothes'.[7] Page-Turner wears an elegant embroidered red silk frock coat, its turned-down collar indicating day rather than evening wear. Batoni's skill in meticulously rendering the details of dress and its decoration on his canvas can be appreciated by viewing contemporaneous surviving suits such as the one illustrated here (fig. 49).

Not all eighteenth-century artists were as sensitive to the aesthetic and expressive possibilities of dress as Batoni. In the portrait of Colonel Archibald Grant painted in 1762 by George Chalmers (c.1720–1791), the sitter is clothed in a red silk coat decorated with gold embroidery, similar to that of Page-Turner (fig. 50). However, the portrait is less refined in its execution and, although the physical reality of Grant's clothing is rendered with some success, the representation of the individual qualities of the fabrics is less subtle and vivid than in the work of Batoni. Grant's clothes communicate his status and wealth, but in combination with the formal pose, plain background and inexpressive face, construct a rather more conventional image of respectable

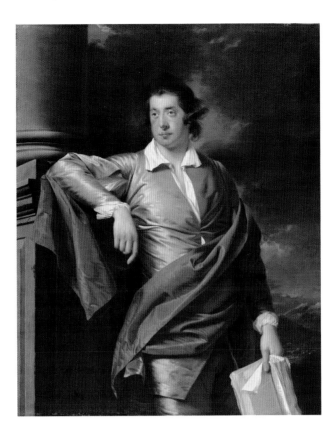

47 Joseph Wright of Derby, *Thomas Day*, 1770. Oil on canvas, framed 144.5 × 120 cm. Manchester Art Gallery (1975.194).

gentility. Chalmers's portraits were criticised for lacking beauty and his style did little to bring his sitter's character to life.[8]

The sumptuous coloured silks and embroideries of the 1760s and 1770s had been superseded by a much more restrained palette and style by 1800. Democratic ideals and the diminishing of class distinctions were reflected in men's clothing through both a greater 'simplicity' and 'uniformity' and greater approximation of 'plebeian' dress.[9] A new combination of plain woollen frock coat, buff-coloured breeches and white linen stock became fashionable, as exemplified in the 1804 portrait of the brewer James Curtis (1750–1835) by Sir Thomas Lawrence (1769–1830). The aesthetic challenge that was presented by this style of dress and its limited colour palette is here successfully overcome by Lawrence, who Ribeiro noted was 'the only early nineteenth-century British artist with a genuine feel for costume and ability to render fabrics to perfection'.[10] Lawrence's particular skill, like that of Batoni, lay in representing the physical appearance and qualities of textiles and how they behaved on the body. The painting gives the impression of a man who dressed neatly and elegantly, but his lack of affectation in dress and pose suggests that fashion was not a great preoccupation. Lawrence has, nevertheless, paid attention to textures and to details such as the soft density of Curtis's black velvet coat collar, which catches the light and contrasts with the stiffer woollen fabric of the dark green coat. The crisp white linen cravat and shirt ruffle are represented with just a few confident, loose brushstrokes and the cool, reflective qualities of the buttons are captured with choice highlights of opaque white paint (fig. 51).

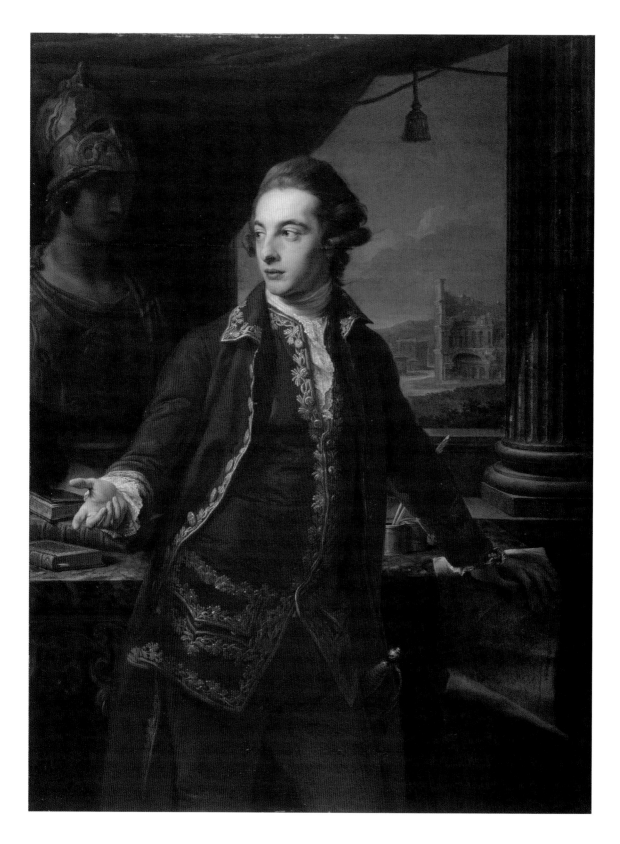

48 Pompeo Girolamo Batoni, *Sir Gregory Page-Turner*, 1768. Oil on canvas, framed 154 × 119 cm. Manchester Art Gallery (1976.79).

49 Detail of red silk coat with metal thread embroidery, 1770–80. Manchester Art Gallery (1960.300).

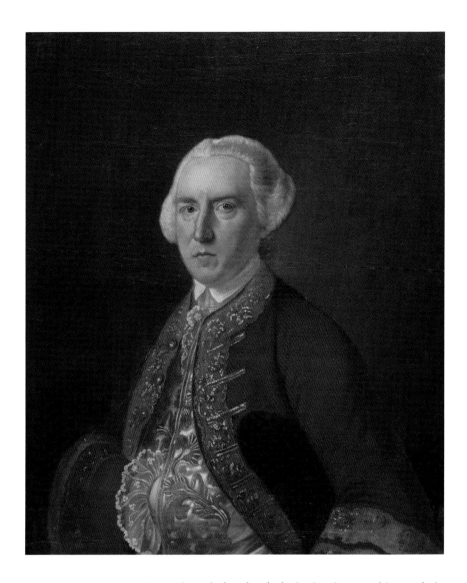

50 George Chalmers, *Colonel Archibald Grant*, 1762. Oil on canvas, framed 91 × 78 cm. Manchester Art Gallery (1986.268).

In contrast to Page-Turner's curled and styled wig, Curtis wears his own hair, possibly powdered, in keeping with the more natural styles that were fashionable by 1804. Richard Dighton's etching, *A View from the Old South Sea House*, printed nearly 20 years later in April 1823, shows Curtis still wearing the clothing he so proudly displays in Lawrence's 1805 portrait (fig. 52). It follows a similar form to Dighton's 1804 watercolour of Beau Brummell (see fig. 1) and is reminiscent of Horace Vernet and Louis-Marie Lanté's series of idealised 'portraits' of *incroyables* (fig. 53). This perhaps reflects how some men remained faithful to the styles of their younger days even when fashion had moved on.

In Lawrence's portrait, Curtis is posed in front of a classical pillar, echoing such earlier portrait backgrounds as Batoni's in his depiction of Page-Turner. More dominant is the swag of rich red fabric, a visual device that Lawrence often used in portraits of men. In his 1835 book *Chromatography*, chemist George Field noted that Indian Red was a colour Lawrence highly valued.[11] This provides a perfect foil to the muted colour of the sitter's clothing and is particularly effective when contrasted with black

51 (*top*) Thomas Lawrence, *James Curtis*, 1804. Oil on canvas, framed 129 × 102 cm. Manchester Art Gallery (1953.441).

52 (*bottom*) Richard Dighton, *A View from the Old South Sea House*, 1823. Engraving. Manchester Art Gallery.

53 George-Jacques Gatine, after
Horace Vernet and Louis-Marie
Lanté, 'Chevelure à la François
1er. Chapeau en Barque. Charivari
de Brelogues', from the series
Incroyables et Merveilleuses, 1814.
Reproduced engraving. Private
collection.

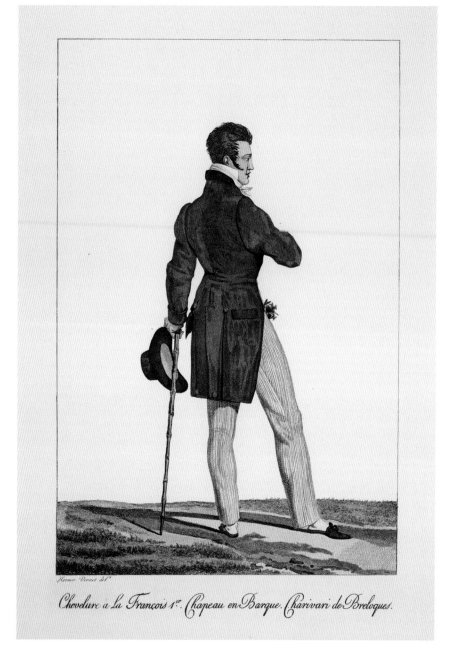

Chevelure a la François 1er. Chapeau en Barque. Charivari de Brelogues.

garments, as seen in Lawrence's c.1821 portrait of the chemist and inventor, Humphry Davy (1778–1829) (fig. 54). Andrew Wilton has noted how Lawrence 'revelled in the deep unmodulated blacks and the sharp white or cream of well-laundered collars and cravats', as is evident here.[12] Painted when Davy was in his early forties and president of The Royal Society, Lawrence's portrait conveys the monochromatic fashionable style of the period, set against an architectural background and featuring the miner's safety lamp that he invented on the red-cloth-covered table to his side. Art and fashion combine in Lawrence's work to communicate particular ideals of masculinity and an image of the Romantic hero that is encapsulated in this portrait of Davy.

Dandy Style

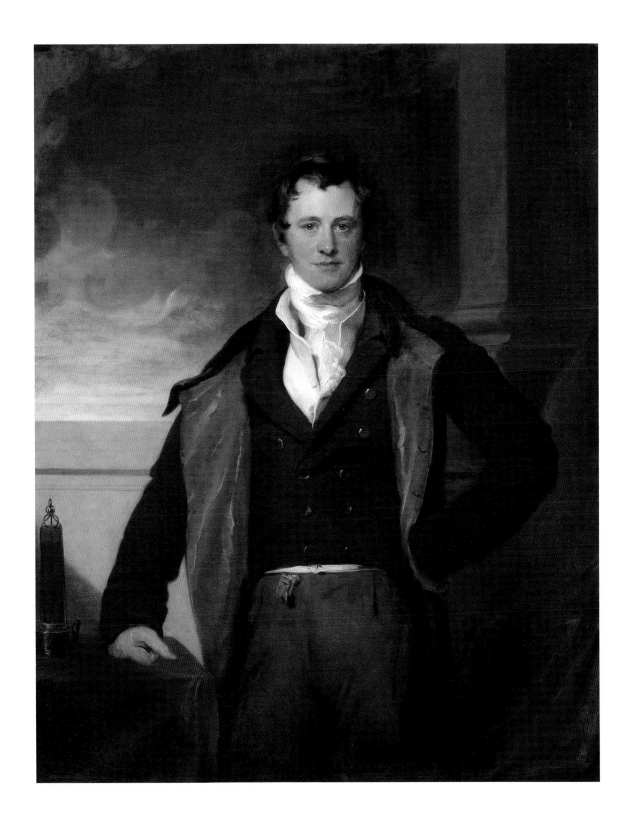

54 Thomas Lawrence, *Humphry Davy*, c.1821. Oil on canvas, framed 142 × 111.5 cm. The Royal Society (RS 9343).

55 (*left*) Mather Brown, *Thomas Fitzherbert*, 1809. Oil on canvas, framed 76 × 63.5 cm. Burton Constable Hall, Leeds City Council (LDS 115).

56 (*right*) Charles Allingham, *Jem Belcher*, c.1800. Oil on canvas, framed 76.2 × 63.8 cm. National Portrait Gallery (NPG 5214).

Painted around twelve years before Lawrence's *Humphry Davy*, a portrait of Thomas Fitzherbert (1789–1857) by the American artist Mather Brown (1761–1831) evokes a similar style and attitude (fig. 55). The looming clouds in each portrait are matched by a similarity in the coats and neckwear of the two sitters. Both sport dark-coloured, double-breasted jackets over (differently coloured) waistcoats with high collars and intricately tied stocks. The black of Fitzherbert's coat makes the detail less clear than in Davy's dark blue garment. Brown has devoted particular attention to the fineness of Fitzherbert's linen cravat and the ruffle of his shirt, capturing the folds and pleating pinned by a gold and red stone tie pin. Brown had arrived in London in 1781, and his portrait of King George III's second son Frederick Augustus led to his appointment as the Prince's History and Portrait Painter, alongside commissions from other members of the royal household and British aristocracy. Other portraits of noble young men (and indeed his own self-portrait), painted around the same time as the depiction of Fitzherbert, demonstrate a similar attention to detail in the rendering of neckwear and other sartorial features.

Fitzherbert was a fashionable country squire, and this dress style was taken up by less wealthy, urban 'bucks' who showed 'excessive devotion to stables, dog-kennels and coachmanship'.[13] The early nineteenth-century sporting writer, Pierce Egan, who noted the sartorial style of the bucks and the dandies, also discussed the bare-knuckle fighter Jem Belcher (1781–1811). Known as the 'Napoleon of the Ring' owing to his early boxing successes, Belcher died aged 30 after his career was ended when he was blinded in one eye. He has been compared to the Romantic poets, Shelley and Keats, for his fame and legacy.[14] Belcher's significance in a discussion of male dress lies in his adoption of a coloured, patterned neckcloth, which was named after him and taken up by fashionable young men of all classes. This is clearly captured in a c.1800

portrait of him by Charles Allingham (c.1778–1850) (fig. 56). Emulating Brummell's intricately tied neckwear, Belcher used a more plebeian patterned, coloured cloth rather than the fine white linen that Brummell changed regularly so as to keep it immaculately clean. In Allingham's portrait, the yellow and gold pattern of Belcher's neckcloth is intricately presented, as is the complexity of the wrapping about his neck and the small neat bow that finishes the tied construction. The plainness of the background perhaps also marks Belcher's class. There are no allegorical landscapes or buildings, no symbols of his scientific achievements, nothing to indicate why he should be honoured. The adoption of the 'belcher' neckcloth signals the beginnings of an interchange between sport and fashion, a more casual take on formal styles, and can be linked to fashionable twentieth-century boxing 'dandies' such as Chris Eubank Senior (1966–) (discussed in Chapter 5).

The formality of the high, close-fitting collar and neckcloth portrayed in Lawrence's portrait of Davy, and in Brown's of Fitzherbert, is in sharp contrast to the less formal neckwear of Lord Byron (1788–1824), which appears in a number of depictions of the poet in the 1810s.[15] A brooding portrait of Byron, painted in 1813 by Richard Westall (1765–1836), presents him in profile as the archetypal Romantic with natural, dishevelled hair and a soft-collared, open-necked shirt, pinned with a cameo (fig. 57). Byron's soft, folded collar was not in Westall's original painting and

57 Richard Westall, *Lord Byron*, 1813. Oil on canvas, framed 76.2 × 63.5 cm. National Portrait Gallery (NPG 4243).

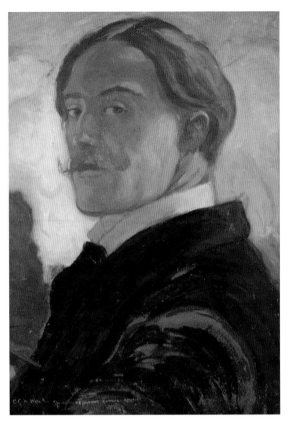

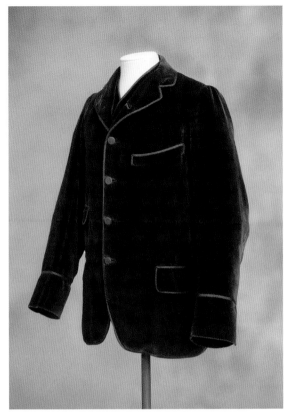

X-ray examination has shown that previously the collar was deeper, falling over the lapel of his crimson coat, and more in keeping with other portraits of Byron.[16] The painting was probably commissioned by a friend of Byron's, most likely the radical MP Sir Francis Burdett, for Byron's publisher John Murray, to illustrate Byron's extended narrative poem *Childe Harold's Pilgrimage*. The way in which Byron is portrayed by Westall resonates with the character of the hero that Byron first introduces in *Childe Harold*. Educated and sophisticated in style, with a disrespect for authority, his cynical, arrogant and self-destructive characteristics became associated with Byron himself and provide the legacy of the Byronic hero in popular culture.[17] Over his coat and casually covering one shoulder Byron wears a sketchily rendered black cloak, echoing the background drapery of Lawrence's portraits, and the historic Romanticism of Byron's self-image.

By the late nineteenth century, artists were becoming 'self-consciously "artistic"' in their choice of dress, and many painters of the time explored image and identity in self-portraits.[18] In his self-portrait, painted around 1895–1900 when he was studying at the Académie Julian in Paris (where he became part of an artistic circle that included Henri de Toulouse-Lautrec and Pierre Bonnard), Charles Conder (1868–1909) presents himself in a soft brown, probably velvet, jacket (fig. 58). The loose, expressive brushwork replicates the soft texture of velvet that appears to change colour with the light. Conder's soft collar, bold cravat and reddish-blonde hair echo Aesthetic movement ideals that challenged men's dress conventions and reflected

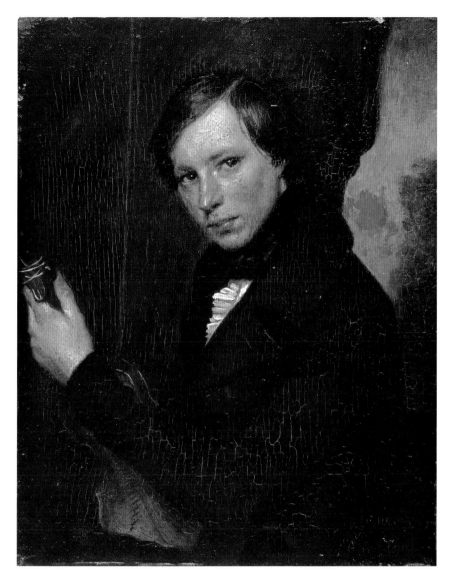

60 Ford Madox Brown, *Frederick Henry Snow Pendleton*, 1837. Oil on panel, framed 34.5 x 31 cm. Manchester Art Gallery (1913.10).

the 'outsider' status often adopted by artists from the 1880s onwards (fig. 59). The challenge offered by the brown velvet suit, when worn by men in artistic or creative fields, continued as a trope into the twentieth century. This can be seen in the 1921 self-portrait, *Portrait of the Artist as the Painter Raphael*, by Wyndham Lewis (1882–1957) and was also adopted by Sir Roy Strong in the 1970s, as discussed in Chapter 2.[19]

Joanna Woodall posited that the monochromatic male wardrobe of the mid-nineteenth century 'seems somewhat more exaggerated in portraiture than in surviving dress'.[20] Museum collections of men's clothing indicate the ubiquity, but not exclusivity, of dark colours, as they infused the portrait and sitter with *gravitas*.[21] Like Lawrence, many artists of the nineteenth and early twentieth-centuries were sensitive to the powerful aesthetic possibilities of men's black clothing. Ford Madox Brown (1821–1893) painted an early, charmingly youthful portrait of his friend Frederick Henry Snow Pendleton (1818–1888) in 1837 in the prevalent Romantic fashion of black coat and cravat, with a mere glimmer of his frilled white shirt (fig. 60). Later in

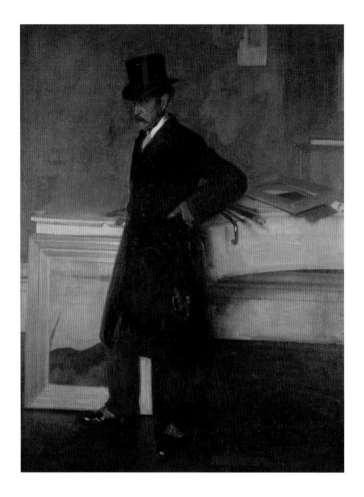

61 William Nicholson, *Walter Greaves*, 1917. Oil on canvas, framed 221 × 172 cm. Manchester Art Gallery (1925.68).

the century, James Abbott McNeill Whistler (1834–1903) and John Singer Sargent (1856–1925) were two of the most celebrated proponents of a similar employment of black costume for dramatic effect. The powerful qualities of the colour black were exploited with particular skill in William Nicholson's (1872–1949) atmospheric 1917 portrait of the artist Walter Greaves (1846–1930), painted when Greaves was in his seventies and enjoying a renewed interest in his work (fig. 61). Greaves had been Whistler's pupil and studio assistant in the 1860s and 70s, and aped his dandified mode of dressing. Nicholson's decorative realism, also inspired by Whistler, both captures and constructs an image of restraint. The low tonality, restricted palette and carefully balanced arrangement of figure and objects, line and form give visual drama and balance to this portrait. Forming a central monochromatic figure, Greaves's combination of overcoat, black top hat and shoes, paired with grey spats and gloves, echoes Max Beerbohm's opinion: 'is not the costume of today, with its subtlety and sombre restraint, its quiet congruities of black and white and grey, supremely apt a medium for the expression of modern emotion and modern thought?'[22]

Close in date to Nicholson's portrait of Greaves is a theatrical portrait made c.1917–18 of the stage and film actor Ernest Thesiger (1879–1961). The artist, William Ranken (1881–1941), plays with the visual drama of black-and-white formal wear (fig. 62). Initially enrolling at Slade School of Art, where he met Ranken in 1899,

Thesiger transferred his interests to acting, making his stage debut in 1909. After being wounded in the trenches in the First World War, Thesiger took up embroidery, an interest he shared with Ranken, founding The Disabled Soldiers' Embroidery Industry and going on to a successful Hollywood and Broadway career. Thesiger's dominant character, however, seems to have taken the lead in the creation of the portrait, as Thesiger himself recalled: 'Since sitting for Sargent I have been painted several times by William Ranken, who always says that I stand at his shoulder telling him how I want to be painted, instead of posing in front of him.'[23] Dressed in an evening suit and swathed in a voluminous black cape, he appears as if on a stage, spot lit from the top left of the picture; everything in terms of the sitter's dress and appearance seems carefully 'staged'. Thesiger's cream scarf, flamboyantly thrown over his shoulder, draws further attention to his animated face, and the elegant pose with hand on hip extends the volume of the black cape almost to the edge of the picture plane. These combined details reflect the character and behaviour of Thesiger – described by fellow actor Walter Fitzgerald as an 'elegant and eccentric dilettante' – as well as his playful and subversive sartorial choices.[24]

Ribeiro has noted that the 'link between artist and sitter was (and is) often intimate' in the production of a portrait, and relationship, personality and power dynamics certainly influence how different men have been presented.[25] However, we

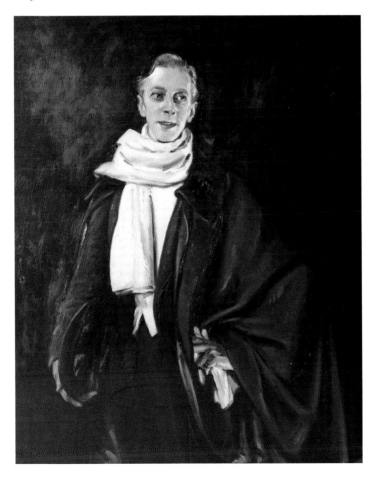

62 William Ranken, *Ernest Thesiger*, c.1917–18. Oil on canvas, framed 140 × 115 cm. Manchester Art Gallery (1942.22).

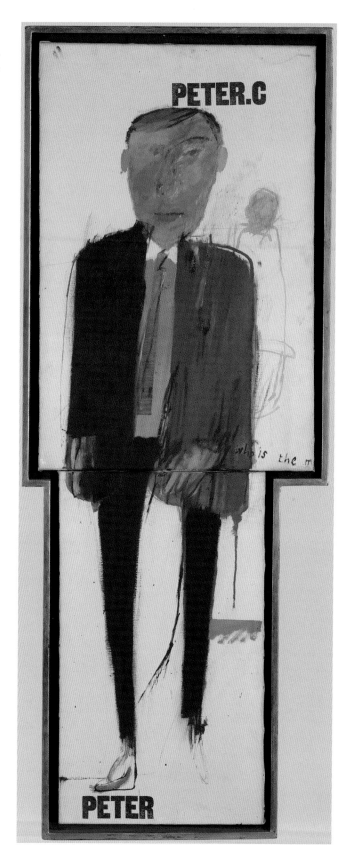

63 David Hockney, *Peter C*, 1961.
Oil on canvas, framed 116 × 45 cm.
Manchester Art Gallery (1985.22).

rarely know how decisions on presentation were taken in the studio and by whom. Thesiger and Ranken were close friends, possibly in a relationship, although by the date of this portrait Thesiger had married the artist's sister. Social convention and the prohibition of homosexuality would have made it difficult for Ranken and Thesiger to make overt references to gay identity or relationships, but by the early 1960s changing attitudes emboldened artists to explore male intimacy in their work. David Hockney's 1961 painting *Peter C* depicts interior designer Peter Crutch (who died in 2002), at that time a fellow student and friend from the Royal College of Art where Hockney studied from 1959 to 1962 (fig. 63). Hockney (1937–) fell for Crutch, but his love was unrequited and the portrait was a means to express visually his experience of, and feelings for, the sitter. An early example of Hockney's Pop Art style, the painting is distinguished by the use of two painted canvas panels, on which stencilled letters repeat the name 'PETER', while the handwritten phrase 'who is the m' trails off to one side, and a red heart decorates the subject's chest. Hockney's style is deliberately naïve, with spontaneous brushwork, and mirrors elements in his other painting of the same date that dealt with his own homosexuality, *We Two Boys Together Clinging*.

Edmund White posits that Hockney's 1961 painting *The Most Beautiful Boy in the World*, which contains similar lettering and a red heart, also referred to Crutch, although it has also been argued that the subject was the singer Cliff Richard.[26] Crutch was considered 'the epitome of cool' and Hockney emphasised this in *Peter C* by focusing on the essential shapes of Crutch's fashionable mod-inspired outfit of drainpipe trousers, box-like jacket, knitted tie, green shirt with contrasting white collar, and pointed shoes, possibly Chelsea boots, that are rapidly sketched in with a few lines.[27] As a design student with a girlfriend studying fashion, Crutch was clearly fashion-conscious and aware of his image. The juxtaposition of two canvases – with the narrower of the two for the lower part of the figure – in one frame enhances the characteristics of the main garments. Hockney originally intended to paint two portraits of Crutch, 'but as he stands so beautifully, I joined the two together and did a full-length picture'.[28] This perhaps accounts for the idiosyncrasies of the portrait, where the jacket appears dark blue on one side and purple on the other, with loose brushwork hinting at a standing collar and a lapel. Hockney returned to Crutch as a subject for an ink drawing a year later; there, the sitter wears a similar shirt and tie but this time with a double-breasted jacket.

In selecting the ways in which sitters were posed and clothed, portraitists have entered into a collaborative process that is determined by social, cultural and economic conditions, as well as a sense of the intended purpose and sites of display and consumption of the finished image. Portraits 'provide invaluable testimony to the culture, the manners, the *vision* of the times' so that 'what they depict and *why* is of crucial importance' to the study of men's fashionable dress.[29] When we look at portraits of men, both contemporary and historic, what we see, Ribeiro says, is 'largely constructed – indeed created – by the clothing they wear'.[30] The sitter's clothing is, therefore, as crucial a part of the constructed portrait image as the actual physiognomy of the sitter.

5
Performing the Dandy

Kate Dorney

This chapter explores some of the ways in which creative artists perform the dandy and how it relates to their on- and offstage personae. It looks in particular at the way in which formal attire, specifically suits and military dress uniform, challenges or conforms to expectations about how artists and performers dress. The examples discussed include the suits and bandsmen's uniforms worn by The Beatles, illustrating the fashion for military dress adopted by rock stars as a counterculture statement, and the tailored profiles of artists whose appearance is at odds with their work: poet John Cooper Clarke, artists Gilbert & George, and boxer Chris Eubank Senior.

The cover of the 1967 Beatles album *Sgt. Pepper's Lonely Hearts Club Band* contrasts two eras of the band's style and the two styles of clothing under consideration in this chapter. In the centre of the cover John Lennon (1940–1980), Ringo Starr (1940–), Paul McCartney (1942–) and George Harrison (1943–2001) are resplendent in brightly coloured satin bandsmen's uniforms sourced from theatrical costumiers Bermans, a firm that initially specialised in military tailoring before expanding to encompass the world of entertainment.[1] They are clearly in 'costume' rather than everyday attire, and they are also in character: no longer The Beatles, but Sgt. Pepper's Lonely Hearts Club Band. Immediately next to them are wax figures borrowed from Madame Tussauds showing the group in an earlier, 'Fab Four' incarnation, soberly suited with matching moptops. These clothes are much more in keeping with everyday dress, blurring the distinction between the band as individuals and as characters performing the role of The Beatles. The bandsmen personae hark back to an earlier age of entertainment, recalling the Edwardian era through their long-length jackets and luxuriant moustaches. In keeping with the album's fusion of past and present, the military

dress appears to acknowledge the then-contemporary fashion for adopting its more flamboyant elements as everyday wear, taken, in this case, to a fantastic extreme. These are not real uniforms that a military band would wear in combat; they are too brightly coloured, too extravagantly frogged and braided, too shiny. The composition of the cover juxtaposes the conservatism and 'reality' represented by the suits and the peacock flamboyance and performative nature of the band members' roles represented by the uniforms. This extreme example is a salutary reminder that people are always performing a role, whether they are in uniform, fancy dress or everyday attire. Sometimes the costume that helps create the role is obvious; sometimes it is hidden in plain sight as ordinary or everyday dress. In the case of all the individuals discussed here, their offstage dress is part of their performance of the role of rock star, artist or celebrity in the public eye, and their style is an integral part of their brand.

The career of The Beatles is book-ended by suits. For a short period they wore the all-black-leather look espoused by Gene Vincent, before coming under Brian Epstein's management in 1962 and adopting the more conventional attire of pop stars of the day – the suit. In common with other bands at the time, they dressed formally. Recalling his time playing with the Isley Brothers, Jimi Hendrix noted: 'we had white mohair suits, patent leather shoes and patent leather hair-dos'.[2] By 1962, the so-called 'Beatles suit', comprising collarless jacket with tapered trousers, was a highly desirable item. The style was originated by Pierre Cardin (1922–), but The Beatles wore copies designed by Manchester-born D. A. 'Dougie' Millings (1913–2001), self-proclaimed 'tailor to the stars', pictured here with the band dressed in 'Beatles suits' (fig. 64). As Nik Cohn notes, the fame of The Beatles revived the fortunes of the style, but did little to line the pockets of either Cardin or Millings because of the difficulty of copyrighting design.[3]

By the time they released *Abbey Road* in 1969, the band were a long way from the solidarity expressed through matching suits and haircuts. Their creative and personal differences were evident in the outfits they chose for the cover. They are

64 The Beatles with Dougie Millings, 1960s. Photograph by Harry Hammond.

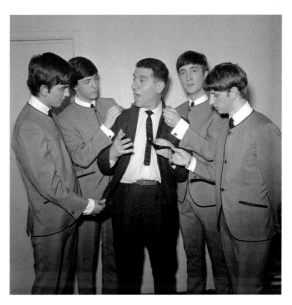

Dandy Style

shown travelling in the same direction over the zebra crossing, but their clothes suggest diverging paths. At the back, a grim-faced George wears a denim shirt, flared jeans and desert boots; in front of him Paul is modelling laid-back conservatism in a double-breasted navy blue suit with loose cut trousers and a light blue shirt, but no tie, and bare feet. [4] Ahead of him is Ringo, dressed in a long-line Edwardian-style black jacket with straight trousers, a white shirt, a cravat instead of a tie, and boots with a Cuban heel that echo the elastic-sided Anello & Davide boots the band wore with their 'Beatles suits'. At the front is John in a white suit, white lace shirt and white plimsolls. Tommy Nutter, one of the tailors behind the reinvention of Savile Row as a destination during the 'Peacock Revolution' of the mid-1960s, claimed to have designed all three suits. Like Millings, Nutter had a reputation as tailor to the stars; his business was backed by Cilla Black and he later counted Ringo Starr, Mick Jagger and Elton John among his clients. The provenance of the *Abbey Road* suits is unclear (some credit Ted Lapidus with Lennon's white suit, while others credit Nutter's partner Edward Sexton with John and Paul's), but what is clear from this image is the creative divergence of the band expressed by their clothes.[5]

The disciplined tailoring of the suit has, at various points in the late twentieth century, offered performers, entertainers and sportsmen a way of drawing attention to the discipline required of them in their professional lives: juxtaposing form and content. John Cooper Clarke and Gilbert & George are renowned for creating and performing work that explores and satirises life in all its messiness and complexity. Chris Eubank's boxing career in the ring was characterised by his composure, discipline and endurance and, out of the ring, he was renowned for dressing and behaving eccentrically (wearing three-piece tweed suits, sporting a monocle and a cane, and speaking with a lisp). For all four of them, the suit is a projection of intent and disruption: they mean business and that business is to challenge received notions of how artists, poets and heavyweight boxers dress and behave. Contemporaries of The Beatles in terms of age (Gilbert was born in 1943 and George in 1942), Gilbert & George explained to one interviewer that, as war babies, 'we felt that we were poor people and if it's an important occasion, if you try to get a job or if you go to a wedding or funeral, you dress up nicely'. Their tailored appearance, while making them extraordinary among artists in their early careers, made them 'completely normal' outside the art world.[6] They expressed their preference for formal dress in their 1969 manifesto, *The Laws of Sculptors*, which begins: 'Always be smartly dressed, well-groomed, relaxed and friendly; polite and in complete control. Make the world believe in you and to pay heavily for this privilege.'[7] Throughout their joint career they have favoured single-breasted, three-button jackets, sometimes pinstripes and sometimes tweed (fig. 65). The most striking change has been in the cut of trousers (always with a turn-up), which has widened over time. As long-standing residents of Spitalfields, the centre of London's rag trade until the 1970s, they claim to use local tailors, although their outfits look as if they hail from a gentlemen's outfitter.[8]

The contrast between Gilbert & George's appearance and the artefacts they produce is key to their articulation of the practice as performing sculptures, which is inseparable from the artefacts. One of their early self-portraits consists of two

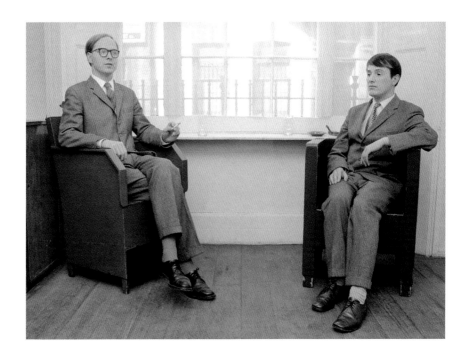

65 Gilbert & George in
Fournier Street, London,
10 August 1972.

photographs, placed side by side, in which they wear suits and ties, complete with
buttonholes and pocket squares, and recline on the grass as if fresh from a wedding,
but with 'George the Cunt' and 'Gilbert the Shit' in cut-out white letters across their
respective chests. The juxtaposition between the clothes and the lettering is typical of
their oppositional style. As they have aged, this contrast between their conservative,
apparently benign, appearance and the topics they address has become more pro-
nounced. The contrast is particularly evident in promotional pictures for their 2016
show *The Banners*, in which the pair, dressed in tweeds, are photographed between
works that read 'Gilbert and George say . . . Burn that Book' and 'Gilbert and George
say . . . Fuck the Planet'.

Former world champion middleweight boxer Chris Eubank Senior's adoption of
tweeds is, he claims, without irony or conscious provocation. A man whose wealth
and reputation were made through the bloody and violent business of receiving and
inflicting physical damage, Eubank sustained his dandy pose throughout his boxing
career (1984–98). He made his home in Brighton, as did the original dandy, Beau
Brummell, but where Brummell modelled restraint, Eubank adopted a more flam-
boyant approach. He acquired the title of Lord of the Manor, a capacious wardrobe
of tweed and pinstripe suits, jodhpurs (comfortable and practical, he says, because
of his muscular thighs[9]), a bowler hat, a cane and a monocle, and became renowned
for driving round his adopted town in a stretch Humvee and talking with a lisp. In
2010, Eubank began a collaboration with tailoring firm The Cad & the Dandy, and
has since routinely teamed formal jackets and shirts with the denim jodhpurs he
designed for them (fig. 66). Despite the ridicule directed at Eubank's flamboyant
dress, 2019 witnessed a fashion for jogging bottoms that aped the distinctive shape of
his favoured jodhpurs: baggy round the thigh and tight from knee to ankle. Regardless
of the apparent lack of guile with which Eubank adopted the dress, accessories and

Dandy Style

speech of the white British upper classes, the appropriation of this style by a black sportsman born into the working class and elevated by his efforts in the boxing ring is a subversive act, as was Jimi Hendrix's adoption of British military dress uniform, discussed below.

Salford-born poet John Cooper Clarke (1949–) shares Eubank's interest in tailoring, but his style is as different from Eubank's as his silhouette and profession. Rake thin in tight, dark trousers (originally drainpipe jeans, more recently jeggings), a tailored jacket, pocket square and skinny tie or cravat, topped with a spiky black *coupe sauvage*, Cooper Clarke's appearance is as superficially oppositional as Eubank's is superficially old-fashioned (fig. 67). He claims to have come to his tailored silhouette through chance encounters with 'a fella called Tom who had a similar figure, with the long thin legs . . . he used to wear these great styles and I asked him where he got them. And he told me he made them himself'.[10] 'Tom' is Savile Row-trained bespoke tailor Sir Tom Baker (his shop opened in 1996). In a long conversation on Cooper Clarke's BBC 6 Music programme 'The Suit', the pair discussed the latter's preference for jeans over suit trousers ('for extra support' and for the half-moon pocket), and boots over shoes (socks should be hidden).[11] Like Millings and Nutter,

66 Chris Eubank outside ITV Studios, 6 June 2016.

67 John Cooper Clarke at the Royal Festival Hall, London, May 2011. Photograph by Marilyn Kingwill.

67 John Cooper Clarke at the Royal Festival Hall, London, May 2011. Photograph by Marilyn Kingwill.

Baker has a client list that includes the rich and famous, but whereas Millings's and Nutter's clients moved from suits to less formal clothes, many of Baker's are moving in the other direction, swapping the hippie style of the 1970s for the more structured form of the suit or tailored jacket.

This chapter began by looking at the military bandsmen's uniforms sported by The Beatles on the cover of *Sgt. Pepper*, and returns to uniform now to provide a brisk survey of counter-culture's fascination with the military dress jacket. The term 'dress' refers to the ceremonial version of the uniform (drawn from earlier versions of military dress), as agreed and regulated in Britain by the Army Dress Board. This typically includes red or blue tunics, gold braid, buttons, epaulettes and frogging, and elaborate headgear. In 1948, as the services were considering the future of 'dress uniform', James Laver predicted that 'the uniforms will continue to exist, paradoxically, as the costume of a soldier *when he is not fighting*'.[12] Laver distinguishes three primary principles of male military dress: seduction, hierarchy and utility. Seduction influences shape and design, 'widens the military man's shoulders, narrows his hips, puffs out his chest, lengthens his legs and emphasises his apparent height'.[13] Hierarchy establishes social position or chain of command. Utility, as the word suggests, is supposed to aid movement and agility. In the case of most dress uniforms, Laver's prediction has come true. They are so elaborate in terms of decoration, tightness

and weight, that they impede movement and speed rather than enhance it. The decorative takes precedence over the utilitarian, as illustrated by the satin material and candy colours of the *Sgt. Pepper* costumes.

McCartney describes how the band visited Bermans to pick out their outfits for the album cover and decided on 'bright psychedelic colours' to 'go against the idea of uniform'.[14] Or perhaps more accurately, against the idea of militarism. The *Sgt. Pepper* costumes still observe the use of decoration to indicate hierarchy – the band members are dressed similarly enough to appear part of the same ensemble – but the different colours and styling of the uniforms and headgear leave space for interpretation as to their function and status. Ringo's jacket has the sergeant's insignia on the sleeve, suggesting that he might be the eponymous sergeant of the album's title. According Ringo leadership of the fictional 'Lonely Hearts Club Band' is another sign of the album's topsy-turvy world view. In the real world, the drummer had little creative agency compared to his bandmates; in the fantasy, he is the leader and the singer.

While The Beatles were dressing up as pretend soldiers, other prominent musicians were buying vintage military dress from Army Surplus Stores and the London-based boutique I Was Lord Kitchener's Valet. Guitarist Eric Clapton (1945–) and Rolling Stones singer Mick Jagger (1943–) were among the first to buy elaborately decorated tunics. Jagger chose a red Grenadier Guardsman's drum major tunic and wore it on *Ready Steady Go* in 1966. According to Robert Orbach, co-owner of the boutique, 'the next morning there was a line of about 100 people wanting to buy this

68 Colin Jones, 'Mick Jagger', 12 March 1967. Iris print. National Portrait Gallery (x134829).

tunic … and we sold everything in the shop by lunchtime' (fig. 68).[15] In the same year, Clapton appeared on stage with Cream in Paris wearing a navy blue military jacket with silver buttons on the shoulder and cuff. Elsewhere, he is seen posing in a black dress jacket with a red and black insignia on the collar and black frogging, over a pink shirt, with a large elongated Maltese cross round his neck.

The seduction principle of lithe young men in tight-fitting, beautifully tailored and elaborately decorated jackets is evident not only in the speed at which the uniforms sold out, but also in the passion these artists inspired, and continued to inspire, in men and women. There is also an element of the hierarchy principle at work here: before they became popular, appearing in these tunics marked out their wearers as distinctive fashion icons, which helped sell records and concert tickets. Their lack of utility to acting servicemen meant that these jackets soon became ubiquitous because there was a large stock of them available for purchase: Robert Orbach and John Paul, co-owners of the Lord Kitchener boutique, got theirs from Moss Bros and the Army Surplus Store. In addition to the relationship between this appropriation of the past, and the disregarding of past hierarchies it entailed, we can also discern another effect, which Elizabeth Wilson identifies as 'oppositional', and this is most clearly identified in the reaction to Jimi Hendrix wearing military dress.[16]

Hendrix (1942–1970) had at least two military tunics, a Hussars dolman tunic in which he was frequently photographed, and also a nineteenth-century-style Royal Army Veterinary Corps dress tunic. At least one source suggests that a group of policemen once demanded that Hendrix remove the RAVC jacket as he was dishonouring the men of the regiment,[17] but (as with many stories about figures from this period) the same tale is also told about the Hussars tunic.[18] What is noteworthy is the lack of anecdotes about Clapton, Jagger or other stars experiencing the same treatment. Hendrix's flamboyant styling of these military jackets alongside the colour of his skin and natural hair immediately brings an edge to his appropriation of the clothes of the Establishment, in a way that his white contemporaries' wearing of them does not. Unlike them, he was not British, but he had been in the armed services. Although he may be in 'costume' in Laver's sense, Hendrix does not look like a child with a dressing-up box, but rather like a man making a statement about who controls his look and story, and who will never again be forced into the matching outfit he wore while performing with the Isley Brothers. Pictured in 1967 with his bandmates from the Jimi Hendrix Experience, he dominates the frame as he points a gun squarely at the viewer, his arm fully extended, whereas his bandmates, Mitch Mitchell (1946–2008) and Noel Redding (1945–2003), hold their arms closer to their bodies (fig. 69). Wilson defines oppositional fashion as that which 'aims to express the dissent or distinctive ideas of a group, or views hostile to the conformist majority', a hostility that is palpable in this photograph.[19]

Punk style emerged as another form of oppositional fashion in the mid-1970s with Vivienne Westwood and Malcolm McLaren's shop Seditionaries providing 'the sartorial identity of the punk movement'.[20] Among its customers was Adam Ant (1954–), who hired McLaren to manage his newly formed band Adam and the Ants. The professional association was short-lived but Ant, like McLaren and Westwood, was both

stylish and committed to challenging accepted notions, including what punk should look like. He located his style in a desire to be oppositional and to challenge the status quo, but also searched for a more gorgeous take on punk's anarchic attitude: 'I wanted to be like a King, not just some guy hanging on the corner moaning about everything and spitting, and wearing safety pins.'[21] For the cover of their 1980 single 'Kings of the Wild Frontier', Ant hired the Hussar tunic that David Hemmings wore in the film *The Charge of the Light Brigade* from theatrical costumiers Bermans & Nathans,[22] and wore it with a white stripe painted across his nose as 'a declaration of war against all that kind of nonsense in the music business and the political stuff I didn't like'.[23] The single was a hit, and it was followed in 1981 by the single 'Stand and Deliver', which begins: 'I'm the Dandy Highwayman'. On the cover of the record Ant wears a cloak, tricorn hat and cream waistcoat frogged with gold braid. Because of these striking costumes (adopted by the whole band), the group's legacy is as much a product of their costume aesthetic (billowing white shirts, tight leather trousers, knee-high boots and cutaway jackets) as their music.

For rock stars, appropriating historical, elite uniform has become a way of challenging conformity and hierarchy, flouting its dress codes to indicate their liberation from social mores. In their conformist appearance, Gilbert & George and Cooper Clarke are also engaged in a form of oppositional dress, in their case challenging notions of what artists and poets look like and flouting the association between 'untidiness' and 'an artistic calling' that Wilson traces back to the nineteenth-century bohemian fashion for 'dishevelled beauty'.[24]

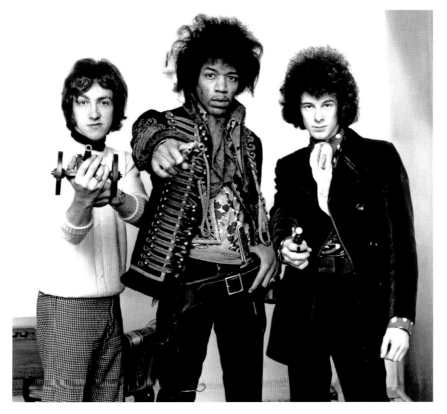

69 Jimi Hendrix Experience, April 1967. *Left to right*: Mitch Mitchell, Jimi Hendrix and Noel Redding.

6

Extravagance and Flamboyance: Decorated Men's Fashion

Miles Lambert

For most of the eighteenth century, as in many earlier periods, the fashionable man dressed as resplendently, as ornately and as extrovertly as his female counterpart. Ostentatious – or indeed unostentatious – display can be explained as an expression of the unconscious self. Explicit and extravagant display by a man (or woman) reveals, perhaps, a latent desire to project personal messages, or to be noticed. What might be communicated can vary: self-confidence, self-expression, personal taste, conspicuous consumption.[1] In the ongoing seesaw between ostentation and sobriety in male dress, there have always been those commentators who regretted their particular context. John Carl Flügel, for instance, lamented the choice of his fellow men in the early twentieth century to dress soberly, calling it the 'Great Masculine Renunciation', and forcefully advocating far more use of colour and decoration.[2] This coloured and decorated 'peacock male' is, of course, the historic archetype considered here and identified as 'The Splendid Man' in the Los Angeles County Museum's 2016 exhibition, *Reigning Men: Fashion in Menswear 1715–2015*. 'Splendid' is then subdivided into sections exploring four showy, decorative styles: 'Glitz', 'Animal', 'Floral' and 'Colour'.[3] The introduction to the catalogue contends that in the past 'Superfluities . . . were once commonplace in men's dress – such as sparkling paste (glass) stones and sequinned embellishments, animal furs, floral patterns, and vividly coloured textiles.'[4] Indeed, it is perhaps difficult not to be seduced by ornamentation and ostentation in any long-term analysis of men's dress. The National Gallery of Victoria's catalogue for a slightly earlier exhibition, *ManStyle: Men and Fashion* (2011), included a chapter entitled 'Decorated Man: Extravagance and Display', in which it concluded that 'the metaphorical male peacock has always advanced a particular reading of fashionable

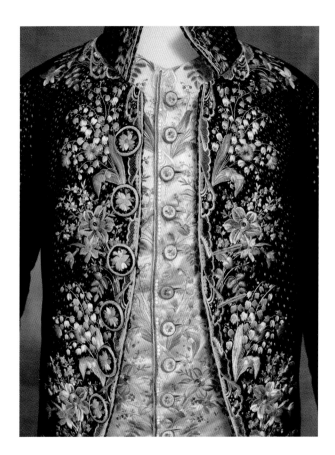

70 Detail of embroidered court
suit, 1770–85. Manchester Art
Gallery (1952.359).

masculinity based on ostentation'.[5] Highly decorated, somewhat stiff and relatively unfitted clothing remained the norm until the late eighteenth century, and often such garments manifest considerable presence, almost independent of the wearer: 'the beauty of the costume, not the man' as Anne Hollander puts it.[6] What changed from around 1800 was the adoption of careful, precise, tailored fit with little embellishment, emphasising and encompassing the human figure. Modern men's tailoring had arrived.

Embroidery represented the most costly, and thus most elite, of decorative techniques, long established and prescribed for male court wear. Often the work of professional French embroiderers, in the eighteenth century it could be breathtakingly elaborate, naturalistic and colourful. Costume collections include disproportionate numbers of these bold court coats and suits because they look too remarkable and decorative to throw out, and because, if they have survived the rigours of the subsequent fancy dress ball or the 'dressing up chest', they have had relatively little heavy wear. Some of the examples are breathtakingly beautifully stitched, with naturalistic coloured flowers embroidered lavishly over the fronts of the coats in deep broad curving borders reaching well across the chest and with deep borders to the cuffs. The associated waistcoat was usually embroidered similarly with a sympathetic and matching, but not identical, design, providing further creative opportunity. Indeed, waistcoats remained the preferred garment for lavish decoration well into the nineteenth century. Such ensembles were intended to inspire

careful examination and admiration (for the embroidery is most intricate) while also demonstrating a clear aristocratic social superiority (fig. 70).

Embroidered outfits could be even more visually arresting when contrasting colours were utilised in the body of the coat and in the costly, exuberant embroidery. The most extreme and mannered British male fashionistas in the 1760s and 1770s were dubbed *macaronis* to indicate a form of 'ultra-fashionable dressing' within an urban and privileged context.[7] Having, in many cases, experienced the continental 'Grand Tour', these men returned home seemingly seduced by all things Italian, including macaroni pasta. Their costume silhouettes were deliberately narrow and sharply fitted, paired with towering hairstyles; decorative emphasis was on block colours rather than on pattern; and when embroidery was employed, it was often supremely delicate and finely professional. Surviving examples are striking: a green and pink silk suit features in the Los Angeles County Museum of Art's *Reigning Men* catalogue, directly matching a fashion plate. The Fashion Museum at Bath has a silver satin coat and waistcoat with breeches in pink.[8] Shown here is a not dissimilar purple silk satin suit with contrasting ice-green satin cuffs, silk lining and waistcoat (fig. 71).[9] It has a provenance from the Earl of Buckinghamshire's family, possibly, in this case, John Hobart, the 2nd Earl. He was Lord Lieutenant of Ireland from 1776 to 1780, which is approximately the date of this suit. It makes a dramatic, almost provocatively over-blown statement, while also exhibiting a meticulous, stylised floral design, created with cream and purple satin appliqué under net and coiled copper thread (fig. 72).

Embroidery as skilled as this elicits admiration and even astonishment from a contemporary audience, and thus provides a rich source of creative inspiration for designers. Gianni Versace was celebrated for his love of extravagant printed patterning, beaded trimming and bold imagery, but he was also keen to plunder historical

71 (*left*) Purple and green silk satin suit with embroidery, 1770–85. Manchester Art Gallery (M6441).

72 (*right*) Detail of embroidery on purple and green silk satin suit (fig. 71).

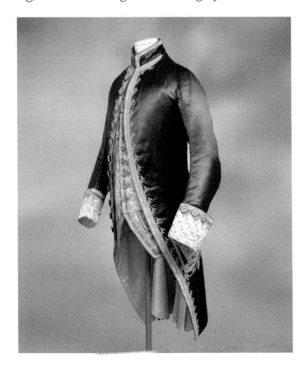

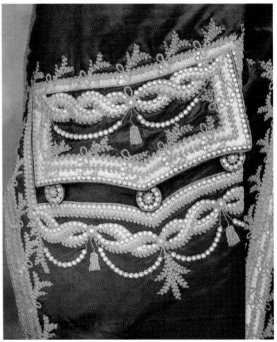

73 (*left*) Alexander McQueen
black woollen coat with
embroidery, Autumn/Winter
1998–9. Manchester Art Gallery
(2018.7).

74 (*right*) Detail of Alexander
McQueen coat (fig. 73).
Manchester Art Gallery (2018.7).

75 (*opposite*) Purple woollen
frock coat, France, 1780–90.
Manchester Art Gallery
(1954.965).

styles. A coat acquired by the art collector, Mark Reed, and now at the Fashion Museum in Bath, has trailing coloured embroidery down the front skirts, clearly mimicking eighteenth-century pieces (see figs 39 and 40).[10] Alexander McQueen (1969–2010) was better known for his frequent referencing of historical styles, and naturalistic embroidery was a favourite; he affirmed, 'There is no better designer than Nature.'[11] Long coats, blazers and jackets are embellished with floral embroidery encircling the neck or brashly emblazoning the skirts. In his Autumn/Winter 1998–9 collection he included striking bird motifs on the front skirts in the form of pairs of love birds or Oriental fighting cocks (figs 73 and 74).[12] Apart from John Galliano (1960–), few recent designers have been able to create more bedazzling, more 'Baroque' catwalk outfits than McQueen, whose male models could appear quite as flamboyant, and often bizarre, as the female.

The long-established impulse towards male fashionable flamboyance came under increasing challenge from the middle of the eighteenth century. The simple, tailored, woollen frock coat worn for fashionable outdoor dress from the 1760s and 70s was adopted as a symbol of British democracy and a refreshing 'egalitarian' change from French ostentation (fig. 75). This style also caught on in pre-revolutionary France as a reaction to the corruption, extravagance and authority of the old guard. In London, Beau Brummell also circumvented this prevalent aristocratic love of conspicuous consumption and embellishment, and his sartorial ethos reflected and promoted the earlier restraint that had begun in England. As early as 1806, the British fashion magazine, *Le Beau Monde*, illustrated a male figure dressed in 'Fashionable Morning Walking Dress' comprising, in essence, Brummell's exemplar of a plain woollen single-breasted frock coat, waistcoat, pantaloons and 'Hussar' boots (fig. 76).[13]

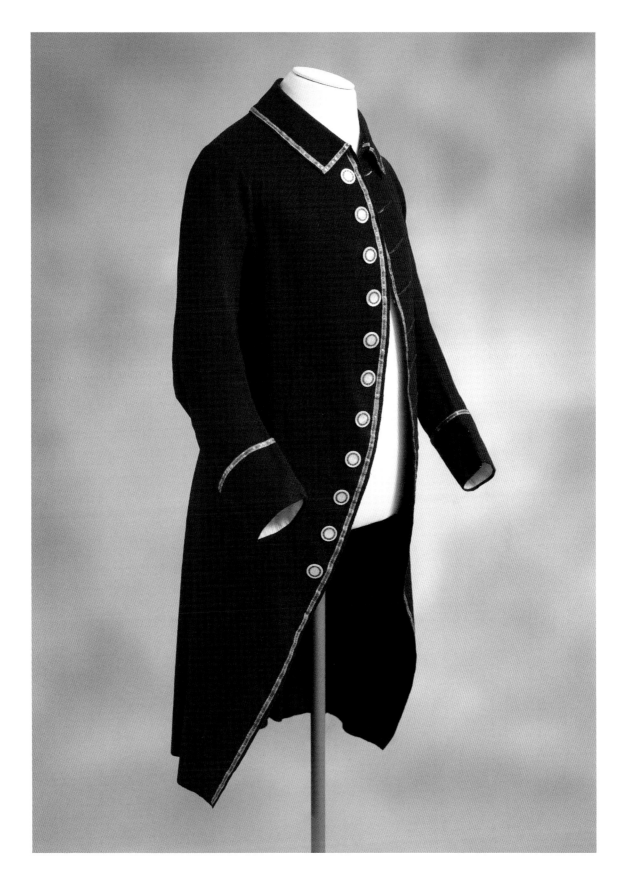

In the wake of Brummell's self-publicised example, many of the excesses of decoration and display did decline during the nineteenth century: black and navy became ascendant colours in a drive towards sobriety and respectability. John Harvey's celebrated work, *Men in Black*, concluded that the nineteenth-century male wardrobe spiralled ever further into a dull and drab dreariness: 'Dickens, Ruskin, Baudelaire all asked why it was, in this age of supreme wealth and power, that men wanted to dress as if going to a funeral.'[14] By the 1840s, certainly, coats were often plain black, brown, green or navy, and outfits were becoming increasingly sober. However, personal taste still played a considerable role in choice of colour, as evidenced by some unusual surviving coats: a dark beige, beaver-wool frock coat from the 1830s at the Victoria and Albert Museum has a bold, contrasting chocolate-brown collar and trim; while a tailcoat from the 1840s at the Fashion Museum Bath is made of a striking mint-green facecloth (fig. 77).[15] Numerous fashion plates also attest to the endurance of variety into the 1850s, with pattern as popular as ever. Trousers, and waistcoats in particular, retained stripes, checks and patterning into the 1860s and 70s, seemingly shunning plainness (figs 78 and 79). Many vibrantly woven, printed and embroidered waistcoats

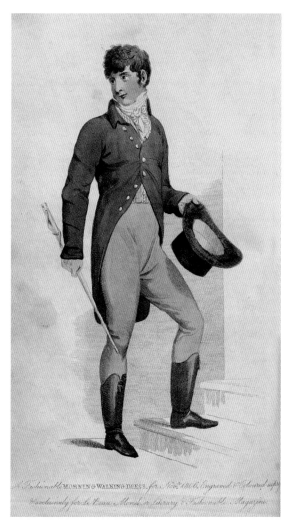

78 Hand-coloured plate from *Gentleman's Magazine*, January 1854. Manchester Art Gallery.

from the 1840s and 50s are arrayed in the early daguerreotype or ambrotype photographs from this date (figs 80 and 81).[16] Rather like the 1980s and 90s City worker, pairing a coloured, patterned tie with his dark blue or grey suit, the Victorian businessman long retained a link to his showy forebears through his decorated waistcoat. He also dressed flamboyantly in a domestic context, sporting brightly embroidered slippers, or smoking caps with fanciful tassels, often made as gifts by wives or sisters. Dispensing with his plain woollen coat when arriving home, he looked to a long-established eighteenth-century *banyan* tradition, donning a bright silk damask or printed cotton gown and relaxing to receive guests, his appearance both elegant and exotic (figs 82 and 83).[17]

At various later periods, almost measurable in steps of a single generation, fashion for men revisited an earlier ostentation. Rebellious artistic figures and devotees of the Aesthetic movement in the 1880s and 1890s, typified by Oscar Wilde, sported deliberately unstructured velvet suits, both tactile and sensory. They revelled in military-inspired frogging and braiding, subverting the seriousness of army uniforms, and also circumvented traditional precepts by creating and wearing costume with deliberately 'feminine' decoration, such as floral embroidery or painting (fig. 84).[18]

The 'bright young things' of the interwar period, a generation later, also flirted with flamboyant dress, androgynous styling and dress reform.[19] The Men's Dress Reform Party (MDRP) was founded in 1929 to 'beautify' men.[20] Campaigns were launched by the MDRP to encourage men to ditch the still ubiquitous three-piece woollen suit, and to choose instead looser jackets and shorts without waistcoats;

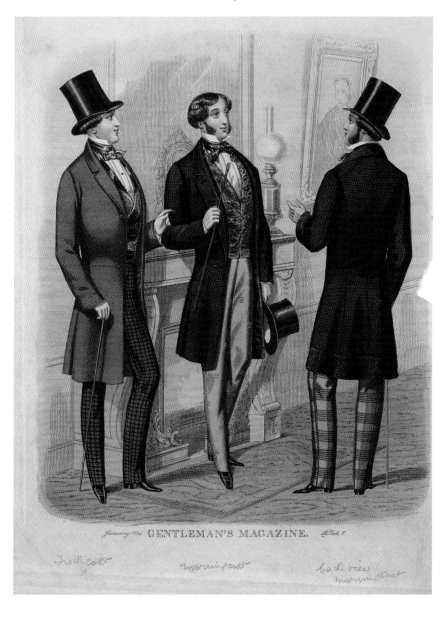

GENTLEMAN'S MAGAZINE.

80 (*top*) Daguerreotype
photograph, undated (c.1840s).
Manchester Art Gallery
(2008.40.1.29).

81 (*bottom*) Ambrotype
photograph, undated (c.1840s).
Manchester Art Gallery
(2008.40.2.174).

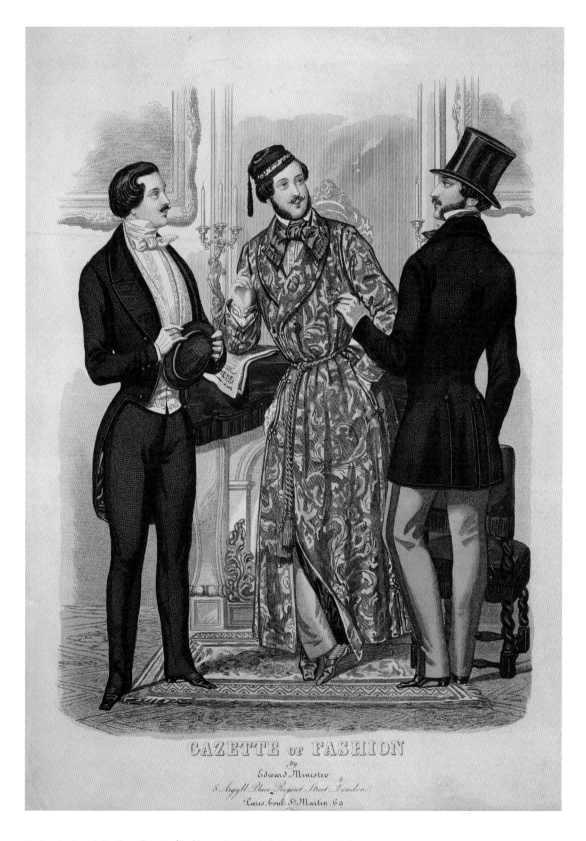

GAZETTE of FASHION
by
Edward Minister
8 Argyll Place Regent Street London
Paris, boul St Martin, 69

82 Hand-coloured plate from *Gazette of Fashion*, undated (c.1850). Manchester Art Gallery.

83 Silk damask dressing gown, 1840–60. Manchester Art Gallery (1948.39).

to select shirts in soft lightweight fabrics such as chiffon or fine poplin and in bolder colours such as navy or dark blue; and to try patterned jumpers and knitted 'sports shirts' with turn-down tennis collars à la Fred Perry (see Chapter 7). Society figures such as Noel Coward, Cecil Beaton and Stephen Tennant played with portraiture and self-image, pushing the parameters of acceptable dress. Beaton (1904–1980), for instance, was photographed (and photographed himself) in a range of poses: as an eighteenth-century courtier; as the Prince Regent; as a Hollywood star, covered in attached portrait photographs; as a mannequin in a mock shop window surrounded by props; or as himself in carefully chosen, softly draped, 'artistic' fashion (fig. 85).[21]

The 1960s saw another generational revolt against social norms and restrictions, and towards more imaginative dress. The title of Geoffrey Aquilina Ross's revealing analysis of the decade 1963 to 1973, *The Day of the Peacock*, sums up the London menswear fashion revival of the 1960s.[22] These new peacocks looked to the past for inspiration: shirt frills and ruffles; bold Rococo woven patterns; frogging and braiding from military uniform (see fig. 68); aristocratic demeanour and deportment. In this 'Peacock Revolution', colour and pattern were allowed far freer reign.[23] The mod, appearing from about 1960, sported sharply styled suits in a new incarnation of distinctive dress, influenced by lightweight, crisp Italian tailoring, sometimes again

in startling bright colours. Burgeoning teenage income and the popularity of such pop groups as The Who spread the movement countrywide, and a dedicated mod could be as obsessive as Beau Brummell, spending hours in front of the mirror each morning, refreshing shirts and underwear several times a day, and having suits and shirts hand-made in Jermyn Street. As Nik Cohn wrote of the movement, 'in its single-mindedness, shamelessness and snobbery, this was in the true Brummell tradition'.[24]

In London, fashionable boutiques and independent tailors sprang up in the mid-1960s, selling a range of stylish, flashy, irreverent clothes. The King's Road and Carnaby Street flaunted establishments run by John Stephen, Michael Fish, Malcolm Hall, Tom Gilbey and Tommy Nutter, which were joined by boutiques such as Granny Takes a Trip, I Was Lord Kitchener's Valet, Take 6 and Mr Freedom. Short-lived shops, including The Beatles' Apple Boutique and the aptly named Dandie Fashions, burst onto the scene and as quickly departed.[25] Michael Fish (1940–) opened his epony-mous shop in Clifford Street in 1966 at the height of this male fashion renaissance, intending from the outset to be outrageous and triumphing because of it: 'His shop was a holocaust of see-through voiles, brocades and spangles, and miniskirts for men, blinding silks, flower-printed hats.'[26] The bright, bold, strident colours of the 1960s can also be interpreted as a glance back to the confidence of the Georgian period.

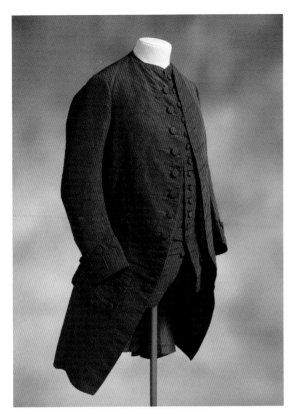

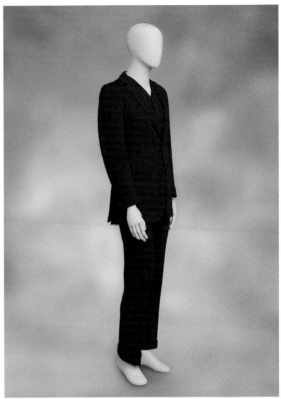

86 (*left*) Red ribbed silk suit, 1760–80. Manchester Art Gallery (1954.960).

87 (*right*) Take 6 red woollen jersey suit, 1969–70. Manchester Art Gallery (1997.16).

88 (*opposite*) *Daks & the New Men*, shop brochure, undated (late 1960s). Manchester Art Gallery.

A Take 6 plain, cherry red suit of 1969–70 is no less arresting than a similarly hued silk suit of exactly two centuries earlier: each is eye-catching, unapologetic and distinctive (figs 86 and 87).

Published magazines began to proffer regular fashion advice for men, perhaps fostering, and reflecting, a new flamboyance and confidence. Sunday colour supplement magazines for the *Telegraph*, the *Observer* and *The Times* featured menswear from as early as 1962, and *Men in Vogue* published issues sporadically from 1965.[27] *Men in Vogue* for November 1965 included an editorial on 'The Sharp Dresser', which stated that the Englishman 'now likes clothes so much that he may once again qualify to be the Best Dressed Man in the World'.[28] Christopher Gibbs, Nigel Lawson, James Astor and Cecil Beaton were among the stylish men featured. A later 'special report' looked at 'New Clothes This Winter', photographed on actors Corin Redgrave and Edward Fox, and promoting sharp tailoring from the Trend shop at Simpsons of Piccadilly, Herbert Johnson, John Michael, Lord John and CUE at Austin Reed.[29] The Paris fashion designers Pierre Cardin and Ted Lapidus (1929–2008) were also featured in this magazine, as was a Shopping Guide by Christopher Gibbs, which looked at 'the most beautiful, extraordinary, most edible, drinkable and wearable things in the shops'.[30] Alongside fashion magazines, trade or shop catalogues proliferated in the 1960s. Burton Tailoring issued a new 'catalogue by post' service for Spring/Summer 1965.[31] Other long-established firms, such as Daks, printed smart, well-designed brochures (with fashion drawings and no prices). One, titled *Daks & the New Men*, asked: 'Are you one of the New Men . . . the leaders of a growing trend? A trend towards quality.

DAKS
REGD

& The New Men

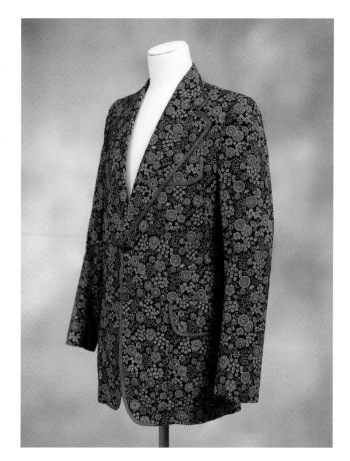

89 (*right*) Ted Lapidus floral printed cotton jacket, 1973–4. Manchester Art Gallery (2014.41).

90 (*opposite*) Vivienne Westwood printed cotton suit, 1993 *Grand Hotel* collection. Manchester Art Gallery (2013.39).

A search for individuality.' It promised readers 'a greater emphasis on colour', assuring them that 'bold designs are back in favour . . . colours are lighter and brighter, with effective contrasts' (fig. 88).[32]

From the later 1960s, printing was widely introduced as an innovation for men's suits and jackets, often on lightweight cotton, silk and man-made fibres, which, unlike wool, could be readily printed. Dramatic all-over patterned jackets and shirts, often in multi-hued floral or geometric prints, transformed the fashionable wardrobe, further helping men to rival women in spectacle and swagger (fig. 89). Vivienne Westwood's collections have continued this love affair with bold print, her creations using painterly prints inspired by toiles de Jouy cottons, or most dramatically by the Rococo oil paintings of François Boucher (1703–1770). In her *Grand Hotel* collection of Spring/Summer 1993, a print based on Boucher's *Hercules et Omphale* (1732–4) was carefully cut to show the couple kissing on the back of every jacket (fig. 90).[33] Influenced by the London club scene of which they were a part, 1980s design duo Bodymap made a name for themselves with innovatively cut and exuberantly patterned garments in cotton and viscose-Lycra. Staying with print, but in a calmer fashion, the asymmetric striped print on their 1990 jersey jumpsuit echoes the bold blue and white stripes of Breton sailor shirts, which were popularised as casual wear by 1960s men's boutique Vince Man's Shop and had associations with 'social outcasts such as pirates, prisoners and prostitutes, outlaws, gangsters, bikers and beatniks' (fig. 91).[34] As a contemporary

Extravagance and Flamboyance

example of imaginative printed fabrics, and drawing on his grandfather's career in the Navy, young designer Glenn Wigham's (1996–) final degree collection at Westminster University (2019) bricolages images and patterns as a take on First World War dazzle-camouflage. His boiler suit, when combined with other layers of garments, creates a noisy surface that subverts the working militaristic heritage of such outfits (fig. 92).

Menswear retained a certain, though not universal, bluster into the twenty-first century, largely driven by street culture, and it now has an established confidence in a vigorous, unapologetic, multicultural context. A man's choice of fashion is individually interpreted with a lexicon and visual vocabulary relevant to a whole range of environments. Designers, media and social commentators, and artists can each shape the fashion scene. Influential figures, often working in London but with a dual heritage, include designer Samson Soboye and artists Yinka Shonibare and Hassan Hajjaj. The Moroccan-born artist and photographer Hajjaj (1961–) grew up immersed in the London club scene of the 1970s and 80s, and now works largely in London. Teasingly dubbed 'the Andy Warhol of Marrakesh', he is perhaps best known for his vibrant photographic portraits, which position models dressed in multicoloured, patterned clothing in front of equally bold, but contrasting, fabric backdrops, with gutsy framing of, for instance, tin cans or thick woven raffia. Shonibare (1962–), a British-Nigerian artist, has derived considerable creative inspiration from a self-conscious reinterpretation of the term 'dandy', specifically in his 2004 *Diary of a Victorian Dandy* series. In an interview that year, he explained his approach: 'What I like most about the concept of the dandy, is that it is the masquerade par excellence.

It is a disguise where you appear to be a member of the aristocracy, but you are always on the outside.'[35] Soboye (1965–), a British-Nigerian designer who established his eponymous brand in Shoreditch in 2002, also creates distinctively African-British fashion revelling in bright, bold patterning, often using West African-inspired printed cottons. He has been quoted as saying that, for him, 'a life is not fully lived if it is not lived in full colour' (fig. 93).[36]

British designers and design teams such as John Richmond (1960–), Christopher Shannon (1981–), Craig Green (1986–), Thomas Tait (1989–) and Sibling (formed 2008) have stimulated new explorations of twenty-first-century embellished male style, experimenting with colour, print and pattern (fig. 94). In an interview in 2013, the celebrated American fashion designer Tom Ford (1961–) selected men in Britain for particular admiration: 'British men are peacocks. You see a lot more style on the streets here than you see anywhere else, on every level.'[37] Bold colour, woven and printed decoration, applied ornament and embellishment, and unusual cutting-edge

94 John Richmond wool and leather biker jacket with hand-painted tattoo designs, c.1988–91. Westminster Menswear Archive, University of Westminster (2019.80).

fabrics and finishes, all keep contemporary British fashionable menswear distinctively dramatic and in the vanguard of change. Avant-garde design labels can have a fragile existence in a cut-throat economic environment (Sibling were forced into liquidation in 2017) but innovation and imagination continue to rejuvenate the industry nonetheless. These themes are discussed in further detail by Jay McCauley Bowstead in the closing chapter of this book.

The fashionable man's clothing purchases have always absorbed his time, attention and income, and the creation of a carefully constructed self-image can be all-consuming. When Nik Cohn looked back on the previous decade of men's fashion in 1971, he concluded by describing a recent visit to Manchester. When he asked a range of male passers-by what their clothes meant to them, one said that he owned seven suits, all from Burtons, and each very carefully chosen and saved up for as a major outlay. 'When I buy a new suit', he stated, 'it's almost like getting a promotion.'[38] The importance of well-made, stylish clothes, of selecting a distinctive individual wardrobe, and of presenting a unique appearance to the world, forms a continuum from the fashionable Georgian man's mannered milieu and from Brummell's more individual sphere, to our own brash and frenetic world. The fiercely independent, self-aware, contemporary male peacock can stride along the catwalk or the urban high street as confidently as his predecessor once flaunted himself in the Georgian Assembly Rooms and spa towns. The social context has transformed, but the cultural, aesthetic and personal impulses are comparable.

7

Casual Subversion

Shaun Cole

Much of the writing on British men's fashion and style has discussed the formality of tailored traditions, whether that be the sober and restrained 'man in black' or a more flamboyant, colourful and creative expression. Alongside this formality often sits another, less formal, approach to dressing that has long reflected leisure and sport, the countryside, social class and informal dressing at home; and, more recently, post-war sub- and club cultures. This chapter will address some of the key figures and moments that anchor the emergence and acceptance of a subversion of the formal expectations of men's dress choices over the past 250 years.

In *ABC of Men's Fashion*, his 1964 'dictionary' aimed at young men with an interest in fashion and clothing, the designer and royal couturier Hardy Amies (1909–2003) described 'Casual Wear' in the following manner: 'This is a horrible trade cliché synonymous with leisure wear, but, like many clichés, it is useful for easy communication. It means any sort of clothing that is comfortable without being sloppy.'[1] Thirty years later, Amies noted that while 'casual gear' was a clothing trade term, all clothes that are worn in place of a suit 'should be "casual"'.[2] This is a pertinent statement and draws on an idea that the suit represents formality (set out in Chapter 3), and that all other men's clothing is not formal and, therefore, casual. But how does this idea come to be fixed in Amies's mind, and how does it relate to the supposedly synonymous term Amies used in 1964, 'leisure'?

In her text on men's clothing, published the same year as Amies' *ABC*, Norah Waugh noted that by the late eighteenth century, the English nobility spent 'much of their lives in cloth, buckskin and boots', hunting, riding and racing on their country estates.[3] This form of 'leisure' clothing became favoured over formal dress, except

when at court. The English riding coat was brought to Paris around the end of the eighteenth century, as Anglomania – influenced by Jean-Jacques Rousseau's advocation of a return to nature and the move towards democracy and increasing dissatisfaction with the *ancien régime* – swept the French capital. Farid Chenoune identifies the less formal English style adopted by fashionable Parisians in town, in the countryside and for travelling as 'undress', but this perhaps has a more domestic connotation in a British context, as will be discussed later.[4] This style can be seen in Horace Vernet and Louis-Marie Lanté's engravings of Parisian *incroyables* (see figs 10 and 53), in portraits of landed gentry by Joseph Wright of Derby and Thomas Lawrence (see figs 47 and 51) and indeed in the portrait of the archetypal dandy Beau Brummell (see fig. 1). James Laver has described Brummell's clothes as a smartened version of 'those of the English sporting squire'.[5]

The formalisation of many British sports in the nineteenth century led to the development of particular sporting 'uniforms' that were adopted into a broader casual wardrobe (figs 95, 96 and 97). In 1887 the writer and cricketer Frederick Gale (1823–1904) advised: 'White … is the colour for the cricket field, so put on your white flannel suit.' The cricketer W. G. Grace (1848–1915) agreed that white was the usual colour for cricket, but also emphasised the need for comfort, with shirts that fitted easily on the shoulders and had loose, open collars.[6] Such garments gradually made their way off the sports fields and courts and into a weekend leisure wardrobe for fashionable young men, as those in white collar occupations now had the time and income to distinguish between their work and leisure wardrobes. Chenoune has

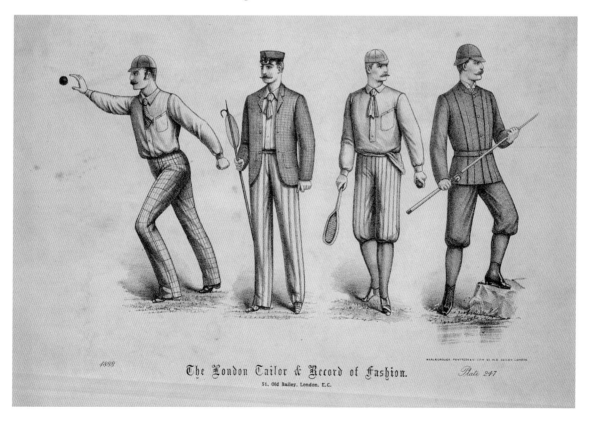

1888 The London Tailor & Record of Fashion. *Plate 247*
51, Old Bailey, London, E.C.

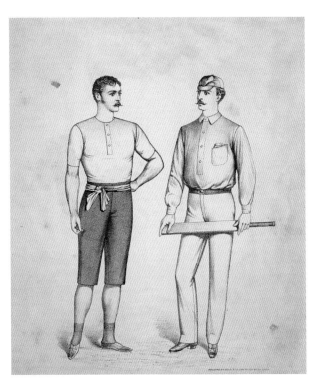

96 (*top*) Uncoloured cricketing fashion plate, undated (c.1890). Manchester Art Gallery.

97 (*bottom*) James Dwight in tennis costume, undated (c.1890). Photographic print. Manchester Art Gallery (2008.40.8.3072).

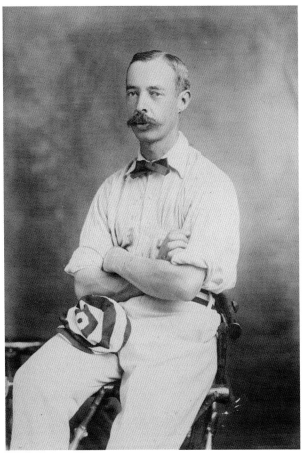

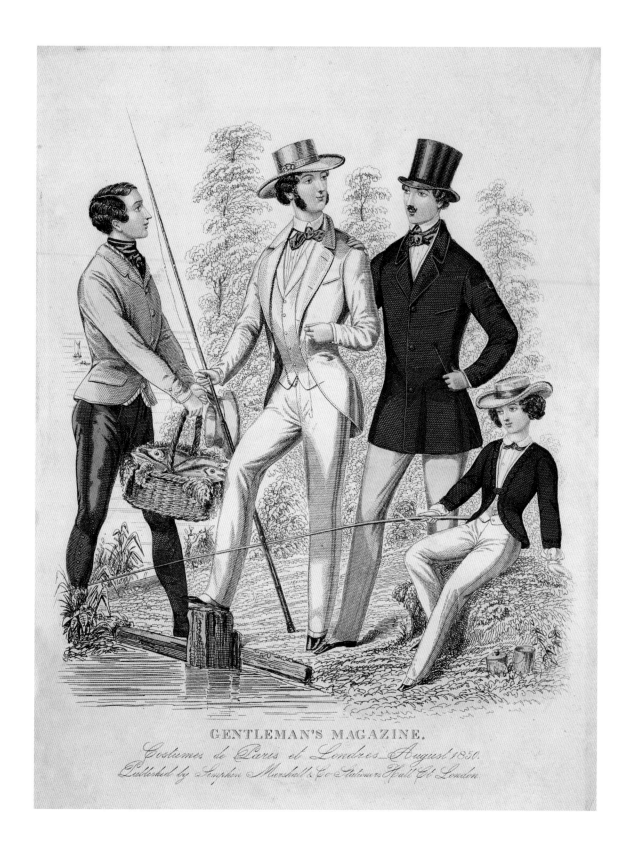

GENTLEMAN'S MAGAZINE.

Costumes de Paris et Londres August 1850.
Published by Simpkin Marshall & Co Stationers Hall Ct London.

98 Hand-coloured plate from *Gentleman's Magazine*, August 1850. Manchester Art Gallery.

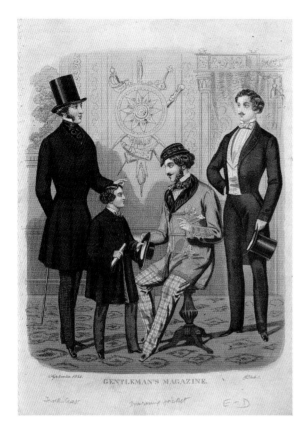

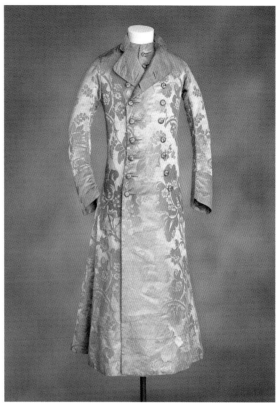

described the popularity of 'tennis style' at the end of the nineteenth century, when 'ready-made tennis suits were popular at the seaside and on river banks' (fig. 98).[7]

Until the early nineteenth century white was the primary choice for sporting and casual wear, and for the majority of men's shirts. Coloured, striped and patterned shirts were introduced throughout the nineteenth century, however, initially for sporting or leisure activities. For example, the 1830s saw the introduction of a striped 'aquatic shirt' for boating, but it was worn by young men when not actually afloat. Formal dress codes were increasingly challenged by young men, so that new styles and colours were introduced, such as the pink shirts, orange ties and purple socks worn by the working-class dandy known as a 'knut'.[8]

The Hosier and Glovers' Gazette (1894) described how the modern man of 1894 'hurries home and puts himself inside his lawn-tennis costume. Later on he wears evening dress, or his smoking jacket', emphasising a move between casual and formal styles.[9] Smoking jackets developed as an informal, after-dinner garment worn to protect the rest of a man's evening clothes as he retired to smoke. Smoking cigarettes became an acceptable and fashionable habit following British involvement in the Crimean War, 1854–6. Made of silk or velvet, the garment was often quilted and decorated with tassels or frogging (fig. 99). While the rules for men's dress in public required certain levels of formality, at home a man's wardrobe could be more relaxed. Originally adopted by British men in the mid-seventeenth century and deriving from Eastern forms of dress, the *banyan* was a forerunner of the smoking jacket and dressing gown. Initially made in sumptuous silk or chintz, it was worn at

99 (*left*) Hand-coloured plate from *Gentleman's Magazine*, September 1854. Manchester Art Gallery.

100 (*right*) Blue silk damask gown or *banyan*, 1760–70. Manchester Art Gallery (1960.301).

home by wealthy upper-class men for relaxing, at their toilette and when informally receiving visitors. Various styles were available, from those that wrapped around the body and tied at the waist to others that buttoned up like a coat, exemplified by the 1760s mid-calf-length damask *banyan*, with matching waistcoat (fig. 100). The popularity of the *banyan* as a casual domestic garment spread to the lower classes, and it became available in cheaper, often imported, printed cotton fabrics, which retained an Orientalist pattern.

It was not just for tennis that shirts with soft open collars were worn. John Saint Helier Lander (1868–1944) painted a portrait of Edward, Prince of Wales (later Duke of Windsor) in 1923 that shows him in his polo outfit, which combines white jodhpurs, black riding boots and a brown belt with a soft open-collar shirt (fig. 101). In his 1960 memoir, *A Family Album,* the Duke noted of the period: 'The soft shirt had arrived. Soft collars and cuffs now came to be worn as a matter of course … when this softening-up process began to extend even to evening-dress, that was a revolution indeed.'[10] Despite initial mixed feelings and resistance to the soft double collar, it became a part of many urban and urbane young men's casual daytime wardrobe in the 1920s. During the summer it was often worn unbuttoned and wide over the jacket lapels, in what was called a 'Danton' or 'Byron' collar, referencing a Romantic historicism (see fig. 57).

One of Edward's major contributions to menswear was his advocacy of a more relaxed style that incorporated sporting and country elements into a royal wardrobe that should have been bound by social convention and strict etiquette. He reflected in his memoir that 'comfort and freedom were the two principles that underlay the change in male fashions throughout [this] freer and easier democratic age'.[11] In many of his dress choices Edward looked towards America, where he was drawn to what Elizabeth Dawson calls 'the ease created by greater informality'.[12] This was seen particularly in his rejection of the higher waist of English tailored trousers, which relied on braces to stay up, in favour of the lower, closer-cut American 'pant' with a waistband and belt loops. Dawson notes how Edward's trousers, including sporting ones, had an invisible internal elasticated girdle;[13] we could assume this is true of the grey, possibly flannel or fine tweed, pair worn in a second Saint Helier Lander portrait (fig. 102).

This second portrait, painted in 1925, presents another of Edward's preferred choices in clothing that challenged the boundary between social convention and comfort, and that fostered a new fashion in casual menswear: the Fair Isle sweater. These complex patterned garments were traditionally hand-knitted by female crofters in the Shetland Islands for everyday wear, with patterns 'based on influence from Baltic and Nordic culture via sea routes'.[14] Edward's pairing of formal grey trousers, a white shirt and dark tie with a tweed flat cap and bright, patterned sweater demonstrates how he mixed conventions, bringing this traditional island work-wear garment out from under a jacket into his urban leisure wardrobe and onto the golf course.[15] The fawn background, overlaid with orange, yellow, maroon and blue, was typical of his love of unconventional combinations, especially of colour and pattern. On the golf course he combined his Fair Isle knitwear with plus fours in wildly bold checks and tweeds and brightly coloured argyle-pattern stockings or socks. Suzy

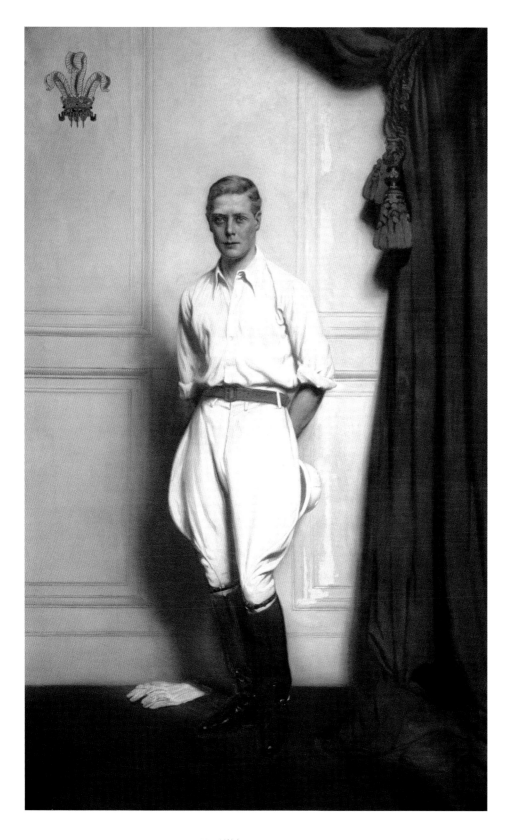

101 John Saint-Helier Lander, *HRH, Edward Prince of Wales*, 1923. Oil on canvas, framed 250 × 159 cm. Manchester Art Gallery (1924.1).

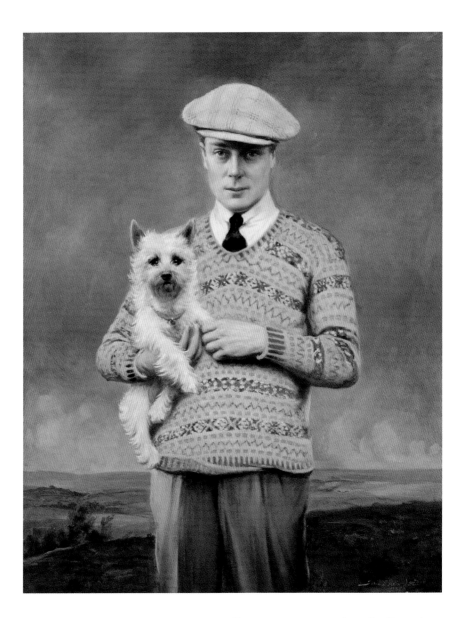

Menkes notes how both contemporary and later commentators described his style as 'quite loud in the way he mixed his checks [and] represented style to his generation'.[16]

This royal influence could be seen in the range of styles sold by manufacturers. For example, four pages of the hosiery manufacturer I. and M. Morley's catalogue (1930) showed golf hosiery, which ranged from plain shades of khaki, camel and white to fine wool all-over patterns similar to those worn by Edward. Christine Arnold has noted that in the 1970s, the availability of knitting machines 'produce[d] a more democratic, highly affordable, convincing facsimile' of hand-knitted originals and that British skinheads wore 'machine mass-produced, garish, acrylic, watered-down versions' of Fair Isle tank tops 'on top of Ben Sherman checked shirts', introducing an interesting subcultural twist.[17] In the later part of the twentieth and the early twenty-first century, brands such as Burberry and fashion designers as diverse as Ralph Lauren (1939–), Karl Lagerfeld (1933–2019) and Alexander McQueen reinterpreted the jumper, with

the McQueen adding his trademark macabre Gothic influence with goats and skulls knitted into the repeat patterns (fig. 103).

The first mods of the late 1950s and early 60s drew on continental European men's style, American Ivy League staples, such as button-down shirts, and an aspirational adoption of local tailors' skills. Chenoune notes that, by the mid-1960s, mods were 'exploit[ing] the "casual" end' of acceptable dress choices, including polo shirts and cardigans, being unable to afford the hand-made, or even off-the-peg, suits.[18] Following a mass adoption and commercialisation of 'mod', many of the early originators, or 'faces', moved away from mod to adopt androgynous hippie or psychedelic styles, or returned to mod's more lower-class origins, becoming 'hard mods': they subsequently spawned the skinhead subculture. Like the early mods, skinheads were inspired by the sartorial manifestations of Britain's West Indian immigrant population, in what became known as 'rude boy style'. One particular casual, short-sleeved shirt that was adopted by both later mods and skinheads was the lightweight knitted 'sports shirt' designed by Salford-born tennis player Fred Perry (1909–1995) in 1952 (fig. 104). Perry's now iconic shirt was developed from his own clothing on the tennis court in collaboration with Austrian footballer Tibby Wegner (1905–1995). It also drew on the tennis shirt designed by French tennis champion René Lacoste (1904–1996), who was known as 'the Crocodile'; a victor's laurel wreath was substituted for Lacoste's crocodile logo on Perry's shirt. Perry understood the importance of dress to his public persona and adopted a sharp, smart look both on and off the court; he modified and slimmed down the traditional looser-fitting white flannel trousers and single-breasted blazers that had been a staple of the tennis court and men's leisure dress since the late 1880s.[19]

The 'casualisation' of mod could be linked with the American post-war leisure style that was imported into Britain along with rock'n'roll and Hollywood teen movies, and led to the emergence of the 'casual' youth subculture. Casuals began as a post-mod and post-skinhead subculture in northern England in the late 1970s, 'a working-class

103 Detail of McQ Alexander McQueen wool Fair Isle sweater, c.2006. Private collection.

thing embedded in the football terraces' whose 'main purpose was to *camouflage* its proponents', through 'subversion [where] social and cultural norms are upturned'.[21] In the multiple histories of the subcultural casual, it is the Scallys of Liverpool and the Perry Boys of Manchester who are credited with linking this style of dress and particular brands with football-terrace hooliganism. Although theirs was not the first subculture to be associated with football supporter violence, their style differed from previous terrace bootboy looks, being derived from a soul boy look, particularly the wedge haircut. Their wardrobes incorporated British heritage brands (often worn by the British middle classes as leisure wear): Fred Perry polo shirts, straight-legged jeans or cords by Lois, Lee or Levi's, and trainers (particularly Adidas, but also Puma and Fila) along with, initially hard to source, European branded sportswear that was acquired at European football matches.[22] Mairi MacKenzie defines 'casuals' as participators in 'a particular form of British working-class dandyism' that could also be linked to the late nineteenth-century working-class gangs of Manchester and Salford, such as the Scuttlers, who wore 'a loose white scarf ... a peaked cap rather over one eye', and trousers 'of fustian ... with "bell bottoms"'.[23]

Ian Hough connects the early casuals to late 1980s and early 90s rave culture, not so much through clothing style as through illegal activities such as football hooliganism and drug taking.[24] The connection is also important in terms of male dress, not just from the continuation of a particular casual subculture style, but also through the dressing down of the mid-1980s 'Hard Times', which moved away from the flamboyant extravagances of early 80s New Romantics.[25] Comfort for long nights of drug-induced dancing became of premier importance, although this could be traced back to the mods' use of amphetamines and the all-nighters of northern soul clubs in the north-west of England in the late 1970s (fig. 105). The loose-fitting and casual clothes, including ponchos, dungarees and baggy T-shirts, which allowed people to 'totally relax and freak out', also drew from a post-hippie, psychedelic 'summer of love' style that included flared jeans, 'smiley face' logos and tie-dye, an influence seen in the

104 'Group of Skins by Mercedes, UK, 1980s'. Photograph by Gavin Watson.

Spring/Summer and Autumn/Winter 2014 collections of British designer Craig Green (1986–) (fig. 106).[26] Epitomising the late 1980s Madchester 'baggy' music scene style, the lead singer of Manchester band The Stone Roses, Ian Brown (1963–), drew from the working-class 'Perry Boy' terrace looks, combined with 1960s and loose-fitting hip-hop styles such as flared jeans, Adidas tracksuits and branded sweatshirts.[27]

Beginning as an athletic shoe company, Adidas designed its first garment, a synthetic fibre tracksuit for German footballer Franz Beckenbauer, in 1967.[28] This innovative take on traditional sportswear, combining zip-front jacket and trousers, has links with the American athletic 'crew-neck' sweatshirt but also the more tra-ditional two-piece men's suit and was, Hardy Amies stated, 'the only totally new garment' to appear in menswear in his lifetime.[29] Like much sportswear, it began as a functional item, intended to keep athletes warm prior to competing, but has been appropriated into men's (and women's) casual wardrobes since the 1970s, as it makes wearers 'feel comfortable, informal, cosy'.[30] By the late 1970s in Britain, the tracksuit was worn across classes and races, with links to both white working-class football supporter culture and black British identity. Both Carol Tulloch and Jo Turney identify the tracksuit's adoption as being associated with major sporting events, such as the Olympic Games, and with black musicians such as Bob Marley and Run DMC; the latter sported Adidas tracksuits for the release of their 1986 track 'My Adidas'.[31] The popularity of rap and hip-hop as a musical style in Britain, and the devel-opment of home-grown forms of rap, such as grime, saw a continued importance of the tracksuit as subcultural garment. Grime MC Novelist (1997–) noted the import-ance of the track suit as casual daily wear. 'Telling me to take off my tracksuit, it's like

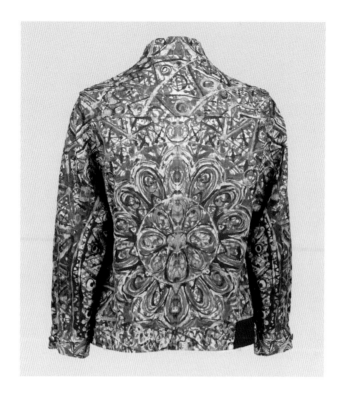

telling me to change my skin color or something. It's just who I am: I'm from the ends, that's what I wear' (fig. 107).[32] Simultaneously, the ease of wearing this two-piece saw its adoption as comfortable leisure wear for travelling and for the elderly, but also as part of the fitness craze from the late 1980s.

Iterations of the tracksuit, such as the shell suit and hoodie, saw an association with the demonised underclass of the 'chav'.[33] The continued wearing of tracksuits by sports stars, both on and off the competitive field, operated perhaps in opposition to the 'degenerate' image. At the opening of the 2002 Commonwealth Games in Manchester, footballer David Beckham (1975–) wore a specially designed white Adidas tracksuit, confirming the garment's high-fashion status.[34] Big-name designers have collaborated with sports companies to produce high-end tracksuits – Yohji Yamamoto with Adidas as Y-3, Ozwald Boateng (1967–) with Nike, and Kim Jones (1979–) with Umbro – confirming the importance of athleisure within the fashion industry.[35] In what has now become a signature of his collections, British designer Christopher Shannon draws on his working-class childhood in Liverpool to reimagine the clichés of the tracksuit, both in a homage to its quotidian functionality and as 'a vehicle to explore different ideas' through cut, colour and pattern.[36] Carlo Brandelli (1969–), creative director of Savile Row tailor Kilgour, believes the tracksuit embodies the desire to feel comfortable when working: 'It's a suit, after all . . . but it's casual, so you are comfortable.'[37] Related to the relaxed, casual tracksuit, which simultaneously 'conceals the body' and 'offer[s] the potential to reveal it' easily through its bagginess and elasticated waistband, is the onesie.[38] Echoing the late nineteenth-century union suit or combination underwear, this millennial casual leisure garment has found a controversial place in public life.

The popularity of the onesie, along with the now almost ubiquitous jogging pant, is indicative of a desire for comfort in contemporary men's fashion. Aligned to forms of long one-piece underwear and the history of casual clothing for domestic wear, such garments blur the division between the public and private in contemporary Britain. Philosopher Gilles Lipovetsky (1944–) has proposed that, in the late twentieth century, a 'demand for greater personal freedom' was 'reflected in fashion … by casualness' and that this 'preference for casual clothing' marked a 'new age of individualism'.[39] The history of men's casual clothing traces a particular path along which garments designed for sporting activity have been appropriated into everyday wardrobes that are 'comfortable, affordable, and durable'.[40] After providing British subcultures of mod, skinhead and casual with the now iconic polo shirt, the Fred Perry company has reappropriated the subcultural capital of these groups by rebranding their products for a contemporary audience and collaborating with contemporary designers, particularly Raf Simons (1968–). The echoes and traces of Edward, Prince of Wales's sartorial gestures, 'aspiring not merely to comfort but in a more symbolic sense to freedom', can still be felt in men's casual dress choices today.[41] In an increasingly changing world, the divisions between formal and casual have blurred and the ways in which previously casual clothing has been integrated and accepted into more formal situations provide an ongoing subversive aspect to men's dress choices.

107 'Novelist chats to an American girl whilst sat on his moped – Lewisham, SE4, 2016'. Photograph by Olivia Rose.

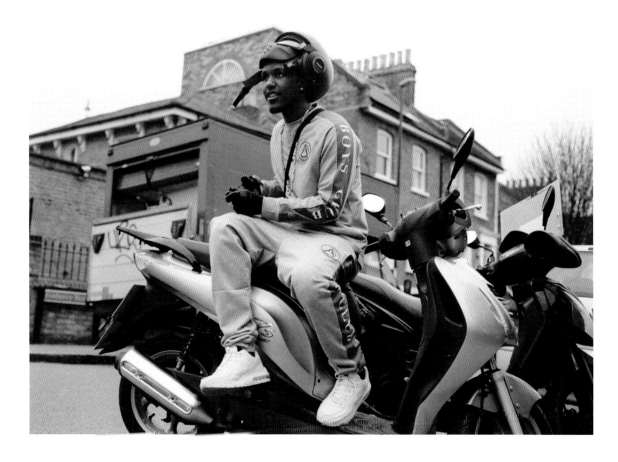

8

Contemporary British Menswear: Hybridity, Flux and Globalisation

Jay McCauley-Bowstead

Designer Kim Jones's debut collection (Spring/Summer 2019) for Dior Men was unveiled in Paris in June 2018 and, as the models proceeded along the runway to the strains of Underworld's 'Born Slippy', many of the major developments that have animated men's fashion in recent years were brought together. Hybridised outfits encompassing elements of sportswear, casual clothing and tailoring appeared: decorative, floral motifs and delicate fabrics were allied to utilitarian flourishes to produce curiously refined boiler suits, soft unstructured trench coats and bomber jackets upon which Neoclassical botanicals unfurled. The aesthetic codes of subculture and street style were combined with the *savoir faire* and elegance of the famous fashion house. Gesturing to the disintegration of barriers between formerly distinct genres of clothing, Jones played with transparency throughout the collection: trousers in lightweight shirting exposed the boxer shorts worn beneath them; a billowing white lace shirt was layered over a chiffon vest, the ornate pattern seeming to float like vapour, veiling the model's naked torso as lightly as dew.

In this collection, Jones, a British menswear designer, drew upon the stylistic references, colours, textures and modes of fabrication of one of the most famous of French fashion houses while simultaneously alluding to a history of British subculture as underlined by the transgressive, elegiac laddishness of the 'Born Slippy' anthem: 'drive boy, dog boy, dirty numb angel boy, in the doorway boy, she was a lipstick boy . . . lager lager lager, shouting'.[1] This exchange between French and British sartorial cultures echoes earlier moments of borrowing, particularly in the eighteenth and nineteenth centuries, as dandy, fop and *macaroni* aesthetics crossed and recrossed the English Channel to the chagrin of jingoists of both nationalities.[2] Six months later,

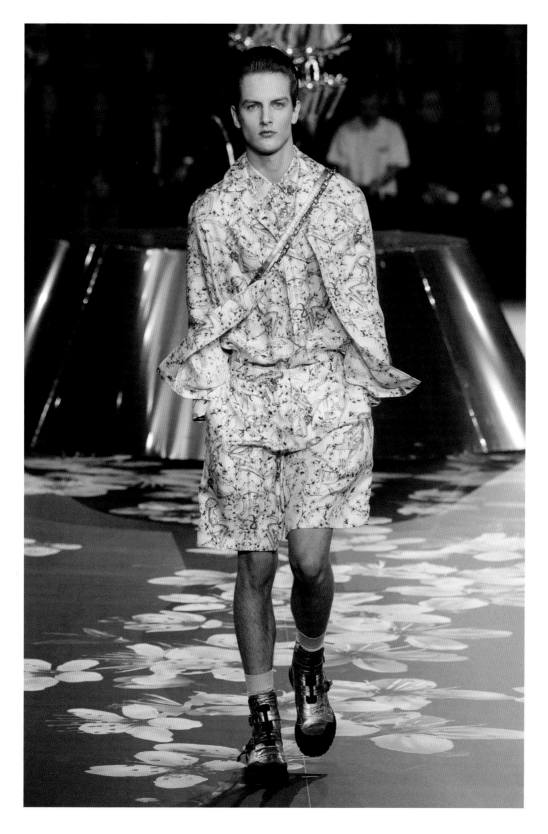

108 Dior, Sorayama print silk overshirt, shirt and shorts. Men's pre-Fall collection, 2019. Photograph by Alessandro Garofalo

Jones's 'pre-Fall' showcase in Tokyo – in collaboration with the artist Hajime Sorayama (1973–) – emphasised the designer's international perspective while foreshadowing the sheer cloths and liminal aesthetics of the coming collection (fig. 108). In this way, Spring/Summer 2019 functioned as a meditation on contemporary masculinities and their increasing porosity and plurality, while also bringing into question what it means to be a British designer in a world both increasingly globalised and riven by nationalist fervour. By addressing notions of hybridity, this chapter will explore how innovative contemporary British designers – and designers working in the UK – have exploited the creative potential of men's fashion in recent years. How does this renaissance in menswear expose the shifting tectonics of gender, taste and national identity?

By the late 1990s the brief boom that British menswear had enjoyed in the 1980s was an increasingly distant memory, and radical fashion was considered, axiomatically, to be womenswear. There were certainly talented and successful tailors and designers – Ozwald Boateng, Paul Smith (1946–) and Joe Casely-Hayford (1956–2019), to name but three (though they often showed in Paris or Milan rather than London). Nevertheless, creative British menswear lacked a platform: men's catwalks were consigned to the last day of the fashion week schedule, few journalists attended them, and there were few magazines to carry the coverage. Italy fared better, retaining an infrastructure in the shape of the Pitti Uomo fashion fair, *Collezioni Uomo*, *L'Uomo Vogue* magazine and big brands such as Gucci and Prada. Nevertheless, by the early 2000s, the feeling that British men's fashion was an essentially conservative form was beginning to wane.

Indeed, over the past 20 years British menswear has become a hugely dynamic field, catapulting to fame such notable designers as Kim Jones, Grace Wales Bonner, Jonathan Anderson, Craig Green and latterly, Feng Chen Wang. The MAN initiative – founded by Lulu Kennedy (1969–) and Fashion East in 2005 and supported by high street retailer Topman – has played a crucial role in supporting creative men's fashion in the UK by providing exposure, financial backing and business advice. It is no coincidence that of the five contemporary designers discussed in this essay, and mentioned above, four were part of the MAN scheme. The global men's fashion market has enjoyed enviable rates of growth over the past decade; menswear-focused social media influencers have multiplied; men's fashion weeks have proliferated; and numerous glossy magazines – *Hero*, *Fantastic Man*, *Man About Town* and *Another Man* – have joined more established titles such as *GQ*. Shifts in attitudes to gender, developments in the media landscape and changing patterns of consumption, as well as an emerging crop of practitioners, have driven a remarkable expansion and diversification of the sector. This aesthetic revolution has provided a site for new forms of masculine identity – the metrosexual, the hipster, the spornosexual, the hypebeast and the modern gentleman – to emerge.[3] Radical though they might be, these developments are not without precedent: the avant-garde menswear styles that have graced the runway and magazine covers over the past two decades owe a significant debt to the youth and subcultural fashions of the late 1960s, 1970s and 1980s.

Given the superabundance of innovative clothing and representations in contemporary men's fashion, one might ask how germane notions of dandyism are

today and to what extent they continue to inform discourses surrounding men's dress and consumption. The parallels between the fashionable male identities that have emerged in recent years and those of the late eighteenth and early nineteenth centuries are obvious. Both involve new styles, silhouettes and accessories, but also a notable pluralisation of masculine subjectivities. As in the nineteenth century, new forms of work and new types of workplaces have emerged: the enormous expansion of clerical posts in the nineteenth century demanded a new uniform for 'white collar' workers. Today, more visual, service-oriented and informal patterns of labour, along with an expanding digital sector, have increasingly demanded a new masculine wardrobe.[4] Simultaneously, styles originating in distant geographical locations are now able to travel at an unprecedented speed via web-enabled technologies.

Men's fashion, as debuted on the catwalk, as worn on the streets of Hongdae, Brooklyn and Peckham, and as disseminated via trendy lifestyle magazines, has been dominated by three major tendencies in recent years.[5] Firstly, globalisation has increased, alongside the rapid growth of East Asian and (latterly) African menswear consumption; designers from these regions have found international fame, and British designers have increasingly drawn on menswear forms originating outside Europe. For example, in his recent collections the British-Nigerian designer Samson Soboye has created garments that reference the West African *dashiki* top, as well as fitted lounge suits made up in vividly patterned *ankara* cloth. Such outfits represent an explicitly hybridised form of menswear that borrows from both African and European forms while rejecting conventionally Eurocentric aesthetic paradigms of chromatic reserve (fig. 109). Secondly, the growing porosity between sportswear and tailored garments has represented a highly significant shift in contemporary men's fashion. This development points both to changing patterns of labour and to a new role for the suit as glamorous occasion wear (rather than an understated corporate uniform). And thirdly, as this chapter will show, an increasingly questioning approach to what contemporary masculinity could or should look like is reflected in daring, decorative and body-conscious men's dress.

With the rise of the tech sector and home working, the boundaries between work and leisure have become more porous. Meanwhile, the formerly strict demarcation between elite culture and popular culture is now much less pronounced, not because social class has disappeared, but because the ways in which status is expressed have changed. Today, increasingly, sophistication, knowledge and cultural capital are communicated through a kind of omnivorousness: an understanding not only of avant-garde fine art, dance or classical music, but also of popular music and street style. This shift away from Bourdieusian taste cultures strictly demarcated by social class has a long twentieth-century history.[6] In the contemporary context, however, the transformation of the economy, the demise of industrial jobs in favour of service and 'knowledge-intensive' occupations, and the rise of a large, culturally engaged demographic who sit outside the traditional middle class, have exerted a significant impact upon canons of taste. In their 2013 study of class, Savage et al. identified a segment of the population they called 'the new affluent workers', a younger-than-average demographic of working-class origins with high levels of 'emergent cultural

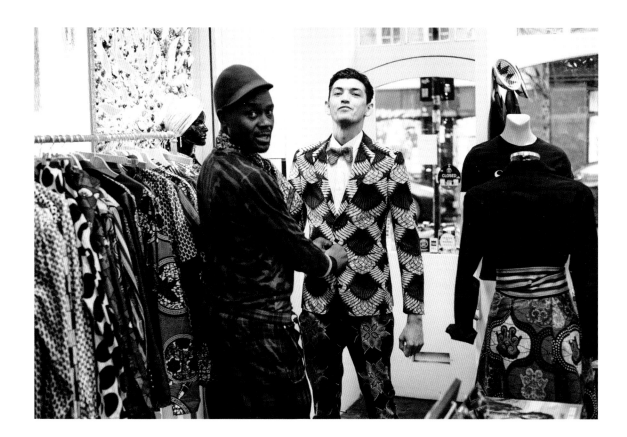

capital' who were knowledgeable about new, edgy creative forms. In this way, the emergence of work that is more focused on service, branding and presentation, along with new class segments, and different types of consumer, are increasingly impacting upon men's fashion.[7] Expensive 'streetwear' brands such as Yeezy or Off-White can be understood as forming part of the increasing destabilisation of formerly dominant notions of 'good taste'.

In June 2019, a year after Jones's debut for Dior, a specially constructed white temple adjacent to L'Institut du Monde Arabe in Paris housed the Spring/Summer 2020 show for Dior Men. The collection resulted from a collaboration with the artist Daniel Arsham (1980–), whose work takes the form of disintegrating, fossilised fragments of contemporary consumer goods. Inside the temple, the fruit of this collaboration was immediately evident on the catwalk, blanketed in an immaculate layer of tinted sand fading from light pastel pink to washed-out magenta, and in the fractured letters D I O R growing out of the even sediment. The opening bars of Malcolm McLaren's 'Waltz Darling' blared out, and the models' transparent rubber boots disturbed the pristine surface as they stomped down the runway.[8] A suit in lightest grey emerged, a satin sash draped over one lapel; a pale pink outfit pinned with a finely wrought lily of the valley brooch followed; then satin shirts; grey-blue double-breasted satin suits with dip-dyed sashes trailing along the ground; and perhaps most startlingly, delicate, swirling, organza pleats – stained in ultramarine or orange and resembling geological strata – applied onto translucent bomber jackets and see-through T-shirts.

Tailoring is often wrongly thought to be unchanging, perennial, classic and timeless. The three-piece suit emerged in a recognisable form at the beginning of the nineteenth century out of a set of profound social and economic transformations: more casual garments, such as trousers, entered into formal wear, displacing breeches.[9] The same process can be seen in the early twentieth century, as the lounge suit replaced the tailcoat and frock coat. Today, Kim Jones's collections indicate a change of a similar magnitude – not just the hybridisation of sport and formal wear, but also the popularity of more elaborate, brightly coloured decorative suits. As Joshua M. Bluteau has suggested in Chapter 3 of this book, for weddings and events, men want to experiment with tailoring, not to use it to make themselves anonymous and invisible. This is not just a phenomenon in high fashion: pastel-coloured suits have been available on the British high street for the past few seasons (fig. 110).

Of course, men's lives are changing not only in terms of work; the adoption of more colourful, embellished, decorative and eroticised menswear also speaks of a renegotiation of ideas surrounding gender. As the sociologists Mechtild Oechsle, Ursula Müller and Sabine Hess have argued, 'the period in which changes in gender relations and images was restricted solely to the modernization of women's lives is now drawing to a close'.[10] There have, in fact, been quite profound changes in the way that masculinity is practised, understood and represented in the past two decades. These shifts are reflected in attitudinal data from both quantitative and qualitative sources. A 2016 poll of 1,692 adults found that younger men placed much less value on normative masculinity than older men.[11] A 2019 study, with a sample of 18,800 adults, by King's College London corroborates this picture of evolving attitudes

110 River Island pistachio cotton suit, 2018. Private collection. Photograph by Jay McCauley Bowstead.

to masculinity, particularly as they pertain to fatherhood and work.[12] Inevitably, these shifts have exerted an impact upon cultures of menswear. While dress has long formed an important site for the contestation of gender, the acceptance that masculinities can be plural and diverse and that there is more than one way of dressing as, or of being, a man is relatively new to mainstream media discourse. Take, for example, the November 2019 edition of *GQ* magazine, which explored 'The New Masculinity'. Its striking front cover featured singer Pharrell Williams, styled by Mobolaji Dawodu (1980–) in a dramatic floor-length tent-dress-cum-coat (designed by Pierpaolo Piccioli and Liya Kebede for Moncler): this, emphatically, is not what *GQ* looked like ten years ago.

None of this is to say that complete gender parity or equality has been achieved, but it does demonstrate that very significant changes in the lives of men and in their attitudes and world views have taken place.[13] And – chiming with this observation – Nick Ferguson, then sales and marketing manager at Estée Lauder, suggested in 2016: 'Traditionally, male grooming brands have spoken to men through a narrow lens of masculinity. [But] this "one size fits all" approach is no longer relevant as concepts of masculinity have become fragmented.'[14] The increasing plurality and diversity of menswear today – on the catwalk, in luxury fashion and among high street retailers – clearly reflects this renegotiation of gender relations. It has heralded the return of a colourful, cosmopolitan *macaroni* style.

At the Spanish label Loewe, where the Northern Irish designer Jonathan Anderson (1984–) is creative director, the Spring/Summer 2020 show represented something of a departure from the previous season (which had featured asymmetric pink tuxedo suits in a glamorous 1970s cut). Substantially rejecting paradigms of conventional western menswear, Anderson instead embraced various robe- and tunic-like garments: the Moroccan and North African *djellaba*, the West African *boubou*, the Indian and South Asian *kurta* and *banyan*. The show commenced with a series of loose-fitting outfits in lightweight shirting, wide trousers, and *peignoirs* open to the waist with capacious open shirts draped over them. There were generously cut robes – like Senegalese *boubou* – some in soft suede, along with striped tunics paired with matching pyjama trousers. As in the Dior Spring/Summer 2020 show, dusty pastels predominated, along with a plethora of multicoloured deckchair stripes. Models carried the leather satchels, backpacks and shoppers for which the brand is well known and wore curious accessories including bizarre fascinators in their hair (fig. 111). The airy, oversized, unstructured garments proposed by Anderson evoked the aesthetic traditions of North and West Africa, and the eastern hippie trail. They also spoke to a tradition of reformed and aesthetic dress in the UK, of the sort favoured by progressive 1930s artists, the Men's Dress Reform Party, and in the pagan ceremonies of the Woodcraft Folk and Kibbo Kift Kindred.

Another practitioner strongly associated with a multicultural approach to menswear is the British-Caribbean designer Grace Wales Bonner (1992–). She has drawn extensively on the aesthetic codes of Nigeria, Mali, Ghana and Ethiopia, while exploring the sartorial traditions of the African diaspora and black masculinity more generally in her work. So it was perhaps unexpected that her Spring/Summer 2019

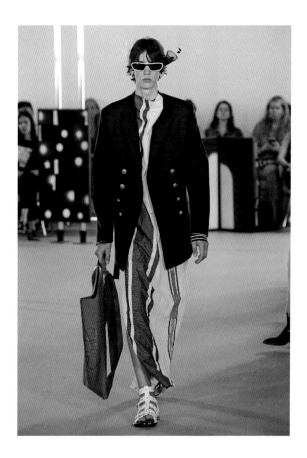

collection extensively mined South Asian culture, manifesting itself in flashes of magenta, burnt orange, saffron yellow, golden brocades and mirrored *shalwar kameez* (among more conventional, tailored garments). This move east makes more sense when seen in the context of Wales Bonner's continued preoccupation with India and particularly with the Siddi community – Afro-Indians descended from enslaved African peoples. Her Spring/Summer 2016 collection, *Malik*, replete with cowrie shells embroidered onto Chanel-style jackets, told the story of Malik Ambar, the Ethiopian slave who rose to be Regent of the Siddi kingdom of Ahmednagar in the sixteenth century, to great acclaim. Referring to a more recent figure for Spring/Summer 2019, Wales Bonner drew inspiration from African American musician Alice Coltrane (1937–2007) and her intense engagement with Indian culture.[15]

There is, of course, a long history of British menswear importing silhouettes, fabrics and style ideas from abroad. In the twentieth century, some of the most significant and successful British outfitters, particularly the multiple tailors[16] like Montague Burton, were founded by Jewish immigrants from the Russian empire, and Jewish entrepreneurs were also influential in popularising ready-to-wear.[17] Moreover, the famous British Carnaby Street and mod looks of the 1960s grew out of a mixture of knock-off Italian tailoring and American and French casual clothing originally marketed to a queer consumer.[18] Later twentieth-century subcultures such as the skinheads and punks drew extensively on Afro-Caribbean cultures of dress.[19] In this sense, the phenomenal success of British men's fashion and the continuing ability

of British designers to 'punch above their weight' on the international stage owes much to the porous nature of British identity, the UK's geopolitical position as a major European economy with strong links to both the continent and former colonies, and a large immigrant (and immigrant-descended) population. Britain's cosmopolitanism, while under threat in recent years, continues to inform, invigorate and enrich contemporary menswear.

The London-based Chinese designer Feng Chen Wang (1986–) is another practitioner whose work speaks of cosmopolitan identity, while also highlighting the male body in sometimes unexpected ways. Her collections combine 1980s and 90s sportswear references with an interest in construction reminiscent of the Belgian designer Martin Margiela (1957–). Sportswear of those decades is perhaps particularly resonant for a Chinese-born designer, offering a reminder of Deng Xiaoping's economic reforms, and the opening up of the Chinese economy. Together, these influences manifest themselves in intricately cut, asymmetric, hybrid garments with panels of contrasting – often translucent – fabric. And while her sensibility for cut and fabrication is somewhat different from that of Jones or Anderson, it is notable that Wang, too, has favoured dusty pastels (and in her last three collections powdery pink formed a key accent colour). For Autumn/Winter 2019 Wang showed panelled

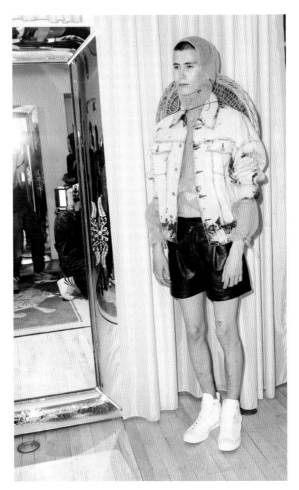

112 Backstage at Feng Chen Wang's Spring 2020 catwalk show. Photograph by Rory James.

113 Backstage at Feng Chen Wang's Spring 2020 catwalk show. Photograph by Rory James.

114 Craig Green catwalk
show, Spring/Summer 2018.
Photograph by dpa.

tailored suits – in pink, of course – alongside shell suits in rose and gleaming gunmetal grey, jumpers knitted with bands of apertures, and complex, oversized down jackets with interweaving pattern pieces cut in the form of a lotus flower. Some months later, for her Spring/Summer 2020 collection, the runway was dressed to resemble a bamboo grove with canes emerging from pale sand. Panels of latticework appeared on shirts and sweatshirts, while jackets, coats and polo shirts were fabricated in transparent beige organza (figs 112 and 113). The use of sheer cloth, and the repeated motif of gaps and openings – not only in Wang's work, but also in that of Jones, Anderson and Craig Green – point to the ways in which the slender physique of the male high-fashion model is highlighted and revealed in contemporary menswear. Both the morphology of this attenuated model-body, and the way in which it is dressed, framed and exposed, point to shifts in attitudes to masculinity and challenges to formerly hegemonic norms of strength, dominance and invulnerability.

A synthesis of eastern and western aesthetics has been key to formal innovation in contemporary menswear, perhaps most notably in the work of British designer Craig Green, whose collections have become synonymous with radical experimentation since his label was founded in 2012 (fig. 114). For Autumn/Winter 2019, Green retained the abstracted, kabuki-like, martial arts-ish elements for which he has become famous, but in the opening looks of the show, these were applied in a relatively quiet and understated manner: elegant double-breasted trench coats with external pocket-bags, subtly contrasting trims, and trailing ties, were fastened with an *obi* at the waist. The collection continued with harness-like tops, fashioned from

padded strips of cloth to resemble woven samurai armour; plaid robes with curiously placed openings; ensembles overlaid with radiating crochet nets; complex ruched and gathered garments; and finally outfits fashioned entirely from heat-sealed, transparent bottle-green plastic. This juxtaposition of delicate and protective materials in Green's collection – as he explained in his show notes – were intended to evoke notions of fragility and protection. Since the turn of the millennium, vulnerability has been an important theme for menswear practitioners, manifesting itself both at the level of the body, and in the way it is framed, styled and photographed. In making visible the vulnerability that is part of all human psyches and experiences, contemporary designers resist and reject hegemonic representations of masculinity (in film, sport and politics) in which strength, agency and dominance are emphasised and in which male fragility is understood exclusively as a failing.

Designer ready-to-wear, as debuted each season on the menswear runways of the major fashion capitals, may be worn by relatively few people, but the colours, silhouettes, cut and fabrications that are proposed on the catwalk strongly influence the offerings of more modestly priced retailers. Moreover, designer menswear today is widely disseminated at the level of image, especially via social media applications such as Instagram and Weibo (the Chinese microblogging site), which reach an enormous audience. Celebrities as diverse as Harry Styles, Tinie Tempah, BTS and A$AP Rocky are pictured in Gucci, Dior and Loewe, thereby communicating ideas about menswear, masculinity and the fashionable male body far beyond the fashion cognoscenti.[21] Fashion practitioners draw on the stylistic influences that surround them to inform their work: clothing as worn on the street and on the dance floor; the utilitarian outfits of police and security guards; the unexpected ways that people mix together second-hand garments; hybrid forms of dress that arise in multicultural metropolises; the aesthetics of artworks, shows and exhibitions. In this way, British menswear represents a space in which some of the most profound ontological questions of this contemporary moment are posed: what does it mean to be British? And what does it mean to be a man?

NOTES

INTRODUCTION

1 Roland Barthes, 'Dandyism and Fashion', in *The Language of Fashion* (London: Bloomsbury, 2013), pp. 65–9, here p. 67.

2 Nigel Rogers, *The Dandy: Peacock or Enigma?* (London: Bene Factum Publishing, 2012), p. 30.

3 James Laver, *Dandies* (London: Weidenfeld & Nicolson, 1968), p. 34.

4 Anne Hollander, 'Heroes in Wool', in P. McNeil and V. Karaminas (eds), *The Men's Fashion Reader* (Oxford: Berg, 2009), pp. 261–4, here pp. 262–3.

5 Christopher Breward, '21st Century Dandy: The Legacy of Beau Brummell', in Alice Cicolini, *The New English Dandy* (London: Thames & Hudson, 2005), pp. 2–5, here p. 2.

6 Christopher Breward, 'The Dandy Laid Bare: Embodying Practices of Fashion for Men', in P. Church Gibson and S. Bruzzi (eds), *Fashion Cultures: Theories, Explorations, and Analyses* (London and New York: Routledge, 2000), pp. 221–38.

7 Elizabeth Wilson, 'A Note on Glamour', *Fashion Theory*, 11, no. 1 (2007), pp. 95–108, here p. 97.

8 Miles Lambert, 'The Dandy in Thackeray's Vanity Fair and Pendennis: An Early Victorian View of the Regency Dandy', *Costume*, no. 22 (1988), pp. 60–69.

9 Ellen Moers, *The Dandy: Brummell to Beerbohm* (London: Secker and Warburg, 1960); Breward, 'The Dandy Laid Bare'.

10 Moers, *The Dandy*, p. 299.

11 Breward, 'The Dandy Laid Bare', p. 232.

12 See Alice Cicolini and Christopher Breward, *21st Century Dandy* (London: British Council, 2003), and Alice Cicolini, *The New English Dandy*; Rhonda K. Garelick, *Rising Star: Dandyism, Gender, and Performance in the Fin de Siècle* (Princeton, NJ: Princeton University Press, 1998); George Walden, *Who's a Dandy: Beau Brummell to Today* (London: Gibson Square, 2002).

13 Charles Baudelaire, *The Painter of Modern Life and Other Essays* (London: Phaidon, 1964), p. 28.

14 The Duke of Windsor, *A Family Album* (London: Cassell, 1960), p. 105.

15 Ibid., pp. 11–12, 13.

16 Colin Campbell, 'Understanding Traditional and Modern Patterns of Consumption in Eighteenth-century England: A Character-action Approach', in J. Brewer and R. Porter (eds), *Consumption and the World of Goods* (London and New York: Routledge, 1993), pp. 40–57, here p. 50.

17 Ibid., p. 53.

18 Ibid., p. 54; Joanne Entwistle, *The Fashioned Body: Fashion, Dress and Modern Social Theory* (Cambridge: Polity Press, 2000), p. 133.

19 Shaun Cole, 'Queers and Mods: Social and Sartorial Interaction in London's Carnaby Street', in A. Reilly, P. Hunt-Hurst and K. A. Miller-Spillman (eds), *The Meanings of Dress*, 3rd edn (New York: Fairchild, 2012), pp. 214–22.

20 Olga Vainshtein, 'Walking the Turtles: Minimalism in European Dandy Culture in the Nineteenth Century', *Fashion, Style and Popular Culture*, 4, no. 1 (2017), pp. 81–104, here p. 89.

21 See Nick Rees-Roberts, 'Boys Keep Swinging: The Fashion Iconography of Hedi Slimane', *Fashion Theory*, 17, no. 1 (2013),

pp. 7–26; Jay McCauley Bowstead, *Menswear Revolution: The Transformation of Contemporary Men's Fashion* (London: Bloomsbury, 2018).

22 John Harvey, *Men in Black* (London: Reaktion Books, 1995). These issues are discussed in the introduction, pp. 9–21.

23 John Carl Flügel, *The Psychology of Clothes* (London: Hogarth Press, 1930), p. 111.

24 Walter Benjamin, *The Arcades Project,* cited in Thomas Mann, *The Dandy at Dusk* (Paris: Paysan Press, 2016), p. 11.

25 Anne Hollander, *Sex and Suits: The Evolution of Modern Dress* (New York: Knopf, 1994), p. 22.

26 David Kuchta, *The Three-Piece Suit and Modern Masculinity: England, 1550–1880* (Berkeley, CA: University of California Press, 2002).

27 Christopher Breward, *The Hidden Consumer: Masculinities, Fashion and City Life 1860–1914* (Manchester: Manchester University Press, 1999), p. 2.

28 Cited in Christopher Breward, 'Renouncing Consumption: Men, Fashion and Luxury', in A. de la Haye and E. Wilson (eds), *Defining Dress: Dress as Object, Meaning and Identity* (Manchester: Manchester University Press, 1999), pp. 48–62, here p. 57.

29 Roy Strong, cited in Prudence Glynn, 'What's a Nice Dress like You Doing in a Place like This?', *The Times* (3 September 1974), n.p.

30 Laver, *Dandies*, p. 21.

31 See Penny Martin, *When You're a Boy: Men's Fashion Styled by Simon Foxton* (London: London College of Fashion, 2009); Shaun Cole, '"Looking Good in a Buffalo Stance": Ray Petri and the Styling of New Masculinities' in Ane Lynge-Jorlén (ed.), *Fashion Stylists: History, Meaning and Practice* (London: Bloomsbury, 2020), pp. 135–154.

32 Dean Chalkley and Harris Elliott, *Return of the Rudeboy* (England: Return of the Rude Boy Ltd, 2015).

33 Personal communication between Harris Elliott and Shaun Cole.

34 Richard J. Powell, cited in Carol Tulloch, *The Birth of Cool: Style Narratives of the African Diaspora* (London: Bloomsbury, 2016), p. 126; Monica L. Miller '"Fresh-Dressed Like a Million Bucks": Black Dandyism and Hip-Hop', in K. Irvin (ed.), *Artist, Rebel, Dandy: Men of Fashion* (New Haven, CT: Yale University Press, 2013), pp. 149–73, here p. 172.

35 Carol Tulloch, 'Rebel Without a Pause: Black Street Style and Black Designers', in J. Ash and E. Wilson (eds), *Chic Thrills* (London: Pandor, 1992), pp. 84–98; Carol Tulloch (ed.), *Black Style* (London: V&A Publishing 2004); Michael McMillan, 'Saga Bwoys and Rude Bwoys: Migration, Grooming, and Dandyism', *Nka: Journal of Contemporary African Art*, no. 38–9 (2016), pp. 60–69; Christine Checinska, 'Stylin': The Great Masculine Enunciation and the (Re)Fashioning of African Diasporic Identities', *Critical Arts: South-North Cultural and Media Studies*, 31, no. 3 (2017) pp. 53–71.

36 William Dalrymple, *White Mughals: Love and Betrayal in Eighteenth-century India* (London: Harper Perennial, 2004), p. xiv.

37 Nathaniel Adams and Rose Callahan, *I Am Dandy: The Return of the Elegant Gentleman* (Berlin: Gestalten, 2013).

38 Baudelaire, *The Painter of Modern Life*, p. 9.

39 Walter Benjamin, *Charles Baudelaire: A Lyric Poet in the Era of High Capitalism*, trans. Harry Zohn (London: NLB, 1973), p. 54.

40 Oscar Wilde, 'De Profundis', in *Collected Works of Oscar Wilde* (London: Wordsworth Editions, 2007), p. 1070.

41 Mark Simpson, 'Here Come the Mirror Men', *Independent* (15 November 1994), https://marksimpson.com/here-come-the-mirror-men (accessed 6 August 2020).

42 See Rowena Chapman and Jonathan Rutherford (eds), *Male Order: Unwrapping Masculinity* (London: Lawrence & Wishart, 1988); Frank Mort, *Cultures of Consumption* (London: Routledge, 1996); Sean Nixon, *Hard Looks* (London: UCL Press, 1996); Tim Edwards, *Men in the Mirror* (London: Cassell, 1997).

43 Mark Greif, 'What Was the Hipster?', *New York Magazine* (24 October 2010), https://nymag.com/news/features/69129 (accessed 6 August 2020).

44 See for example: Susan Filin-Yeh (ed.), *Dandies: Fashion and Finesse in Art and Culture* (New York: New York University Press, 2001); Peng Hsiao-yen, *Dandyism and Transcultural Modernity: The Dandy, the Flâneur, and the Translator in 1930s Shanghai, Tokyo, and Paris* (London and New York: Routledge, 2010); Kate Irvin, *Artist, Rebel, Dandy: Men of Fashion* (New Haven, CT: Yale University Press, 2013); Shantrelle P. Lewis, *Dandy Lion: The Black Dandy and Street Style* (New York: Aperture, 2017); Monica L. Miller, *Slaves to Fashion: Black Dandyism and the Styling of Black Diasporic Identity* (Durham, NC: Duke University Press, 2009); Danielle Porter Sanchez, 'Zoot Suiters and Sapeurs: The Politics of Dress in the World War II Era', in T. Falola and D. Porter Sanchez (eds), *African Culture and Global Politics: Language, Philosophies, and Expressive Culture in Africa and the Diaspora* (New York and London: Routledge, 2014) pp. 340–65; Dominic Richard David Thomas, 'Fashion Matters: La Sape and Vestimentary Codes in Transnational Contexts and Urban Diasporas', MLn, 118, no. 4 (2003), pp. 947–73; Olga Vainshtein, 'Orange Jackets and Pea Green Pants: The Fashion of Stilyagi in Soviet Postwar Culture', *Fashion Theory*, 22, no. 2 (2018), pp. 167–85.

45 See http://lubainahimid.uk/portfolio/tailor-striker-singer-dandy (accessed 6 August 2020).

46 Ulrich Lehmann, *Tigersprung: Fashion in Modernity* (Cambridge, MA: MIT Press, 2000); Caroline Evans, *Fashion at the Edge: Spectacle, Modernity and Deathliness* (New Haven, CT and London: Yale University Press, 2003).

47 Aileen Ribeiro, *The Art of Dress: Fashion in England and France, 1750–1820* (New Haven, CT and London: Yale University Press, 1995), p. 5.

48 Linda Baumgarten, *What Clothes Reveal: The Language of Clothing in Colonial and Federal America* (New Haven, CT: Yale University Press, 2002), p. 5.

49 *Reigning Men: Fashions in Menswear, 1715–2015*, exh. cat. (Los Angeles County Museum of Art/DelMonico Books, 2018) p. 9; Christopher Breward, 'Modes of Manliness: Reflections on Recent Histories of Masculinities and Fashion,' in G. Riello and P. McNeil (eds), *The Fashion History Reader: Global Perspectives* (London: Routledge, 2010), pp. 301–7, here p. 301.

50 'Value of the Clothing and Accessories Market in the United Kingdom (UK) in 2013 and 2017, by Category', *Statista*, www.statista.com/statistics/317394/clothing-and-accessories-market-value-in-the-united-kingdom-uk-by-category (accessed 6 August 2020). Men's underwear sales rose from £0.6 to £0.7 billion and men's accessories from £1 to £1.2 billion in the same period.

51 'UK Menswear Is Strong But There Are Too Many Markdowns – Report', *Fashion Network* (10 June 2019), https://uk.fashionnetwork.com/news/Uk-menswear-is-strong-but-there-are-too-many-markdowns-report,1106334.html (accessed 6 August 2020).

1 Sally Gray and Roger Leong, 'Introduction: Special Issue: "Exhibiting Masculinity"', *Critical Studies in Men's Fashion*, 4, no. 1 (2017), pp. 3–10, here p. 4.

2 Avril Harte, *Four Hundred Years of Fashion* (London: V&A Publishing, 1984), p. 61.

3 Julia Petrov, 'Gender Considerations in Fashion History Exhibitions', in M. R. Melchior and B. Svensson (eds), *Fashion and Museums: Theory and Practice* (London: Bloomsbury, 2014), pp. 77–90, here p. 80.

4 Ibid., p. 88.

5 Jeffrey Horsley, 'The Absent Shadow: Reflections on the Incidence of Menswear in Recent Fashion Exhibitions', *Critical Studies in Men's Fashion*, 4, no. 1 (2017), pp. 11–29.

6 Sharon Sadako Takeda, 'Introduction', in *Reigning Men*, p. 9.

7 Quoted in Sarah Young, 'Invisible Men: Largest Ever Menswear Exhibition in UK is Coming to London', *Independent*, 14 August 2019, www.independent.co.uk/life-style/fashion/invisible-men-westminster-menswear-archive-exhibition-london-dates-alexander-mcqueen-when-a9056881.html (accessed 6 August 2020).

8 Baumgarten, *What Clothes Reveal*, p. 182.

9 Russell Belk, cited in Susan M. Pearce, *Interpreting Objects and Collections* (London: Routledge, 2003), p. 318.

10 The museum gives every accessioned item a unique number, prefaced by MCAG: the tailcoat is MCAG 1922.1910.

11 *Hearn's Rudiments of Cutting Coats* (3rd edn, 1819): plate 1 includes waist seams.

12 Sir Thomas Lawrence, *Sir Humphry Davy* (The Royal Society, RS9343).

13 Richard Dighton, April 1824, hand-coloured print (Manchester Art Gallery).

14 MCAG 1936.88.

15 Platt Hall donor letter: *H. Wright*: 17 April 1936.

16 Guardian Archives: Obituary: *Dr C. W. Cunnington, Authority on English Costume*: 25 January 1961.

17 Harvey, *Men in Black*, front cover.

18 Platt Hall purchase letter: *F. G. Pakenham*: 17 August 1946.

19 MCAG 1946.169.

20 Platt Hall purchase letter: *Lady Partridge*: 6 February 1949.

21 Platt Hall purchase letter: *Roger Warner*: 11 August 1952.

22 MCAG 1949.55. Platt Hall donor letter: *Miss M. V. Walmsley*: 25 March 1949. Miss Buck described the smoking jacket 'with hand painted lapels' as 'a most unusual and interesting addition'.

23 Platt Hall purchase letter: *Chas H. Cook*: 20 April 1951.

24 MCAG 1951.293–304.

25 Platt Hall purchase letter: *Ervin Wiesner*: 12 July 1954.

26 MCAG 1954.1098–1104.

27 MCAG 1985.167 (for example).

28 MCAG 1990.128–134.

29 *Men's Wear*, 4 November 1976, p. 43.

30 MCAG 2010.137-139 (139 illustrated).

31 MCAG 1973.288.

32 *Gazette of Fashion*, undated fashion plate, late 1840s (Manchester Art Gallery). The Los Angeles County Museum of Art has a blue and green check two-piece suit dated 1860–70 (illustrated in *Reigning Men*, pp. 150–51).

33 MCAG 2018.82.

34 MCAG 1989.177.

35 *Reigning Men*, p. 235.

1 For an overview, see Jules D. Prown, 'Mind in Matter: An Introduction to Material Culture Theory and Method', *Winterthur Portfolio*, 17 (1982), pp. 1–19; Jules D. Prown, *Art as Evidence: Writings on Art and Material Culture* (New Haven, CT: Yale University Press, 2001); Ingrid Mida and Alexandra Kim, *The Dress Detective: A Practical Guide to Object-based Research in Fashion* (London: Bloomsbury Academic, 2015).

2 See Prown, 'Mind in Matter'; Prown, *Art as Evidence*; Thomas J. Schlereth, 'Material Culture Research and Historical Explanation', *The Public Historian*, 7 (1985), pp. 21–36; Judy Attfield, *Wild Things: The Material Culture of Everyday Life* (Oxford: Berg, 2000); Susan Küchler and Daniel Miller (eds), *Clothing as Material Culture* (Oxford: Berg, 2005); Ian Woodward, *Understanding Material Culture* (London: Sage Publications, 2012).

3 Igor Kopytoff, 'The Cultural Biography of Things: Commoditization as Process', in A. Appadurai (ed.), *The Social Life of Things: Commodities in Cultural Perspective* (Cambridge: Cambridge University Press, 1986), pp. 64–91; Janet Hoskins, *Biographical Objects: How Things Tell the Stories of People's Lives* (New York: Routledge, 1998).

4 Jane Tozer and Sarah Levitt, *Fabric of Society: A Century of People and their Clothes 1770–1870* (Carno, Powys: Laura Ashley, 1983).

5 See Christopher Breward, *The Culture of Fashion: A New History of Fashionable Dress* (Manchester: Manchester University Press, 1995); Christopher Breward, 'Cultures, Identities, Histories: Fashioning a Cultural Approach to Dress', *Fashion Theory*, 2, no. 4 (1998), pp. 301–13; Christopher Breward, *Fashion* (Oxford: Oxford University Press, 2003); Amy de la Haye, Lou Taylor and Eleanor Thompson, *A Family of Fashion: The Messels: Six Generations of Dress* (London: Philip Wilson, 2005); Richard Grassby, 'Material Culture and Cultural History', *Journal of Interdisciplinary History*, 35, no.4 (Spring 2005), pp. 591–603; Carl Knappett, *Thinking Through Material Culture: An Interdisciplinary Perspective* (Philadelphia, PA: University of Pennsylvania Press, 2005); Küchler and Miller (eds), *Clothing as Material Culture*; Alistair O'Neill, *London – After a Fashion* (London: Reaktion Books, 2007); Francesca Granata, 'Fashion Studies In-between: A Methodological Case Study and an Inquiry into the State of Fashion Studies', *Fashion Theory*, 16, no. 1 (2012), pp. 67–82; Elizabeth Wilson, *Cultural Passions: Fans, Aesthetes and Tarot Readers* (London: I. B. Tauris, 2013).

6 Prown, 'Mind in Matter'.

7 Peter Stallybrass, 'Worn Worlds: Clothes, Mourning and the Life of Things', in D. B. Amos and L. Weissberg (eds), *Cultural Memory and the Construction of Identity* (Detroit, MI: Wayne State University Press, 1999), pp. 27–44, here p. 31.

8 Ibid.

9 Frank Mort, *Cultures of Consumption: Masculinities and Social Space in Late Twentieth-century Britain* (London: Routledge, 1996).

10 Alistair O'Neill, 'John Stephen: A Carnaby Street Presentation of Masculinity 1957–1975', *Fashion Theory*, 4, no. 4 (2000), pp. 487–506.

11 Edwina Ehrman, 'London as a Fashion City', in L. Skov (ed.), *Berg Encyclopaedia of World Dress and Fashion* (vol. 8) (Oxford: Berg, 2010), pp. 299–304, here p. 299.

12 A firmly woven, ribbed ribbon, similar to grosgrain.

13 Oral testimony from Mark Reed. Interviewed by Ben Whyman, 6 November 2014.

14 Ibid.

15 Joseph A. Amato, *Surfaces: A History* (Berkeley, CA and London: University of California Press, 2013).

16 Daniel Miller, *The Comfort of Things* (Cambridge: Polity Press, 2008).

1 Terence S. Turner, 'The Social Skin', in B. Luvaas and J. B. Eicher (eds), *The Anthropology of Dress and Fashion: A Reader* (London: Bloomsbury Visual Arts, 2019), pp. 43–51, here p. 43.

2 See Dorinne K. Kondo, *Crafting Selves: Power, Gender, and Discourses of Identity in a Japanese Workplace* (Chicago, IL: Chicago University Press, 2009). See also Erving Goffman, *The Presentation of Self in Everyday Life* (London: Pelican, 1980).

3 Daniel Miller and Sophie Woodward, *Blue Jeans: The Art of the Ordinary* (Berkeley, CA: University of California Press, 2012), p. 89.

4 There are echoes of this concept in the 2019 exhibition of men's workwear and fashion from the University of Westminster Archive entitled *Invisible Men*, which explored garments that are typically absent from museum exhibitions and the historical narrative of menswear as a continuous evolving trope.

5 Kenneth Rose, *Superior Person: A Portrait of Curzon and his Circle in Late Victorian England* (London: Weidenfeld & Nicolson, 1969), p. 268. See also Helen Callaway, 'Dressing for Dinner in the Bush: Rituals of Self-Definition and British Imperial Authority,' in R. Barnes and J. B. Eicher (eds), *Dress and Gender: Making and Meaning* (Oxford: Berg, 1992), pp. 232–47, here pp. 234–5.

6 Daniel Rosenblatt, 'The Antisocial Skin: Structure, and "Modern Primitive" Adornment in the United States', in B. Luvaas and J. B. Eicher (eds), *The Anthropology of Dress and Fashion: A Reader* (London: Bloomsbury Visual Arts, 2019), pp. 66–77, here pp. 70–71.

7 See Sophie Woodward, *Why Women Wear What They Wear* (Oxford: Berg, 2007). See also Barbara Brownie, *Acts of Undressing: Politics, Eroticism and Discarded Clothing* (London: Bloomsbury Academic, 2017).

8 See Lance Richardson, *House of Nutter: The Rebel Tailor of Savile Row* (New York: Crown Publishing Group, 2018).

9 Shaun Cole, *'Don We Now Our Gay Apparel': Gay Men's Dress in the Twentieth Century* (Oxford: Berg, 2000); Shaun Cole, 'Queerly Visible: Gay Men, Dress, and Style 1960–2012', in V. Steele (ed.), *A Queer History of Fashion: From the Closet to the Catwalk* (New Haven, CT: Yale University Press, 2013), pp. 135–65.

10 The Milanese buttonhole is a particular style of hand-stitched buttonhole, usually only found on the lapels of suits made by certain bespoke tailors. Unlike traditional buttonholes, which are first stitched (typically by machine) and then cut open, the Milanese buttonhole involves the cloth being first cut and then exquisitely hand-stitched. Silk thread is wound around the cut cloth and an additional thread, known as a gimp, to give a neat finished and raised profile to the buttonhole.

11 Denis Bruna (ed.), *Fashioning the Body: An Intimate History of the Silhouette* (New Haven, CT: Yale University Press, 2015).

12 Sophie Lamotte, 'Corsets, Stomach Belts, and Padded Calves: The Masculine Silhouette Reconfigured', in Bruna, *Fashioning the Body*, pp. 199–211, here p. 200.

13 Christopher J. Berry, *The Idea of Luxury: A Conceptual and Historical Investigation* (Cambridge: Cambridge University Press, 1994).

14 Sapeurs are members of *La Sape*, an abbreviation of the *Société des Ambianceurs et des Personnes Élégantes*, a subculture originating in the Republic of Congo and the Democratic Republic of Congo, primarily found in the cities of Kinshasa and Brazzaville. This group espouses a peaceful lifestyle and its members devote themselves to a flamboyant and colourful style of dress, centring around brightly coloured tailoring from European designers. See Jonathan Friedman, 'The Political Economy of Elegance:

An African Cult of Beauty', in J. Friedman (ed.), *Consumption and Identity* (Reading: Harwood Academic Publishers, 1994), pp. 167–88.

15 Christopher Breward, *The Suit*.

CHAPTER 4

1 Early studies include: James Laver, *Costume of the Western World* (London: George Harrap, 1951); Brian Reade, *The Dominance of Spain 1550–1669* (London: George Harrap, 1952); Stella Mary Newton, *Health, Art and Reason: Dress Reformers of the Nineteenth Century* (London: John Murray, 1974); Anne Hollander, *Seeing Through Clothes* (New York: Viking Press, 1978); Aileen Ribeiro, *A Visual History of Costume: The Eighteenth Century* (London: B. T. Batsford, 1983); Stella Mary Newton, *The Dress of the Venetians* (London: Scholar Press, 1988).

2 Ribeiro, *The Art of Dress*, p. 236.

3 Ibid., p. 6.

4 Ibid., p. 236.

5 Hollander, *Seeing Through Clothes*, p. xvi.

6 In her discussion of the clothes worn by the Swedish portrait painter Michael Dahl (1659–1743), Ribeiro describes a similar long-sleeved vest as a 'kind of informal jacket'. Aileen Ribeiro, *Clothing Art: The Visual Culture of Fashion, 1600–1914* (New Haven, CT and London: Yale University Press, 2016), p. 43.

7 Aileen Ribeiro, *The Gallery of Fashion* (London: National Portrait Gallery, 2000), p. 15; William Page (gen. ed.) and Oswald Baron (ed.), *The Victorian History of the Counties of England: The History of Northamptonshire, Geneological Volume* (London, 1906), p. 44.

8 David Irwin and Francina Irwin, *Scottish Painters at Home and Abroad, 1700–1900* (London: Faber & Faber, 1975), pp. 73–4.

9 Flügel, *The Psychology of Clothes*, p. 111.

10 Ribeiro, *The Gallery of Fashion*, p. 17.

11 George Field, *Chromatography* (1835), p. 96, cited in Jacob Simon, 'Lawrence's Materials and Processes', www.npg.org.uk/research/programmes/artists-their-materials-and-suppliers/thomas-lawrences-studios-and-studio-practice/lawrences-materials-and-processes (accessed 6 August 2020).

12 Andrew Wilton, *The Swagger Portrait: Grand Manner Portraiture in Britain from Van Dyck to Augustus John, 1630–1930* (London: Tate Gallery, 1992), p. 52.

13 Colin McDowell, *The Man of Fashion: Peacock Males and Perfect Gentlemen* (London: Thames & Hudson, 1997), p. 50.

14 Biography of Jem Belcher at: http://boxingbiographies.co.uk/html/body_jem_belcher-bb.HTM (accessed 6 August 2020).

15 See Laver, *Dandies*; and Ian Kelly, *Beau Brummell: The Ultimate Dandy* (London: Hodder & Stoughton, 2005) for more on Brummell's neckwear. Farid Chenoune makes a comparison between the 'open-necked shirts (*à la Marat*)' of the revolutionary *sans-culotte*s and the 'high-necked muslin cravats (*à la Garat*)' of the stylish bourgeois fops, known as *Muscadins* and later *incroyables*, in the mid-to-late 1790s: Farid Chenoune, *A History of Men's Fashion* (Paris: Flammarion, 1993), pp. 19–20.

16 Richard Walker, *Regency Portraits*, Vol. I: Text (London: National Portrait Gallery, 1985), p. 82.

17 Peter L. Thorslev, *The Byronic Hero: Types and Prototypes* (Minneapolis, MN: University of Minnesota Press, 1962).

18 Ribeiro, *The Gallery of Fashion*, p. 177.

19 Lewis's *Portrait of the Artist as the Painter Raphael* is held at Manchester Art Gallery (1925.579).

20 Joanna Woodall, 'Introduction: Facing the Subject', in J. Woodall (ed.), *Portraiture: Facing the Subject* (Manchester: Manchester

University Press, 1997), pp. 1–25, here p. 5.

21 Ribeiro, *The Gallery of Fashion*, p. 17.

22 Max Beerbohm, 'Dandies and Dandies', in *The Works of Max Beerbohm* (London: John Lane, The Bodley Head and New York: Charles Scribner's Sons, 1896), p. 19.

23 Ernest Thesiger, *Practically True* (London: William Heinemann, 1927), p. 13.

24 Walter Fitzgerald, *Fifty Years of Strutting and Fretting*, cited in 'Ernest Thesiger: Himself', http://ernestthesiger.org/Ernest_Thesiger/Himself.html (accessed 6 August 2020).

25 Ribeiro, *The Gallery of Fashion*, p. 10.

26 Edmund White, 'Sunlight, Beaches and Boys', *The Guardian* (8 September 2006), www.theguardian.com/artanddesign/2006/sep/08/art1 (accessed 6 August 2020).

27 John Bampton, 'Paying Tribute to Furniture Designer Peter Crutch', *Design Week* (15 August 2002), www.designweek.co.uk/issues/15-august-2002/paying-tribute-to-furniture-designer-peter-crutch (accessed 6 August 2020).

28 Quote from Hockney contained in a letter from author Peter B. Webb to curator Sandra Martin, MAG Hockney Artist's File, 10 May 1987. Webb is quoting a letter from Hockney to Martin Berger of 28 May 1961.

29 Aileen Ribeiro, 'Re-fashioning Art: Some Visual Approaches to the Study of the History of Dress', *Fashion Theory*, 2, no. 4 (1998), pp. 315–25, here p. 323.

30 Ribeiro, *The Gallery of Fashion*, p. 10.

CHAPTER 5

1 John Gudenian, 'Bermans and Nathans, Costume and the Entertainment World', *Costume*, 15, no. 1 (1981), pp. 60–66, here p. 60.

2 Alan Freeman, 'Quite an Experience!', *Rave* (June 1967), reprinted in full in Steven Roby (ed.), *Hendrix on Hendrix: Interviews and Encounters with Jimi Hendrix* (Chicago, IL: Chicago Street Press, 2012), pp. 23–38.

3 Nik Cohn, *Today There Are No Gentlemen: The Changes in Englishmen's Clothes Since the War* (London: Weidenfeld & Nicolson, 1971), p. 76.

4 Philip Norman suggests this is the same suit that McCartney later wore for appearances in court during the case he brought against the other Beatles and their company, Apple. Philip Norman, *Paul McCartney: The Biography* (London: Weidenfeld & Nicolson, 2016), p. 430.

5 Caroline Evans, 'Post-War Poses', in Caroline Evans, Christopher Breward and Edwina Ehrman (eds), *The London Look: Fashion from Street to Catwalk* (New Haven, CT and London: Yale University Press, 2004), pp. 117–28. The attribution of the suits varies across sources. The claim for Nutter is made in numerous obituaries and attributed to him; Philip Norman gives the maker of Paul and John's *Abbey Road* suits as Edward Sexton (Nutter's partner in the business, Nutter's of Savile Row); see Norman, *McCartney: The Biography*, p. 671. In 2010, when it was sold at auction, Lennon's suit was credited to French designer Ted Lapidus.

6 Slava Mogutin, 'The Business Satire of Gilbert and George' (Winter 2013), http://slavamogutin.com/gilbert_and_george (accessed 6 August 2020).

7 Gilbert & George, *The Laws of Sculptors* (1969), quoted in *10 Game-Changing Art Manifestos* (10 April 2015), www.royalacademy.org.uk/article/ten-game-changing-manifestos (accessed 6 August 2020).

8 Mogutin, 'The Business Satire of Gilbert and George'.

9 Alan Hubbard, 'Chris Eubank: The Dandy Bounces Back Off the Ropes – Now He's the Daddy', *Independent* (18 July 2010), www.independent.co.uk/news/people/profiles/chris-eubank-the-dandy-bounces-back-off-the-ropes-ndash-now-hes-the-daddy-2029321.html (accessed 6 August 2020).

10 John Cooper Clarke, 'John Cooper Clarke on his Love for Clothes', *Savile Row Style Magazine* (29 October 2015), http://savilerow-style.com/profiles/media-music/john-cooper-clarke (accessed 6 August 2020).

11 John Cooper Clarke, *The Suit*, BBC 6 Music (broadcast 28 September 2014).

12 James Laver, *British Military Uniform* (London: Penguin, 1948), p. 26.

13 Ibid., p. 26.

14 Clare Press, '50 Years After Sergeant Pepper, The Beatles' Retro Military Jackets Continue to Inspire', *Fashionista* (14 June 2017), https://fashionista.com/2017/06/sgt-pepper-beatles-suits-uniform-fashion (accessed 6 August 2020).

15 Robert Orbach, 'Interview with Robert Orbach', Victoria and Albert Museum (February 2006), www.vam.ac.uk/content/articles/i/robert-orbach (accessed 6 August 2020).

16 Elizabeth Wilson, *Adorned in Dreams: Fashion and Modernity* (London: I. B. Tauris, 2003), p. 184.

17 The 1894 Uniforms Act makes wearing military uniform without 'Her Majesty's permission' a criminal offence punishable by a fine or one month's imprisonment. www.legislation.gov.uk/ukpga/Vict/57-58/45/2009-10-31 (accessed 6 August 2020).

18 There are also conflicting stories about where the Hussar tunic was purchased. Some sources identify Lord Kitchener's boutique, others the Chelsea Antiques market.

19 Wilson, *Adorned in Dreams*, p. 184.

20 Claire Wilcox, *Vivienne Westwood* (London: Victoria and Albert Museum, 2005), p. 13.

21 Eileen Shapiro, 'A Conversation with Adam Ant', *Huffington Post* (21 January 2017), www.huffpost.com/entry/interviewadam-ant_b_5883db6fe4b0d96b98c1dca1 (accessed 6 August 2020).

22 The merger of the two theatrical costumiers took place in 1972.

23 Min Chen, 'King of the Wild Frontier: All the Ways in which Adam Ant Lived Up to the Part of Pop Pirate', *Proxy Music* (2018). https://proxymusic.club/2018/11/01/adam-ant-kings-of-the-wild-frontier (accessed 6 August 2020).

24 Wilson, *Adorned in Dreams*, p. 184.

CHAPTER 6

1 Roland Barthes, *The Language of Fashion* (London: Bloomsbury, 2013) pp. 31–2.

2 Flügel, *The Psychology of Clothes*.

3 *Reigning Men: Fashion in Menswear*.

4 Ibid., p. 11.

5 *ManStyle: Men and Fashion*, exh. cat. (Melbourne: National Gallery of Victoria, 2011), p. 53.

6 Anne Hollander, 'Heroes in Wool', in McNeil and Karaminas (eds), *The Men's Fashion Reader*, here p. 263.

7 Peter McNeil, 'Macaroni Men and Eighteenth Century Fashion Culture', *The Journal of the Australian Academy of the Humanities*, 8 (2017), pp. 57–71, here p. 58.

8 *Fashion Museum Bath* (Peterborough: Jarrold Publishing, 2016), pp. 24–5.

9 MCAG M6441.

10 BATCM 2011.124.13.

11 Cited in Lindsay Baker, 'How Fashion Can Stop Ruining the Planet', BBC website (20 April 2018), www.bbc.com/culture/story/20180419-how-fashion-can-stop-ruining-the-planet (accessed 6 August 2020).

12 MCAG 2018.7.

13 *Le Beau Monde* (November 1806), p. 59.

14 Harvey, *Men in Black*, front cover.

15 V&A: T.748-1913: BACTM: 11.06.16.

16 Examples of waistcoats: MCAG 1936.89, 1970.85, 1970.136, 1986.204. Examples of such early photographs: MCAG 2008.40.2.29, 30, 182.

17 For gowns, see MCAG 1960.301 and 1948.39.

18 MCAG 1947.1401; 1949.55.

19 Barbara Berman, 'Brighter and Better Clothes: The Men's Dress Reform Party, 1929–40', in McNeil and Karaminas (eds), *The Men's Fashion Reader*, pp. 130–42.

20 Simon Carter, 'Fashion, Male Beauty and the "Men's Dress Reform Party"', *Cost of Living* (Charisma: Consumer Market Studies, 15 April 2013), www.cost-ofliving.net/fashion-male-beauty-and-the-mens-dress-reform-party (accessed 6 August 2020).

21 National Portrait Gallery: photographs by Anthony, Bachrach, Bassano, Newman, Tanqueray and Beaton himself.

22 Geoffrey Aquilina Ross, *The Day of the Peacock: Style for Men 1963–1973* (London: V&A Publishing, 2011).

23 Ibid., p. 16.

24 Cohn, *Today There Are No Gentlemen*, p. 80.

25 Richard Lester, *Boutique London: A History. King's Road to Carnaby Street* (Woodbridge, Suffolk: ACC Editions, 2010).

26 Cohn, *Today There Are No Gentlemen*, p. 143.

27 Ross, *Day of the Peacock*, p. 23.

28 *Men in Vogue* (November 1965), p. 51.

29 Ibid., pp. 76–85.

30 Ibid., pp. 90–91 and p. 106.

31 Burton by Post catalogue, Spring/Summer 1965 (Manchester Art Gallery archives).

32 *Daks and the New Men*: fashion brochure (Manchester Art Gallery archives).

33 MCAG 2013.39.

34 Roger K. Burton, *Rebel Threads: Clothing of the Bad, Beautiful and Misunderstood* (London: Laurence King, 2017), quotation p. 10; see Shaun Cole, 'Queers and Mods: Social and Sartorial Interaction in London's Carnaby Street', in A. Reilly, P. Hunt-Hurst and K. A. Miller-Spillman (eds), *The Meanings of Dress*, 3rd edn (New York: Fairchild, 2012) pp. 214–21.

35 Claudia Dias, *Moda Vivendi* web post (27 June 2009) www.independent.com/2009/03/12/yinka-shonibare-brings-textile-art-sbma (accessed 6 August 2020).

36 www.soboye.co.uk/samson-soboye (accessed 1 September 2019).

37 Jessica Punter, 'Interview with Tom Ford', *GQ Magazine* (December 2013), www.gq-magazine.co.uk/article/tom-ford-skin-care-range-interview (accessed 6 August 2020).

38 Cohn, *Today There Are No Gentlemen*, p. 172.

CHAPTER 7

1 Hardy Amies, *ABC of Men's Fashion* (New York: Abrams, 2007), p. 26.

2 Hardy Amies, *The Englishman's Suit*, 2nd edn (London: Quartet, 1996), p. 70.

3 Norah Waugh, *The Cut of Men's Clothes: 1600–1900* (London: Faber & Faber, 1964), p. 54.

4 Chenoune, *A History of Men's Fashion*, p. 14.

5 Laver, *Dandies*, p. 33.

6 Cited in Diana Rait Kerr, 'The Costume of the Cricketer', *Costume*, 7, no. 1 (1971), pp. 50–54, here p. 50.

7 Chenoune, *A History of Men's Fashion*, p. 117.

8 *The Tailor and Cutter* (1909), quoted in Shaun Cole, *The Story of Men's Underwear* (New York: Parkstone Press, 2010), p. 44.

9 Cited in Christopher Breward, 'Manliness, Modernity and the Shaping of Male Clothing', in J. Entwistle and E. Wilson (eds), *Body Dressing: Dress, Body, Culture* (Oxford: Berg, 2001), pp. 165–81, here p. 165.

10 The Duke of Windsor, *A Family Album* (London: Cassell, 1960), p. 107.

11 Ibid., p. 11.

12 Elizabeth Dawson, '"Comfort and Freedom": The Duke of Windsor's Wardrobe', *Costume*, 47, no. 2 (2013), pp. 198–215, here p. 199.

13 Ibid.

14 Christine Arnold, 'An Assessment of the Gender Dynamic in Fair Isle (Shetland) Knitwear', *Textile History*, 41, no. 1 (2010), pp. 86–98, here p. 89.

15 Ibid., p. 92.

16 Suzy Menkes, *The Windsor Style* (Topsfield, MA: Salem House, 1988), p. 102.

17 Arnold, 'Fair Isle (Shetland) Knitwear', p. 88.

18 Chenoune, *A History of Men's Fashion*, p. 254.

19 Catherine Horwood, '"Anyone for Tennis?": Male Dress and Decorum on the Tennis Courts in Inter-War Britain', *Costume*, 38, no. 1 (2004), pp. 100–105, here p. 100.

20 Bill Osgerby, *Playboys in Paradise: Masculinity, Youth and Leisure-style in Modern America* (Oxford: Berg, 2001).

21 Ian Hough, *Perry Boys: The Casual Gangs of Manchester and Salford* (Wrea Green, Lancs: Milo Books, 2007), pp. 74, 10; Jo Turney, 'Fear and Clothing in Adidas: Branded Sportswear and Fashioning the "Handy Dandy"', in J. Turney (ed.), *Fashion Crimes: Dressing for Deviance* (London: Bloomsbury, 2019), pp. 81–92, here p. 81.

22 Steve Redhead, 'Soccer Casuals: A Slight Return of Youth Culture', *International Journal of Child, Youth and Family Studies*, 3, no. 1 (2012), pp. 65–82; Mairi MacKenzie, 'Football, Fashion and Unpopular Culture: David Bowie's Influence on Liverpool Football Club Casuals 1976–79', *Celebrity Studies*, 10, no. 1 (2019), pp. 25–43.

23 MacKenzie, 'Football, Fashion and Unpopular Culture', p. 28; Geoffrey Pearson, 'Victorian Boys, We Are Here!', in K. Gelder and S. Thornton (eds), *The Subcultures Reader* (London and New York: Routledge, 1970), pp. 281–92, here p. 289.

24 Hough, 'Perry Boys'.

25 In September 1982, *The Face* described a shift in London's clubland away from exaggerated, exotic styles towards a more 'functional' style of dress, which it called 'Hard Times'.

26 John Godfrey, 'The Amnesiacs', *i-D*, no. 52 (June 1988), p. 70.

27 Dan Jones, *50 Men's Fashion Icons that Changed the World* (London: Conran Octopus, 2016), p. 72.

28 For Adidas company history, see www.adidas-group.com/en/group/history/ (accessed 6 August 2020).

29 Amies, *The Englishman's Suit*, p. 70.

30 Jo Turney, 'From Revolting to Revolting: Masculinity, the Politics and Body Politics of the Tracksuit', in Turney (ed.), *Fashion Crimes*, pp. 169–212, here p. 170.

31 Tulloch (ed.), *Black Style*; Turney, 'From Revolting to Revolting', p. 172.

32 Quoted in Amos Barshad, 'The Meaning of Tracksuits', *The New Yorker* (18 September 2019), www.newyorker.com/culture/annals-of-inquiry/the-meaning-of-tracksuits?fbclid=IwAR1mtpSohp5qGq26rljfifB81KVxfoH9eLejLCm-OSD4ASmMzk5VccF3lF0 (accessed 6 August 2020).

33 Owen Jones, *Chav: The Demonisation of the Working Class* (London: Verso, 2011); Jo Turney, 'The Horror of the Hoodie: Clothing the Criminal', in Turney (ed.), *Fashion Crimes*, pp. 23–32.

34 Jennifer Craik, *Uniforms Exposed: From Conformity to Transgression* (Oxford: Berg, 2005), p. 177.

35 See McCauley Bowstead, *Menswear Revolution*.

36 Christopher Shannon, quoted in Jake Hall, 'Christopher Shannon: Passion before Profit', *Crack* (n.d.), https://crackmagazine.net/article/long-reads/christopher-shannon-passion-before-profit (accessed 6 August 2020).

37 Ryan Thompson, 'The Tracksuit Takeover', *Financial Times* (21 June 2016), www.ft.com/content/2c5c0c9e-17a0-11e6-b197-a4af20d5575e?FTCamp=engage/CAPI/website/Channel_EBSCO//B2B (accessed 6 August 2020).

38 Turney, 'From Revolting to Revolting', p. 178.

39 Gilles Lipovetsky, *The Empire of Fashion: Dressing Modern Democracy* (Princeton, NJ: Princeton University Press, 1994), p. 123.

40 Barshad, 'The Meaning of Tracksuits'.

41 Windsor, *Family Album*, p. 105.

CHAPTER 8

1 Underworld (Rick Smith and Karl Hyde), 'Born Slippy. NUXX' (London: Junior Boys Own, 1996).

2 John Finkelberg, 'Transnational Dandies, Exquisites, and Lions: The Transnational Language of Masculinity in France and Britain, 1815–1830', paper presented at *De/Constructing Masculinities? Critical Explorations into Affect, Intersectionality, and the Body*, Erlangen, Bavaria, 23 June 2018.

3 Ioanna Karagiorgou, 'The "Modern Gentleman": Luxurious Lifestyles and UK-based Personal Lifestyle Blog', paper presented at *Fashion, Costume and Visual Cultures Conference*, Roubaix, 9–11 July 2019.

4 Breward, *The Suit*; Mike Savage, Niall Cunningham, Mark Taylor, Johs Hjellbrekke, Brigitte Le Roux and Sam Friedman, 'A New Model of Social Class: Findings from the BBC's Great British Class Survey Experiment', *Sociology*, 47, no. 1 (2013), pp. 219–50.

5 Hongdae is a fashionable district of Seoul (South Korea), located next to arty Hongik University; Brooklyn is an ethnically diverse borough of New York City (USA) known for its Jewish, black, Chinese, Irish, South and Central American and other communities; Peckham in south London (UK) is an increasingly modish district with a large Caribbean and African population.

6 Pierre Bourdieu, *Distinction: A Social Critique of the Judgement of Taste* (London: Routledge & Kegan Paul, 1984).

7 Savage et al., 'A New Model of Social Class'.

8 David LeBolt and Malcolm McLaren, 'Waltz Darling' (Los Angeles, CA: Epic, 1989).

9 The practice of wearing a three-piece suit can be traced back to the reign of Charles II and the autumn of 1666 (Breward, *The Suit*). However, the suits worn at Charles's court, with their voluminous breeches, long waistcoats and coats, are markedly different in cut and silhouette to the contemporary business (or lounge) suit, which originated in the nineteenth century.

10 Mechtild Oechsle, Ursula Müller and Sabine Hess, *Fatherhood in Late Modernity: Cultural Images, Social Practices, Structural Frames* (Opladen, Germany: Barbara Budrich, 2012).

11 Will Dahlgreen, 'Only 2% of Young Men Feel Completely Masculine (Compared to 56% of Over 65s)', Yougov: *What The World Thinks* (13 May 2016), https://yougov.co.uk/topics/politics/articles-reports/2016/05/13/low-young-masculinity-britain (accessed 6 August 2020).

12 Report by Global Institute for Women's Leadership in association with Ipsos MORI, *International Women's Day 2019: Global Attitudes Towards Gender Equality* (London: Kings College London, 2019), www.kcl.ac.uk/giwl/research/global-attitudes-towards-gender-equality (accessed 6 August 2020).

13 Eric Anderson, *Inclusive Masculinity* (New York: Routledge, 2009); Ann-Dorte Christensen and Sune Qvotrup Jensen, 'Combining Hegemonic Masculinity and Intersectionality', *NORMA: Nordic Journal For Masculinity Studies*, 9, no. 1 (March 2014), pp. 60–75.

14 Nick Ferguson, quoted in Helena Pike, 'Can Grooming Brands Get "Low Maintenance" Men to Buy Beauty?', *The Business of Fashion* (6 April 2016), www.businessoffashion.com/articles/intelligence/can-grooming-brands-get-low-maintenance-men-to-buy-beauty (accessed 6 August 2020).

15 Matthew Schneier, 'Grace Wales Bonner, a New Designer Who Looks to African and Indian History', *New York Times* (2015), www.nytimes.com/2015/06/18/fashion/mens-style/grace-wales-bonner-a-new-designer-with-ancient-history.html?_r=0 (accessed 6 August 2020).

16 In the years leading up to the First World War and during the inter-war period, increasing demand for tailored suits from men of all social classes was met by innovative 'multiple tailors'. The multiple tailors combined chains of shops where customers could be measured, with centralised manufacture predominantly based in Leeds where suits could be produced highly efficiently. This enabled companies such as Montague Burton to provide made-to-measure suits at affordable prices. See Katrina Honeyman, 'Tailor-Made: Mass Production, High Street Retailing, and the Leeds Menswear Multiples, 1918 to 1939', *Northern History*, 37, no. 1 (2000), pp. 293–305.

17 Elizabeth Selby (ed.), *Moses, Mods and Mr Fish: The Menswear Revolution* (London: Jewish Museum, 2016); Elizabeth Selby, 'Case Study: Moses, Mods and Mr Fish: An Exhibition on Men's Fashion at the Jewish Museum London', *Critical Studies In Men's Fashion*, 4, no. 1 (2017), pp. 31–41.

18 Cohn, *Today There Are No Gentlemen*; Shaun Cole, *'Don We Now Our Gay Apparel'*.

19 Dick Hebdige, *Subculture: The Meaning of Style* (London: Routledge, 1979).

20 McCauley Bowstead, *Menswear Revolution*.

21 This brand awareness translates into sales of high-margin branded products such as colognes, skincare and eyewear as well as bags and luggage.

SELECT BIBLIOGRAPHY

Anderson, Eric, *Inclusive Masculinity: The Changing Nature of Masculinitie*s (New York: Routledge, 2009).

Attfield, Judy, *Wild Things: The Material Culture of Everyday Life* (Oxford: Berg, 2000).

Barthes, Roland, *The Language of Fashion* (London: Bloomsbury, 2013).

Baudelaire, Charles, *The Painter of Modern Life and Other Essays*, trans. Jonathan Mayne (London: Phaidon, 1964).

Beerbohm, Max, *The Works of Max Beerbohm with a bibliography by John Lane* (London: John Lane, The Bodley Head and New York: Charles Scribner's Sons, 1896)

Breward, Christopher, *The Hidden Consumer: Masculinities, Fashion and City Life 1860–1914* (Manchester: Manchester University Press, 1999).

———, 'The Dandy Laid Bare: Embodying Practices of Fashion for Men', in P. Church Gibson and S. Bruzzi (eds), *Fashion Cultures: Theories, Explorations, and Analysis* (London and New York: Routledge, 2000), pp. 221–38.

———, *The Suit: Form, Function & Style* (London: Reaktion Books, 2016).

Chapman, Rowena and Jonathan Rutherford (eds), *Male Order: Unwrapping Masculinity* (London: Lawrence & Wishart, 1988).

Chenoune, Farid, *A History of Men's Fashion*, trans. Deke Dusinberre (Paris: Flammarion, 1993).

Cicolini, Alice, *The New English Dandy* (London: Thames & Hudson, 2005).

Cohn, Nik, *Today There Are No Gentlemen: The Changes in Englishmen's Clothes Since the War* (London: Weidenfeld and Nicolson, 1971).

Cole, Shaun, *'Don We Now Our Gay Apparel': Gay Men's Dress in the Twentieth Century* (Oxford: Berg, 2000).

———, '"Looking Good in a Buffalo Stance": Ray Petri and the Styling of New Masculinities' in Ane Lynge-Jorlén (ed.), *Fashion Stylists: History, Meaning and Practice* (London: Bloomsbury, 2020), pp. 135–54.

Edwards, Tim, *Men in the Mirror: Men's Fashion, Masculinity and Consumer Society* (London: Cassell, 1997).

Entwistle, Joanne, *The Fashioned Body: Fashion, Dress and Modern Social Theory* (Cambridge: Polity Press, 2000).

Evans, Caroline, Christopher Breward and Edwina Ehrman (eds), *The London Look: Fashion from Street to Catwalk* (New Haven, CT and London: Yale University Press, 2004).

Filin-Yeh, Susan (ed.), *Dandies: Fashion and Finesse in Art and Culture* (New York: New York University Press, 2001).

Flügel, John Carl, *The Psychology of Clothes* (London: Hogarth Press, 1930).

Garelick, Rhonda K., *Rising Star: Dandyism, Gender, and Performance in the Fin de Siècle* (Princeton, NJ: Princeton University Press, 1998).

Gray, Sally and Roger Leong, *Critical Studies in Men's Fashion*, 4, no. 1 (2017) (Special issue: 'Exhibiting Masculinity').

Harvey, John, *Men in Black* (London: Reaktion Books, 1995).

Hebdige, Dick, *Subculture: The Meaning of Style* (London: Routledge, 1979).

Hollander, Anne, *Sex and Suits: The Evolution of Modern Dress* (New York: Knopf, 1994).

Irvin, Kate, *Artist, Rebel, Dandy: Men of Fashion* (New Haven, CT: Yale University Press, 2013).

Kelly, Ian, *Beau Brummell: The Ultimate Dandy* (London: Hodder & Stoughton, 2005).

Kuchta, David, *The Three-Piece Suit and Modern Masculinity: England, 1550–1880* (Berkeley, CA: University of California Press, 2002).

Laver, James, *Dandies* (London: Weidenfeld & Nicolson, 1968).

Lewis, Shantrelle P., *Dandy Lion: The Black Dandy and Street Style* (New York: Aperture, 2017).

McCauley Bowstead, Jay, *Menswear Revolution: The Transformation of Contemporary Men's Fashion* (London: Bloomsbury, 2018).

McNeil, Peter, *Pretty Gentlemen: Macaroni Men and the Eighteenth-Century Fashion World* (New Haven, CT and London: Yale University Press, 2018).

McNeil, Peter and Vicky Karaminas (eds), *The Men's Fashion Reader* (Oxford: Berg, 2009).

Miller, Monica L., *Slaves to Fashion: Black Dandyism and the Styling of Black Diasporic Identity* (Durham, NC: Duke University Press, 2009).

Moers, Ellen, *The Dandy: Brummell to Beerbohm* (London: Secker & Warburg, 1960).

Pearce, Susan M. (ed.), *Interpreting Objects and Collections* (London: Routledge, 2003).

Reigning Men: Fashions in Menswear, 1715–2015, exh. cat. (Los Angeles County Museum of Art/DelMonico Books, 2018).

Ribeiro, Aileen, *The Art of Dress: Fashion in England and France, 1750–1820* (New Haven, CT and London: Yale University Press, 1995).

———, *Clothing Art: The Visual Culture of Fashion, 1600–1914* (New Haven, CT and London: Yale University Press, 2016).

Ross, Geoffrey Aquilina, *The Day of the Peacock: Style for Men 1963–1973* (London: V&A Publishing, 2011).

Tulloch, Carol (ed.), *Black Style* (London: V&A Publishing, 2004).

Walden, George, *Who's a Dandy: Beau Brummell to Today* (London: Gibson Square, 2002).

Waugh, Norah, *The Cut of Men's Clothes: 1600–1900* (London: Faber & Faber, 1964).

Wilson, Elizabeth, *Adorned in Dreams: Fashion and Modernity* (London: I. B. Tauris, 2003).

INDEX

ACKNOWLEDGEMENTS

The editors and authors would like to thank the following people, organisations and institutions for their generous support: Saul Allen; Biddy Hayward at ArenaPal; Centre for Fashion Curation, University of the Arts London; Jason Evans; Rosemary Harden and Fleur Johnson at Fashion Museum Bath; Lubaina Himid; David Hockney Inc.; Rory James; Michael Pollard; Mark Reed; Olivia Rose; Sir Roy Strong; Danielle Sprecher and Andrew Groves at Westminster Menswear Archive, University of Westminster; and Jamie at Youth Club Archive.

CONTRIBUTORS

JOSHUA M. BLUTEAU is an anthropologist and formerly a lecturer at the University of Manchester.

SHAUN COLE is Associate Professor in Fashion at Winchester School of Art, University of Southampton.

KATE DORNEY is Senior Lecturer in Modern and Contemporary Performance at Martin Harris Centre for Music and Drama, the University of Manchester.

MILES LAMBERT is Curator of Costume at Manchester Art Gallery.

JAY MCCAULEY BOWSTEAD is Cultural and Historical Studies Lecturer and co-convenor of the Masculinities Research Hub at London College of Fashion, University of the Arts London.

REBECCA MILNER is Curator of Fine Art at Manchester Art Gallery.

BEN WHYMAN is Manager of the Centre for Fashion Curation, London College of Fashion, University of the Arts London.

PICTURE CREDITS

Art Collection: 3/Alamy Stock Photo: fig. 56
Classic Image/Alamy Stock Photo: fig. 2
David Cole/Alamy Stock Photo: fig. 43
Shaun Cole: figs 10, 53, 103
Dior/Alessandro Garofalo: fig. 108
dpa picture alliance/Alamy Stock Photo: fig. 114
Jason Evans: figs 7, 8
Everett Collection Inc/Alamy Stock Photo: fig. 15
Fashion Museum Bath/Peter Stone: figs 29, 33, 35, 36, 37, 38, 39, 40, 77
Paul Fuller: figs 93, 109
GL Archive/Alamy Stock Photo: fig. 1
Granger Historical Picture Archive/Alamy Stock Photo: fig. 85
Lubaina Himid: fig. 9
David Hockney Inc./Manchester Art Gallery: fig. 63
Rory James: figs 112, 113
Colin Jones/Topfoto/ArenaPAL: fig. 68
Marilyn Kingwill/ArenaPAL: fig. 67
Leeds City Council: fig. 55
Leeds Museums and Galleries (Lotherton Hall) U.K./Bridgeman Images: fig. 102
Manchester Art Gallery: p. 6 and figs 3, 4, 5, 6, 11, 12, 13, 14, 16, 17, 19, 20, 21, 22, 23, 24, 25, 26, 27, 28, 41, 42, 44, 46, 47, 48, 49, 50, 51, 52, 58, 59, 60, 61, 62, 63, 70, 71, 72, 73, 74, 75, 76, 78, 79, 80, 81, 82, 83, 84, 86, 87, 88, 89, 90, 93, 95, 96, 97, 98, 99, 100, 101
Jay McCauley Bowstead: fig. 110
Photoshot/TopFoto: fig. 69
Olivia Rose: fig. 107
The Royal Society: fig. 54
Science History Images/Alamy Stock Photo: fig. 57
Trinity Mirror/Mirrorpix/Alamy Stock Photo: fig. 65
Victoria and Albert Museum, London: fig. 64
WENN Rights Limited/Alamy Stock Photo: figs 45, 66
Westminster Menswear Archives, University of Westminster: figs 91, 94, 106
Ben Whyman: figs 30, 31, 32, 34
Glenn Wigham and Manchester Art Gallery: fig. 92
Wolverhampton Art Gallery: fig. 18
Xinhua/Alamy Stock Photo: fig. 111
YOUTH CLUB: figs 104, 105

First published by Yale University Press 2021

302 Temple Street, P. O. Box 209040, New Haven CT 06520–9040

47 Bedford Square, London WC1B 3DP

yalebooks.com | yalebooks.co.uk

ISBN 978–0–300–25413–6 HB

Library of Congress Control Number: 2020941540

10 9 8 7 6 5 4 3 2 1

2025 2024 2023 2022 2021

Designed by Rita Pereira

Printed in China

Front cover: Detail of red ribbed silk suit, 1760–80. Manchester Art
Gallery (1954.960).

Frontispiece: Detail of embroidered court suit, 1770–85. Manchester Art
Gallery (1952.359).